THE FOLK ART
OF
LATIN AMERICA

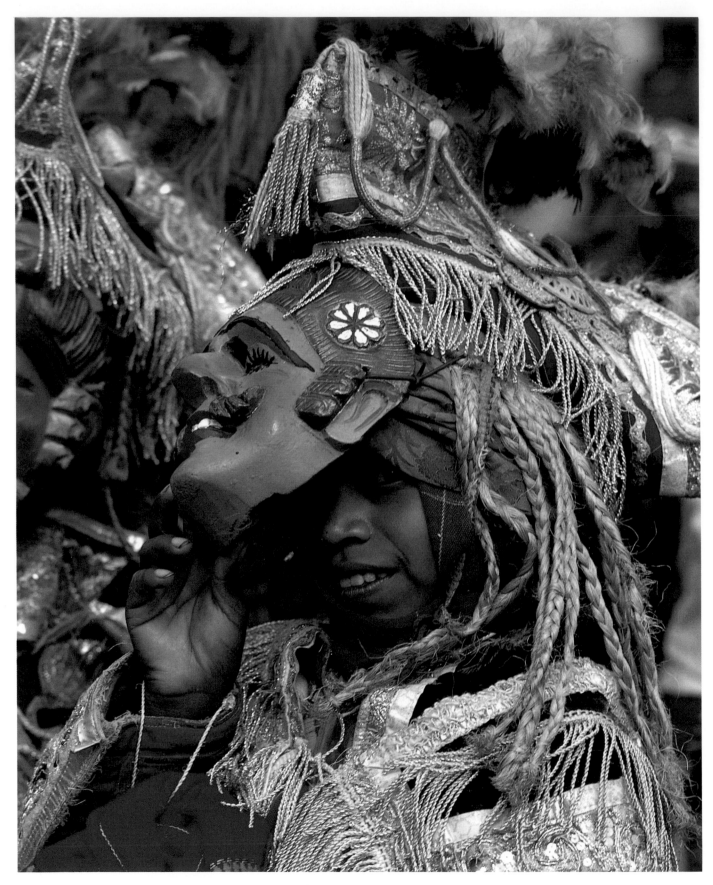

Fig. 1. *Boy from Dance of the Conquest*, c. 1988, Joyabaj, Guatemala.

THE FOLK ART OF LATIN AMERICA
VISIONES DEL PUEBLO

MARION OETTINGER, JR.

Curator of Folk Art and Latin American Art
San Antonio Museum of Art

Dutton Studio Books

in association with the

Museum of American Folk Art

New York

This book is dedicated to the memory of
Robert Bishop

"A saint who is not seen is not worshipped."

—LATIN AMERICAN FOLK SAYING[1]

DUTTON STUDIO BOOKS
Published by the Penguin Group
Penguin Books USA Inc., 375 Hudson Street,
New York, New York, 10014, U.S.A.

Penguin Books Ltd, 27 Wrights Lane,
London W8 5TZ, England

Penguin Books Australia Ltd, Ringwood,
Victoria, Australia

Penguin Books Canada Ltd, 2801 John Street,
Markham, Ontario, Canada L3R 1B4

Penguin Books (N.Z.) Ltd, 182-190 Wairau Road,
Auckland 10, New Zealand

Penguin Books Ltd, Registered Offices:
Harmondsworth, Middlesex, England

First published by Dutton Studio Books, an imprint of Penguin Books USA Inc.

Library of Congress
Catalog Card Number: 92-71072

Printed and bound by Dai Nippon Printing Co., Ltd., Tokyo, Japan
Book designed by Kingsley Parker

ISBN: 0-525-93435-9 (cloth); ISBN: 0-525-48599-6 (paperback)

LENDERS TO THE EXHIBITION

Saundra Abbott, Los Angeles, California
American Museum of Natural History, New York, New York
Peter Bartlett, Los Angeles, California
Jim and Veralee Bassler, San Pedro, California
Jim Caswell, Santa Monica, California
Peter P. Cecere, Reston, Virginia
Colorado Springs Fine Arts Center, Colorado Springs, Colorado
Tad Dale, Santa Fe, New Mexico
Martha Egan, Santa Fe, New Mexico
Gordon Frost, Benicia, California
Gloria Galt, San Antonio, Texas
Jaime and Vivian Liebana, Lima, Peru
Robert and Susan Morris, Chapel Hill, North Carolina
Alan Moss, New York, New York
The Museum of International Folk Art, Santa Fe, New Mexico
Avon Neal and Ann Parker, North Brookfield, Massachusetts
Tom and Alma Pirazzini, Encinitas, California
Private Collection, San Antonio, Texas
The San Antonio Museum Association, San Antonio, Texas
Bill and Faye Sinkin, San Antonio, Texas
Jonathan Williams, Austin, Texas
Virgil Young, Los Angeles, California

CONTENTS

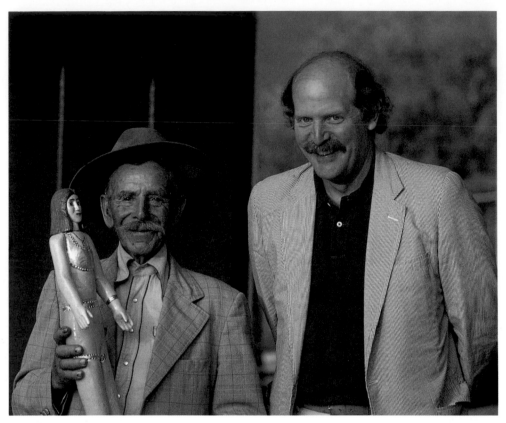

Fig. 2. *Venezuelan Wood Carver, José de los Santos with Marion Oettinger, Jr.*, c. 1989, Mérida, Venezuela. Photo by Mariano Díaz.

LIST OF ILLUSTRATIONS

FIGURES

PLATES

FOREWORD

Dr. Robert Bishop, the late Director of the Museum of American Folk Art, initiated the project that led to the publication of this book and to the exhibition it is designed to complement. To the delight of audiences in Caracas, Bogotá, São Paulo, Montevideo, and other cities, a selection of objects from the Museum's collection of American folk art previously toured Latin America under the auspices of the United States Information Agency. In view of the overwhelming success of that undertaking it seemed especially appropriate that a reciprocal exhibition of Latin American folk art be presented in the United States. With the generous support and encouragement of our friends at Ford Motor Company, the Museum conceived and developed this project as a means for bringing a rich, cultural heritage to the United States, where it remained largely unknown. I am delighted to acknowledge with warm thanks the outstanding scholarship of Dr. Marion Oettinger, Jr., Curator of Folk Art and Latin American Art at the San Antonio Museum of Art, who accepted Bob Bishop's challenge and spearheaded the effort as Project Director and Guest Curator.

During the four or five years since the exhibition was conceived, my colleagues and I have been intrigued by the arrival at the Museum, at regular intervals, of objects uncovered by Marion Oettinger while conducting his fieldwork in Latin America. As these objects were uncrated, we became increasingly involved in an absorbing process of discovery. It was during this time that the diversity, creativity, and ingenuity of Latin American folk artists, so wonderfully portrayed in the pages of this book, became eloquently apparent to us. I am especially pleased that Bob Bishop was able to participate in this exciting process, although he did not live to see the project's completion.

There are remarkable parallels between the *arte popular* of Latin America and the folk art that flowered north of the Rio Grande. North or south, there is a complex history of diversity that has had a direct impact upon folk expression, the most vigorous forms frequently resulting from a fusion of cultural influences. In both parts of the hemisphere, folk art often developed out of earlier, provincial adaptations of urban style and then reached full vitality in the nineteenth-century's profusion of regional and local traditions. In Latin America, as in the United States and Canada, the twentieth-century has witnessed a surprising resiliency of folk expression, now often incorporating highly individualistic interpretations of community traditions. Wherever it is created, folk art promotes a sense of cohesion and continuity. It helps us understand ourselves.

As the forces of industrialization and mass communication tend to limit the production of handmade objects, the conservation of folk traditions has become increasingly important. This is as true in the United States as it is in Latin America. It is only through projects like this that a precious aspect of our shared heritage will be known and maintained. I am proud that the Museum of American Folk Art was the catalyst for the organization of this exhibition, which not only will be seen by our audiences in New York but also by visitors to the San Antonio Museum of Art; the Field Museum of Natural History, Chicago; The Corcoran Gallery of Art, Washington, D.C.; the Natural History Museum of Los Angeles County; and the Art Museum at Florida International University, Miami. It is deeply gratifying to know that through this exhibition and the pages of this book, the wonders of Latin American folk art will become known to a wide and, I am certain, deeply appreciative, audience.

GERARD C. WERTKIN
Director
Museum of American Folk Art

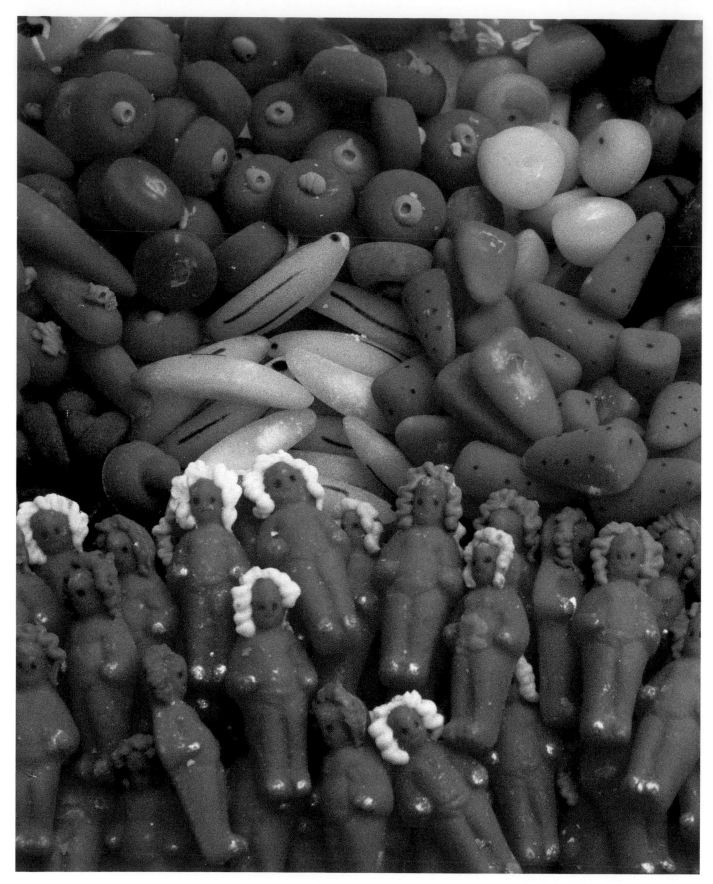

Fig. 3. *Day of the Dead Sweets*, c. 1985, Huejotzingo, Mexico.

PREFACE

The Folk Art of Latin America began one afternoon in 1989 when I received a telephone call from the late Dr. Robert Bishop, Director of the Museum of American Folk Art, asking if I would be interested in serving as Project Director and Guest Curator for a major exhibition of Latin American folk art that would open in New York some time during 1992. The museum, he explained, was keenly aware of the changing demographics of the United States, particularly those involving Latin Americans, and wanted to reflect its interest in these changes. The exhibition would concentrate on objects from the twentieth century in order to show that folk-art traditions are alive and well throughout Latin America. Fieldwork would be necessary, and I would have to spend a great deal of time away from home and the San Antonio Museum of Art, where I am Curator of Folk Art and Latin American Art. For most of my professional life, I had called myself a "Latin Americanist," although I had visited only one-third of the countries in that part of the world. Now, at last, I would be able to live up to my title. After speaking with my wife Jill and the director of my museum, I eagerly accepted the challenge.

Meetings were held in New York and Washington to discuss goals, parameters, schedules, publications, and other aspects of the project, and a tentative calendar was established. We agreed on an approximate size for the exhibition, and decided that, whenever possible, I would purchase folk art at its source, from the places where it is made and used. When such a strategy was not possible or practical, we would borrow objects from museums and private collectors in the United States and Latin America. A fieldwork schedule was established, and the chase began with a three-month trip to the Caribbean and Venezuela during the fall of 1989. Six months later, I traveled to South America, spending three months in Brazil, Ecuador, Bolivia, and Peru. In between these two field sessions, I made several trips to Mexico and Guatemala, both countries I already knew well from a variety of perspectives. I knew, from the outset, that it would be impossible for me to visit every part of Latin America during the limited time allotted, so I decided to concentrate on those areas with the strongest intact folk-art traditions. By the time my fieldwork was concluded, I had traveled to thirteen countries in Latin America and had arranged to borrow objects from four other countries I was unable to visit.

I used several criteria in choosing material for this exhibition. My first criterion was a geographical one; I concentrated on paintings and objects from Latin America, i.e., Mexico, Central and South America, and Spanish- and French-speaking islands in the Caribbean. However, because culture does not necessarily abide by political boundaries, I also decided to include several outstanding examples of folk art from the southwestern United States, namely New Mexico and south Texas. Second, I was interested primarily in those things that were made *by* Latin Americans *for* Latin Americans—I was not interested in folk art made for export. Not unexpectedly, this often presented a dilemma. In Haiti, for example, there is a long-established tradition of mural and easel painting to depict religious subjects and important scenes from typical daily or ceremonial life. With the recent increase of interest abroad in Haitian "primitive" painting, artistic energies have shifted almost totally to this export commercial audience to the detriment of more traditional forms of folk painting. Since I was interested only in those works of art that reflected local aesthetics and that respond to local tastes, these readily available, but gallery-oriented, paintings were unacceptable. Simply put, I was interested in folk art that tells us about the tastes and preferences of Latin American culture and not our own. It was this emphasis on the Latin American perspective that inspired the subtitle of our exhibition, *Visiones del Pueblo*, or *Visions of the People*.

Third, we have attempted to include those objects that are central to Latin American religious and secular life. At the same time, however, we have tried hard to avoid the cliché manifestations of folk culture, preferring instead those that are equally important but less known to museums in this country. Finally, we have tried to strike a balance between the aesthetic qualities of a piece and its functional importance for those who made and used it. Consequently, we feel that the objects shown here are not only aesthetically pleasing, but that they also play central roles in Latin American society and culture.

Projects as ambitious as this always run into difficulty from time to time, and this one was no exception. Planned fieldwork sessions in Colombia, Haiti, Peru, and Panama had to be rescheduled and, in two cases, canceled because of political unrest. My work in Brazil, highly successful overall, had to be cut short by two weeks because the recent economic crisis there made my U.S. dollars next to worthless. Finally, I was unaware of just how often the strongest visual expressions of folk culture do not lend

themselves to removal from their natural context. Puerto Rican murals advertising trades or professional services, hand-painted and intricately carved peasant huts in rural Haiti, boldly risqué carnival floats in Recife, Brazil, and dramatic roadside shrines in Venezuela had to remain where they were made and most appropriately used *(Figs. 4, 5)*.

Furthermore, ephemeral folk forms, such as festive foods and floral arrangements, which are designed to last a few hours or days, had to be passed over in favor of those things that could be practically transported back to the States. For example, special altars and grave decorations I observed in Sumpango, Guatemala, for Days of the Dead would have greatly enhanced the look of the New York installation and would have contributed enormously to our understanding of the nature of that type of folk expression, but it was not to be *(Figs. 6, 8)*. Most folk art does not travel well. Therefore, it should be allowed to grow, blossom, and die with dignity in its proper setting. In this case, and dozens like it, I had to be content to return home, not with the object itself, but with photographs and rich memories instead.

Fig. 4. *Mural*, c. 1989, Ponce, Puerto Rico.

One of the paradoxes of folk-art collecting, whether for museum exhibitions or otherwise, is that often, in order to find good folk art, one must be present on the occasions when it is used. But if it is being used, it is usually not available for purchase. In order to see carnival dance masks and costumes, for example, one must be present on

the occasions when they are worn. Almost never, however, are they sold to anyone until after the celebration is over. Unless one is willing to exercise patience and spend the time necessary to attend such events, then wait around until after they are over, will one be a successful collector of Latin American folk art. One of the game boards in this exhibition is a good example. I stumbled upon this exciting object while it was being used by a man in the Otovalo market of Ecuador. I unsuccessfully played the game myself for about fifteen minutes. After deciding that the board would make an important addition to the exhibition, I then photographed and interviewed its owner as he cleverly used the board to work the crowd around him *(Fig. 29)*. Finally, I asked if he would be interested in selling the board to me for an exhibition in the United States. He thought for a moment, and said yes, but only if I wait until the market was over so he could ply his trade as his audience expected. To help pass the time, I unsuccessfully tried my luck again—and again, and again. Fortunately for my budget, the day finally ended, and we decided on a price, and I made the purchase. I returned to the same market the following week, only to see my game-board friend barking his invitations to another crowd from behind a new, hand-painted game board that was just as effective as the one I had purchased earlier.

The present catalogue (and the exhibition it documents) is designed to provide an overview of Latin American folk art and to alert us to the rich variety of folk forms from that part of the world. Chapter 1 grapples with the nature of folk art and explores this form of expression through time in Latin America. Special attention is paid to Indian, European, and other roots of contemporary Latin American folk art in order to understand better its composite character. Chapter 2 deals with contemporary Latin American folk artists and concentrates on their socialization as artists. It also briefly examines folk artists' impressions of the contributions they make to local society and traditions. Chapter 3 explores the rich variety of folk forms in present-day Latin America and divides those forms into four functional categories—ceremonial, utilitarian, recreational, and decorative. Finally, Chapter 4 examines the ever-changing nature of folk art

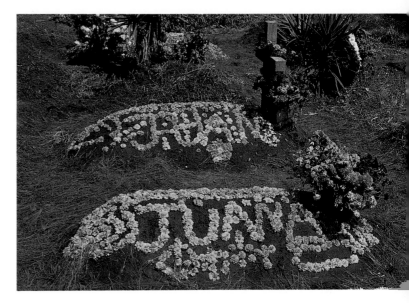

Fig. 6. *Decorated Graves*, c. 1988. Sumpango, Guatemala.

and what such changes mean to the quickly evolving societies folk art serves.

The *Folk Art of Latin America* project came about at this time, partly to commemorate the five hundredth anniversary of the first encounter between European and New World cultures, and partly to remind us that important discoveries can still be made about the vital societies of contemporary Latin America. In our unfortunate Eurocentrism, we have consistently ignored the significance of Latin American culture, making us pitifully ignorant of the artistic richness of that part of the world. Here, we hope to attack that problem, especially as it relates to folk culture. More specifically, we hope that this project will provide two levels of revelation. First we hope that it will be a discovery of the nature of modern folk art of Latin America, much of which is unknown and previously unrecorded. Second, we hope that it will be a revelation of Latin American culture through folk art. Through this exhibition, visitors should be able to discover a new and valuable window through which to view and better understand Latin American culture and society.

Fig 5. *Rural Hut*, c. 1989, Haiti.

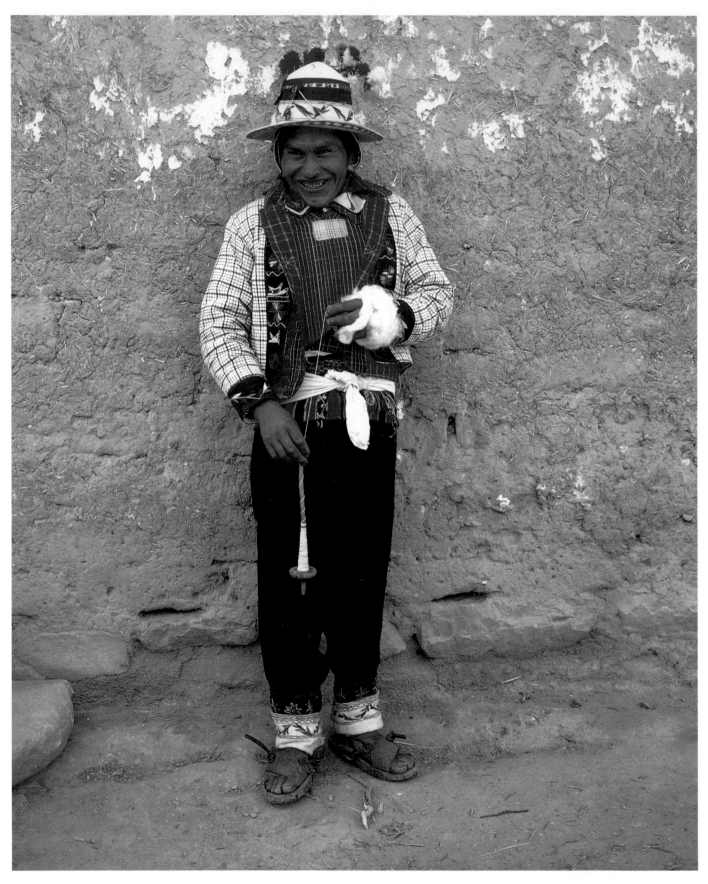

Fig. 7. *Boy with Drop-spindle*, c. 1980, Bolívar, Bolivia.

ACKNOWLEDGMENTS

The Folk Art of Latin America is the result of the combined efforts of many people from all over this hemisphere. Without the assistance and support of scores of anthropologists, folklorists, art historians, photographers, museum specialists, and others who value the inherent beauty and importance of Latin American folk culture, this catalogue and the exhibition it chronicles would never have been born. Each made my work more interesting and enjoyable, and all must share in any praise this project might receive.

Robert Bishop, the late Director of the Museum of American Folk Art, planted the first seeds out of which this project grew. Throughout the long and often tiring process of project definitions, proposal writing, negotiations with publishers and potential object lenders, and planning related to complementary events, Bob was an enthusiastic participant. I applaud him for the tremendously important work he did on behalf of folk art in general, and I am grateful for his valuable assistance and constant support. His death in September 1991 has saddened us all, but his legacy in the field of folk art will live on in the many projects he inspired, including this one.

Johleen Nester, former director of Development for the Museum of American Folk Art, has also been closely involved in the creation and evolution of this project. In her firm but charming manner, she shepherded the exhibition through all sorts of weather, fair as well as inclement, and brought it through in sound shape. Catherine Dunworth, Acting Director of Development, did not miss a beat and effectively tied up loose ends after Johleen's departure. Ann-Marie Reilly and Lucille Stiger oversaw the myriad registration details, including shipment of objects, conservation, loan contracts, and the integration of objects into the museum fold, and they always did so professionally and with smiles. Alice Hoffman, Director of Exhibitions, has booked an excellent tour and her hard work is evident at every venue.

Gerard Wertkin, the new Director of the Museum of American Folk Art and Stacy Hollander, Curator of Collections, were involved in most aspects of the project and they provided valuable insight into the production of the catalogue, the mounting of the exhibition, and the development of educational programming. Their capable leadership will move the museum through the tough years that lie ahead, a journey that will be both exciting and meaningful to our better understanding of the folk world that touches us all. Katherine Fukushima and Rebecca Danziger worked hard to develop an effective and creative education program related to the Latin American project, and they are to be commended for their fine work. Susan Flamm, Director of Public Relations for the museum, has been tireless in her efforts to find new ways to "spread the word" about this project, and her creative efforts have borne rich fruit.

Clifford La Fontaine, the exhibition designer, worked his magic as only he can. As usual, he has demonstrated great creativity and a special sensitivity for the objects themselves. Rosemary Gabriel expertly designed invitations, posters, and other printed materials associated with this project, and her contributions are fresh and exciting.

The exhibition was funded by a generous grant from Ford Motor Company. Ford has long been interested in the culture of Latin America and the vital role it plays in achieving a better understanding of that part of the world. Leo J. Brennan, Jr., Frank V. J. Darin, and Gary L. Nielson, all of Ford, have been strong supporters throughout the project, and we greatly appreciate their help. Mabel H. Brandon, Director of Corporate Programming, has been very helpful from the moment Ford became involved, and her assistance is appreciated. Her training as an art historian and her past experience with the museum world brought special insight to the Latin American project.

Ambassador Robert Gelbard, Principal Deputy Assistant Secretary for the Bureau of Inter-American Affairs, has also been actively involved in this project from the very beginning. As a former Peace Corps volunteer in Bolivia, where he later returned to serve as U.S. Ambassador, and an avid collector of folk art, Bob was keenly aware of the richness of Latin American folk art and the important role it plays in the lives of people from that part of the world. I'll never forget how touched I was when Bob and Alene Gelbard and their bright little daughter Alexandra brought me into their home during my fieldwork in La Paz and surprised me with a lovely cake on my birthday.

Ambassador Michael Skol, head of the U.S. Mission to Venezuela, was also helpful in setting up connections with key people in Latin America, and his assistance is gratefully acknowledged. Anne Hirshorn of the Arts America program of the United States Information Agency was enormously helpful during the early stages of the project. Marty Adler, Howard Shapiro, Phil Parkerson, Tom Mesa, Mel Carriaga, John Dwyer, Patricia Sharp, and Bill

Lowry, also with the agency, provided special assistance during my visits to their duty stations and set up valuable contacts with local scholars and collectors all over Latin America. My special thanks go to Robin Smith, cultural attaché of the U.S. Embassy in Haiti, for her valuable assistance in obtaining objects from there.

Although most of the objects in the Folk Art of Latin America exhibition were purchased in the field, others are included because of generous loans from individuals and institutions here and abroad. Charlene Cerny and Barbara Mauldin of the Museum of International Folk Art in Santa Fe were generous with their time and helped me obtain valuable loans from their institution. Nancy Fullerton and Gabriela Truly of the San Antonio Museum of Art smoothed the way for key loans from that institution. Craig Morris, Curator of South American Archaeology of the American Museum of Natural History, took time away from his busy schedule to help with a key loan from his museum. Kathy Wright of the Taylor Museum in Colorado Springs kindly assisted with the loan of an important object from the Colorado Springs Fine Arts Center.

Martha Egan and Peter Cecere deserve a special thanks for their assistance throughout the project and for the generous loans they made to the exhibition. Both are keenly involved in the study and preservation of Latin American folk art, and their support was invaluable. Virgil Young, Ted Dale, Gordon Frost, Gloria Galt, Peter Bartlett, Bill and Fay Sinkin, Jonathan Williams, Jaime and Vivian Liebana, Jim and Veralee Bassler, Alan Moss, Ann Parker, Avon Neal, Saundra Abbott, Robert and Susan Morris, Jim Caswell, and Tom and Alma Pirazzini made important loans from their personal collections, and their generosity is gratefully acknowledged.

Roberto Benjamin, Jonathan Williams, and Gale and Bill Simmons made important donations to the exhibition, and these objects have become valuable parts of the museum's permanent collections.

Folklorists, anthropologists, museum specialists, and collectors here and all over Latin America shared with me their notes, their connections, and, at times, their homes, which made possible an exhibition with this broad a scope. All have become valuable colleagues, some have become close friends. Mariano Díaz, Venezuela's foremost folk-art specialist, graciously shared with me his deep knowledge and hospitality during my visit to that country and invited me to accompany him to the lovely Andean town of Mérida where he introduced me to the leading folk artists of that region. María Teresa de Merlo, Director of Ethnology at the Banco Central in Quito, generously shared her files with me and escorted me into the culturally rich area around Ibarra and Otovalo. Others who were very helpful include Henrique and Teresa Levy, Fatima Bercht, Roberto Benjamin, and Ana María Chindler for Brazil: Agustín Coll and Angel Romero for Venezuela; Marilee Schmidt, Claudio Malo, Peter Cecere, and Karen Stothert for Ecuador; Luís Torres, John Nunely, Teodoro Vidal, Robert Brictson, Emerante de Pradines Morse, Ann Parker, and Avon Neal for the Caribbean; Peter McFarren, Gale Hoskins, and Hugo Daniel Ruiz for Bolivia; and Cecilia Alayza de Losada and Jonathan Williams for Peru.

Cyril I. Nelson of Dutton Studio Books served as editor of this volume. Cy's many years of experience as a book editor, his deep love of folk art and his wonderful eye for design have brought a special quality to this book, and I feel fortunate for the opportunity to have worked with him.

Gavin Ashworth shot most of the object photographs for this publication. His excellent eye, extraordinary understanding of the relationship between light and film, and his sensitivity for the objects themselves bring a special visual flavor to this publication. Photographers Anthony Richardson, Jeff Oshiro, Steve Tucker, and Roger Fry expertly shot the rest. Unless otherwise noted, all context photographs are mine.

I also wish to thank the San Antonio Museum Association for time away from my curatorial duties there and to Nancy Fullerton, Assistant Curator of Folk Art, for keeping the ship afloat during my absence. Trinity University in San Antonio graciously provided me an office in which to work and where I could escape the telephone and noise of my normal workspace, and, once again, I am grateful to Dr. Ronald Calgaard and Baker Duncan for making that office available.

I give special thanks to my wife Jill and my daughters Julia and Helen for their constant love and support. Long hours at the office and lengthy absences from home were strains on the family, but they kept the home fires burning and inspired me to continue when things were difficult.

Finally, I thank the thousands of people I met during my travels in Latin America who endured my intrusive camera and persistent inquiries. I was always shown politeness, patience, and cooperation during my fieldwork, and I feel very indebted to them for their understanding and help.

THE AMERICAS

CANADA

UNITED STATES

ATLANTIC OCEAN

MEXICO

DOMINICAN REPUBLIC

PUERTO RICO

HAITI

GUATEMALA
SALVADOR

VENEZUELA

PANAMA
COLOMBIA

ECUADOR

PACIFIC
OCEAN

N

PERU

BRAZIL

BOLIVIA

CHILE

URUGUAY

ARGENTINA

LATIN AMERICA

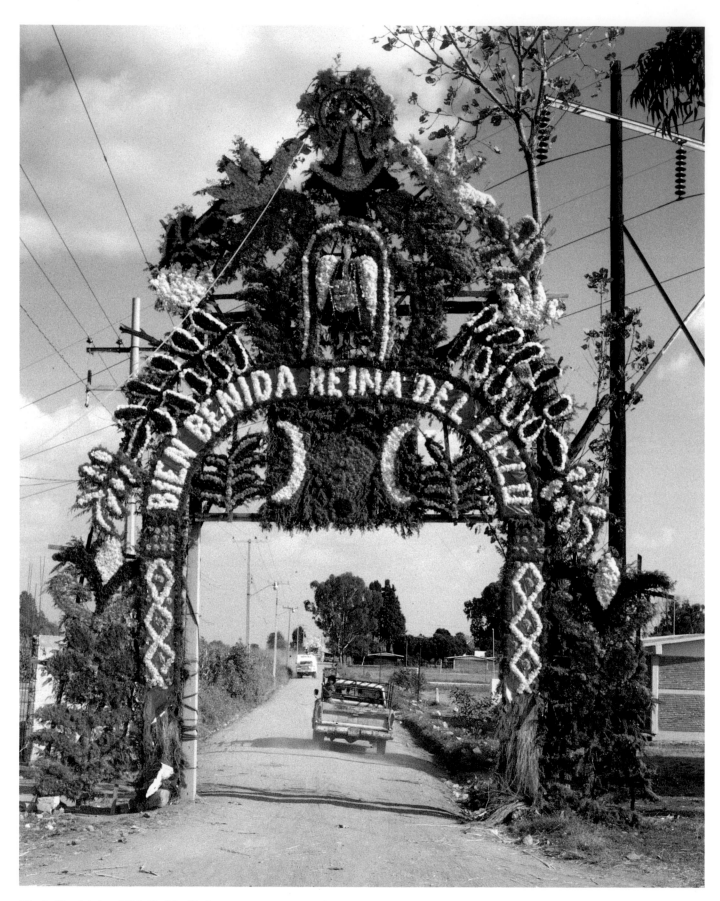

Fig. 8. *Floral Arch*, c. 1985, Cholula, Mexico.

THE NATURE OF LATIN AMERICAN FOLK ART

"Folk art is above all the synthetic expression of the soul of a people, its tastes, its ideals, its imagination, and its concept of life."

—ADOLFO BEST-MAUGARD[1]

1

Since pre-Columbian times, folk art *(arte popular)* in Latin America has been the primary vehicle through which people have expressed their dreams and fears, courted their lovers, amused their children, worshipped their gods, and honored their ancestors. In modern times, it continues to be an important device for coping with the physical, social, and spiritual worlds. Today, as in the past, folk art is found in every corner of Latin America. It is seen in the home, adorning a family's altar or adding a bit of color and decoration to the rustic furnishings of a peasant hut. It is incorporated into architecture, secular as well as religious, local advertising, culinary habits, religious ritual, and political customs. Indeed, folk art pervades most facets of Latin American life.

No other part of the world has produced folk art more abundantly and in greater variety than Latin America. Yet, as in many parts of the world, folk art has played stepsister to academic art and ancient art in Latin America until relatively recently. Made by the "popular classes" for the most part, it was never a part of the system of symbols used by the upper classes to justify, maintain, and bolster social status. Instead, it was associated primarily with those away from the centers of power, whose heritage was often derived from the vanquished rather than the victors. Latin American folk art (and folk art, in general) has also been outside the purview of scholarly research until relatively modern times. Consequently, the field of Latin American folk art studies is still in its infancy. While growth over the past several decades has been rapid, the pains associated with it are notable, and there are many gray areas that still need to be rethought and examined more thoroughly. The most crucial of

these, and one that is at the very core of the discipline, is a clear determination of exactly what lies within the boundaries of folk art and how this differs from other areas of Latin American art.

How is folk art different from the "fine art" of Latin America? Are Latin American folk art and craft the same, or do they represent distinct forms of artistic expression? Do we include plastic and tinsel altars constructed now in all parts of Latin America to celebrate a plethora of important religious festivals, or should we insist that the materials used be from nature as in the past? Do the works of traditional Latin American folk artists such as Pedro Linares of Mexico still belong to the folk category even though most of his wonderful *papier-mâché* figures are now made to order for galleries and collectors in New York, Paris, and San Antonio? These questions and many more are now being hotly debated wherever interest in Latin American folk art is alive.

One typical area of concern is the position of folk art *vis à vis* other nonmainstream art, particularly that which has been unfortunately labeled "primitive art." While most primitive art functions in many of the same ways as folk art, most museums obstinately separate the two. For them, primitive art is the product of isolated, autonomous or semiautonomous tribal societies. On the other hand, folk art is seen as the creation of peasant societies, those societies that define themselves in terms of greater society and depend largely, but not wholly, on it for innovation and change. While this demarcation seems workable at first glance, closer examination reveals inherent shortcomings. For example, with very few exceptions, classical tribal societies in Latin America no longer exist, and those that were tribal during the seventeenth, eighteenth, and nineteenth centuries when they were first encountered by Europeans, today have become dependent upon larger societies, making them posttribal peasant societies. Does the art of these groups, though rooted in the immediate past in a tribal context, move into the realm of peasant art, i.e., folk art? And what are we to do about urban folk art? If it exists, is it a product of "urban peasants," or do we have to extend our definition of folk art beyond the domain of peasantries?

Another hindrance to our understanding of the true nature of folk art has been our failure to examine it holistically. In order to appreciate the full nature of folk art it is always necessary to go beyond the aesthetics of a particular object to examine the context in which it exists. Most folk art objects found in museums today are mere fragments of larger cultural complexes. A Guatemalan dance mask, for example, is part of a costume, which is part of a dance drama, which is part of a local festival, which is part of an annual ceremonial cycle. And each of these levels must be examined dychronically for a clear understanding of the dynamics of a particular folk phenomenon. Fortunately, many museums now recognize this past error and are taking steps to remedy it.

Toward a Working Definition of Latin American Folk Art

Several years ago, a well-known art critic observed that "folk art, like pornography, is easier to recognize than it is to define."[2] As with its generic parent, art, the question of definition is more often avoided than addressed. Visually, most of us can easily separate folk painting and sculpture from other types of art, but when called upon to explain exactly what makes folk art a discrete category, we are often hard-pressed to do so. This is true not only of the layman, but of the art historian, anthropologist, and folklorist as well.

Approaches toward a clearer understanding of folk-art classification differ strongly and at present seem to be divided into two camps. The first, which we will call the "art object" school, directs its attention toward the formal and aesthetic qualities of the object itself, rather than the function it fulfills in society and the context in which it is found. For this group, "art" takes precedence over "folk."[3]

The second group, which we will call the "cultural context" school, assigns primary importance to the context in which a piece of folk art is found and the function it has for those who made and use it. Comprised mainly of folklorists and anthropologists, this group pays little attention to the aesthetics of an object, except when it is truly reflective of the perspective held by the group that made it. Robert Teske, a folk-art specialist and an advocate of this approach, has made considerable progress toward its clarification and insists that folk art must be defined in terms of "1. its acceptance of and dependence upon a communal aesthetic shared by a group of artists and their audience and shaped and reshaped over time; 2. its traditional nature, with its emphasis upon perfecting old forms instead of creating entirely new ones; and 3. its transmission via apparently informal, yet often highly structured and systematic means." In summary, he says that "it is the social context in which an artifact is created and responded to, rather than the attributes of the artifact itself or the collector's intuitive response to these attributes, that provides the firmest basis for classifying the object as folk art."[4]

Perhaps the solution is not an either/or situation, but an intelligent combination of the two. Both are inadequate by themselves; together, they can be of considerable analytical use. For those of the "art object" school to ignore the context within which an object exists is a seri-

ous omission and unacceptably subjective in its approach. Form follows function, and in no place is this more true than in folk art. To ignore function is to overlook a significant part of the meaning of any folk object. For those of the "cultural context" school to ignore the aesthetics of folk art, in spite of the fact that they are often more easily seen than functional qualities, is also a serious omission. These attributes are real, and, in many cases, can be recognized cross-culturally. Here, we have incorporated both approaches in making the selection of artifacts for the exhibition and have selectively drawn from the research of scholars from both camps to explain their importance.

Perhaps the strongest single characteristic of Latin American folk art, setting it apart from the other arts, is its inseparable tie with tradition. It is tradition, whether at a family or community level, which establishes and maintains folk art. It is also tradition that sets the standards to which Latin American folk artists must adhere and defines the boundaries limiting choice. Because of this strong connection with tradition, Latin American folk art is a chronicler of the life of the community that produces and uses it. Folk art is not removed from local culture, as often occurs with contemporary "fine" art, for example. Instead, it is a vital part of that culture and, as such, can be a valuable window through which many parts of Latin American society can be more clearly viewed and better understood. Art that exists outside of an established tradition in Latin America is not folk but something else, i.e., fine art or craft. This is not to say that all Latin American art which is part of an established tradition is folk. The great Mexican muralists (Rivera, Orozco, Siquieros), for example, exploited a medium which was grounded in a thousand years of Mexican tradition, but they were not folk artists. The difference is that the Mexican muralists of the twentieth century made a conscious choice to use the mural form over many other forms available to them. Their worldview, formed by years of studying art history and technique all over the world, provided options that were almost limitless. The folk artist, on the other hand, is part of the tradition in which he is working. For him, there are few options. To a great degree, he must take what is handed him by his small, local society and do the best he can within a limited range of traditional techniques and subject matter.

Another strong characteristic of Latin American folk art—indeed, of folk art everywhere—is its persistent loyalty to local artistic and social values, from which it draws its strengths, and to which it contributes on a continuing basis. Contemporary "fine" art, contrarily, looks to a much broader universe for its primary lessons. Although the content of his or her paintings may be Colombian, a contemporary painter from Bogotá, for example, most likely shares a common knowledge of art theory, perspective, and technique with colleagues in New York, Paris, São Paulo, and elsewhere. Generally speaking, contemporary artists also have at their disposal a common store of papers, paints, canvases, etc. The folk artist, on the other hand, conservatively adheres to local knowledge about perspective, color, and form and he or she usually gleans materials from the local environment, just as previous generations have done. Options available to the contemporary fine artist are enormous, but for the folk artist, they are limited to what is available and acceptable locally. Folk art is mainstream art and, for the most part, sticks to local community tastes and values. Contemporary art, on the other hand, constantly works on the outer limits of acceptability and strives to be avant-garde. The folk artist consciously looks for the proper expression of communality, but the contemporary artist seeks acceptance of his or her individuality.

In addition to persistent problems of definition, we are faced with another set of problems when trying to understand and describe Latin American folk art through time—a lack of the objects themselves, and, with the exception of relatively recent periods, a serious lack of written information on the context in which folk art was found. Because of the ephemeral nature of most folk art, very little pre-Columbian and colonial folk art has survived in Latin America. The vast majority of folk art, then as now, was used, worn out, and discarded, only to be re-created the following year with the same results. Furthermore, until the end of the nineteenth century, Latin American folk art, like folk art elsewhere, was not considered worthy of collecting and therefore not brought into the folds of museums where it would have been protected for future generations to see, study, and appreciate. Luckily, this attitude of neglect has changed, and folk art collecting and preservation are now actively pursued in many parts of Latin America and elsewhere.

Clearly, problems of definition persist and differ widely among collectors, scholars, and others. *The Folk Art of Latin America* is less ambivalent and concentrates on a particular type of Latin American artistic expression. We have omitted "tribal art" of Amazonia and other highly isolated areas in favor of art in less isolated communities that are influenced from many outside directions. We are not concerned with "craft," which is produced primarily for the tourist trade, but prefer to include art made *by* Latin Americans *for* Latin Americans. We have also omitted so-called "outsider art," a form of nontraditional artistic expression that is highly idiosyncratic and is born and dies with the artist who produces it. Rather, we are concerned with traditional artistic expression that speaks with a communal voice.

The art seen here is a special form of artistic expres-

sion. It belongs to the world of peasants and urban proletariat, relatively poor people who are far from the centers of power, wealth, and formal learning in Latin America. Our folk artists reside mostly in small farming and fishing villages, and in the poor barrios of the cities. Their art is not meant to be used outside of its place of origin, and certainly was never intended to grace the interiors of spotless museum vitrines. Their art is direct in its message and is always at the service of the society from which it springs.

Above all, we are interested in presenting Latin American folk art as visual manifestations of Latin American culture—culture that is society's way of dealing with problems that arise in its physical, social, or spiritual environments. Therefore, folk art should be thought of as a problem-solving device, one of society's many coping mechanisms. Folk art acts as society's buffer against internal and external threats and, in this respect, it is amazingly plastic, capable of being altered and molded to meet whatever changes take place.

Latin American Folk Art Through Time

Latin American folk art has been alive and well for several thousand years. Pre-Columbian Latin America, like Latin America today, produced "fine" as well as "folk" art. Fine art was made by highly trained artists who attended the rigorous art schools in Mesoamerica and elsewhere, such as the one in Texcoco, Mexico, made famous by the great poet/king Nezahualcoyotl (d.1472). These artists were part of what the late anthropologist Robert Redfield called the "Great Tradition" of urban culture and learning. They worked for an elite and aristocratic patronage and adhered strictly to the standards set by leaders of civil-religious hierarchies in the complex centers of learning, and political, religious, and economic power such as Tihuanaco, Tikal, and Monte Albán. Art of these centers was standard-setting and innovative. On the other hand, folk art was peasant art and was therefore more vernacular and local. It was part of what Redfield called the "Little Tradition" of peasant villages that drew both from a tribal past as well as from a contemporary dominant culture to create its special way of life and art.[5] Folk art was of the people who produced it for daily use in their homes and for local celebrations of religious or secular events. Because of its conservative nature and its reticence to change, folk art, then as now, had an old-fashioned quality, keeping it several steps behind the innovative art forms of centers of power. Although strongly influenced by the fine art of these important urban centers, folk art of this and later periods was more attuned to the immediate needs of the common people, and as such, was strongly

reflective of their perspectives, values, and dreams. Change, then as now, was not a one-way street. Just as peasant society and the "Little Tradition" defined itself in terms of the city and the "Great Tradition," so, too, was urban society influenced by the periphery. Folk art takes from and gives to the art of the "Great Tradition."

Unfortunately, there is a dearth of information on the folk art of ancient America. Until relatively recently, archaeologists had devoted most of their energies toward excavating sites that would yield the most elegant and sophisticated artifacts, that is, elite burial sites and large ceremonial centers. Graves and household structures belonging to ordinary people, peasants, were overlooked. As archaeologists began to turn their attention away from the centers of high art toward provincial settlements, understanding of vernacular art, folk art, began to develop and the codependent relationship between fine and folk became clearer.

Another factor that has been a hindrance is that very little folk art of pre-Columbian Latin America has survived. As in modern Latin America, ancient folk art was made of many different materials—some lasted for generations, even centuries; some only a few days, or for the duration of festival. With very few exceptions, perishable materials such as feathers, bone, wood, wax, flowers, and other things have not survived into modern times. One of the most notable exceptions, of course, is the preservation of pre-Columbian Andean textiles, due primarily to their interment in arid environments. Usually, however, only those things that were made to last for a long time—stone statuary and implements, pottery, and, less frequently, metal objects—have survived the abrasions of time. Consequently, we know a great amount about pre-Columbian objects of stone and ceramic but very little about those pieces made of ephemeral materials, which were in the majority.

Enchanting, albeit brief, descriptions of Latin American indigenous folk art of the early sixteenth century have been left by several of the great chroniclers of the period—Guaman Pomar de Ayala, Fr. Diego Durán, Fr. Bernardino de Sahagún, and others. Sahagún, a Franciscan mendicant, considered the first ethnographer in the New World, wrote a very thorough study of indigenous life shortly after the conquest of Mexico entitled *A General History of the Things of New Spain* (frequently referred to as the *Florentine Codex* after the city where it is now preserved). In Book 10 of this highly important work, Sahagún provided an intriguing glimpse of the ideal folk artist of that time. We are told, for example, that "the good craftsman is able, discreet, prudent, resourceful, and retentive. He is a willing worker, patient and calm. He works with care, he makes works of skill; he constructs, prepares, arranges, orders, fits, and matches

materials." On the other hand, "the stupid craftsman is careless, a mocker, a petty thief and a pilferer. He acts without consideration; he deceives, he steals."[6]

And later, Sahagún describes the attributes of a particular type of folk artist—the potter: "The potter is wiry, active, energetic. The good potter is a skilled man with clay, a judge of clay—thoughtful, deliberating; a fabricator, a knowing man, an artist. He is skilled with his hands. The bad potter is silly, stupid, torpid."[7]

From these descriptions and others like them we can see that the work of the folk artist was closely tied to one's moral life and was part of those things which established his or her standing in the community. A similar connection is still found today in various parts of Latin America *(Fig. 9)*.

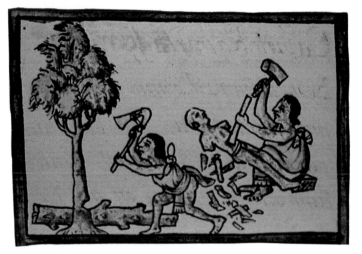

Fig. 9. *Aztec Wood Carver*, from *General History of the Things of New Spain* by Fr. Bernardino de Sahagún.

With the arrival of Europeans in the early sixteenth century and the subsequent destruction of native societies in Latin America, life in the New World changed dramatically, often tragically, and the arts, especially folk art, followed suit. Prior to contact with each other, Spain (and Portugal) and what is today Latin America had fully developed peasantries, each with its own distinctive forms of popular expression. After the bloodied dust of conflict had begun to settle, new patterns of folk life started to emerge. Many of the old forms of folk expression in Latin America were destroyed or outlawed; others were nurtured and survived; still others, foreign to the New World, were introduced by the Spanish and Portuguese and adopted by the Indians of Mexico, Peru, and elsewhere.

The Spanish, for example, whose influence in Latin America was spread with amazing rapidity, had no tolerance for folk forms that threatened their rule and the religion which legitimized it. Some art forms, especially those associated with paganism, were completely prohibited by the new lords of the lands. Figural ceramics and stone sculpture, particularly when associated with non-Christian ritual, were always suspect, and, in most cases, destroyed. Temple art in the great urban centers such as Tenochtítlan and Cuzco, as well as vernacular religious expression found in the hinterlands, was outlawed with swift and severe punishment promised for those who failed to comply. Pictographic manuscripts and other religious paraphernalia were burned by overzealous priests, much to the dismay of the Indian population and subsequent generations of scholars of Latin American history and anthropology. In Mesoamerica, for example, amaranth cakes made in the form of the Aztec war god, *Huitzilopochtli*, and eaten during festivals in his honor (much as Christians partake of the Eucharist), were outlawed and, for a while, production of amaranth in any form was strictly forbidden.

Eradication of the old ways was more successful in some areas than in others. In the larger towns and other places under tight European colonial control, non-Christian religious folk art was destroyed qute thoroughly; but in the hinterlands, far from the watchful eyes of Catholic priests, it managed to survive in many instances.

While outlawing or destroying certain forms of native art, Christianity also became a new vehicle for folk art during the colonial period. Dance masks, for example, when used in proper Christian context, were acceptable, and the art of masking enjoyed a renaissance during the seventeenth and eighteenth centuries. Catholic mendicants immediately recognized the important role played by dance masks in pre-Columbian Latin America and adopted them for use in their own evangelistic projects. Christian/Moor dance dramas took place as early as 1524 in Mexico and quickly spread throughout Latin America, teaching the history of Christianity to the Indians using folk forms with which New World populations were already familiar.

Almost immediately after the conquest, the Spanish established a European-style system of artisan guilds in New Spain and elsewhere, and by the end of the seventeenth century hundreds of different guilds had been created to teach apprentices their arts, control quality, market products, and manage funds belonging to each guild. In theory, some guilds were exclusively for Spanish artisans and their descendants: silver and gold smithing, sculpture, painting, gold leafing, tailoring, and glass blowing. Others were exclusively Indian: pottery production, candle making, Indian weaving, wax working, and other specialties.[8] In reality, however, there were many exceptions. The late art historian Elizabeth Weisman reminds us that in Mexico: "For a long time, while memories of preconquest religions remained, the people—that is, the

Indians—were not allowed to paint holy figures or to carve them. . . . But it was impossible that properly examined members of a guild in Mexico City could supply the thousands of churches in the country, much less the household shrines, and so (like so many other things in Mexico) practice went off at a tangent from the law."[9]

In Lima, during the seventeenth century, Indians and Spaniards belonged to many of the same artisan guilds, but Indians were often kept from positions of real power within them. As a consequence, parallel guilds were established—one Indian, one Spanish—that allowed Indians upward mobility.[10]

In some regions of Latin America, religious folk art became a syncretic blend of pagan and Christian forms, satisfying local tradition as well as orders from the new Catholic hierarchy. The magnificent frescoes of colonial churches and convents in Ixmiquilpan (Mexico), Cuenca (Ecuador), and hundreds of other towns throughout Latin America are often fine examples of this rich blend of the two worlds which first met in the early sixteenth century *(Fig. 10)*.

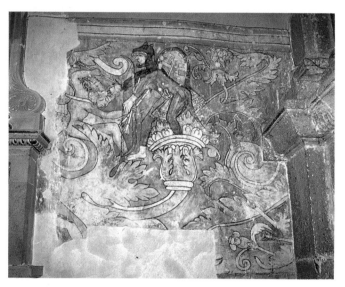

Fig. 10. *Colonial Mural*, Ixmiquilpan, Mexico. Photo by Donna Pierce.

Also common were objects and paintings, executed by Indian craftsmen, in purely indigenous styles, but dealing with European Christian subject matter. Christian saints, brought to the New World by the early mendicants, often in the form of inexpensive prints, were handed to traditional Indian artists who rendered them in stone, wood, or feather mosaic, a technique popular in Pre-Columbian America. This new Indo-European style (also called *tequitqui*) became the predominant form in much of Latin America and its heavily folk quality quickly endeared it to local populations.

Conversely, folk art of the New World was enriched

with the introduction of European materials and techniques. The European foot loom, and the lathe, glazed pottery, and the potter's wheel, glass and iron, and the craft of fine leather-making, are but a sampling of foreign contributions that enhanced the myriad selection of techniques already available to the native populations of Latin America. In many places, however, newer, more efficient methods of production were never adopted by Indian folk artists.

In communities all over Latin America, folk artists doggedly retain some of the old forms and techniques. Many potters still prefer to build their vessels by hand, using time-tested methods of coiling instead of the potter's wheel. The same is true of a clear preference for the back-strap loom over the more productive treadle loom introduced by the Spanish. In most parts of the Andes, Indian women still weave traditional cloth on pre-Columbian style looms, but men, the weavers of *bayeta* or common cloth, use crude Spanish-style looms.

Indian craft schools were established in Latin America to teach and preserve traditional arts and crafts. In Michoacan, Mexico, Bishop Vasco de Quiroga established a network of craft communities, based on Thomas More's *Utopia*. Each community specialized in a particular craft, and existed symbiotically with other communities in the region. "Uruapan was dedicated to the making of lacquered gourds; Tremendo, to the tanning of skins; Paracho, to the fabrication of furniture and musical instruments; Aranza, to drawn cloth; Capula or Xenguaro, to the cutting and selling of wood; Quiroga, to wood working and decorating; Patamban and Tzintzuntzan, to ceramics; San Felipe de los Herreros, to iron work; and Huario, to weaving wool."[11] Janet Brody Esser, a leading authority on Latin American folk art, observes that "a town that was busy and productive not only complied with More's plan for the ideal society but would be, the clergy reasoned, less susceptible to the corrupting influences of the colonists."[12]

Convents also became places where folk art was made, used, and frequently sold. Nuns and monks followed age-old traditions of creating beautiful objects for use in their convents and monasteries. Elaborate nativity scenes, often incorporating as many as a thousand pieces, were made in convents and displayed to the public at Christmas to teach the doctrine. Nuns augmented the meager incomes of their orders by selling embroidered cloth and intricately cut paper figures to eager customers outside the walls of the convent. Sisters of the Carmelite cloister in Cuenca, Ecuador, still make, maintain, and display elaborate nativity scenes, which they have been doing for over two hundred years. They also continue to embroider and decorate a variety of paintings and other religious items in the convent.

Edouard Pingret and Jean-Baptiste Debret of France, Carlos Nebel of Germany, Johann Moritz Rugendas of Austria, Claudio Linati of Italy, and dozens of other *costumbrista* artists left important visual proof of the richness of folk art of the period.

Other *costumbrista* artists were Latin Americans, who, burning with a new nationalism, were very eager to show those cultural forms that were theirs and not European. Artists like Juan Agustín Guerrero of Ecuador, Pancho Fierro of Peru, and Carmelo Fernández of Colombia left a rich collection of drawings showing local festivals, religious customs, native dress, and racial types. Many of these illustrations include folk art such as dance masks, religious statuary, native dress, and other items *(Fig. 11)*.

Fig 11. *Nineteenth-Century Masked Dancers*, by Juan Agustín Guerrero, Ecuador.

In summary, colonial folk art of Latin America was plentiful and varied—a rich blend of styles and techniques emanating from many directions.

The first quarter of the nineteenth century was a period of tremendous social change throughout Latin America. By 1830, most New World republics were free of the colonial yokes of Spain, Portugal, and France. As in previous periods, folk societies thrived and their populations produced and used folk art as needed, responding to the many demands made by their social, physical, and spiritual environments. Pottery, much of which endured the ravages of time and use, religious paintings tucked away in the dark corners of provincial churches, and family heirlooms, such as special furniture, jewelry, and clothing, are among those objects most frequently left from the nineteenth century. Unfortunately, because the great majority of folk art was perishable and did not survive up to the present, museums retain only a few examples from this important period.

Much of our knowledge about nineteenth century Latin American folkways comes not from the objects themselves but from those who saw them and recorded their form and the context in which they were used. Prior to the break with European rule, free travel in colonial Latin America had been difficult, especially for foreigners, but that situation changed with independence. Eager to know more about the emerging nations of Latin America, adventurers, writers, and painters came from France, England, Germany, the United States, and elsewhere to record local customs, physical types, occupations, clothing, and other distinctive elements of society.

Fig 12. *Santiago Matamoros*, Sixteenth Century, from *Nueva crónica y buen gobierno* by Felipe Huaman Poma de Ayala, Peru.

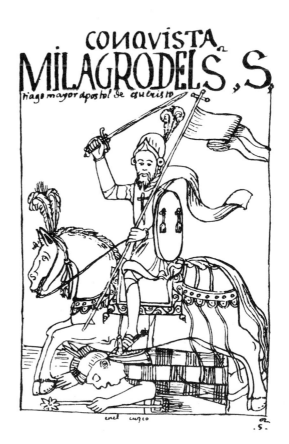

The Roots of Contemporary Folk Art

Contemporary Latin American folk art, like the Latin American population itself, is an amalgam, a composite, of influences and forces from many directions. Just as the majority of modern Latin America's population is mestizo or racially mixed, so, too, is its folk art. As we have seen, without doubt the strongest influences derive from Indian and European sources. For better or for worse, the encounter between European and Indian cultures in the early sixteenth century and later left indelible influences on every aspect of New World life, including folk art. Strong influences came from other directions as well.

African contributions to the variegated complexion of Latin American folk art began almost immediately after Old World/New World contact, and those influences continue to be strong in many parts of Latin America today, most notably in those areas comprising the circum-Caribbean region. With the tragic depopulation of indigenous groups, due mainly to mistreatment and the rampage of European diseases against which New World populations had no immunity, African slaves were brought in to work the mines and plantations of the colonists. African physical types continue to be found today throughout all of the Caribbean, along the coasts of Mexico, Central America, and Northern South America, much of Northeast Brazil, and in other areas. From the earliest years of this immigration, Africans brought with them kinship systems, religious practices, house types, music, dance, art, and countless other cultural elements from their homelands. Voodoo, xango, and candomblé, Afro-American religious cults found predominately in the circum-Caribbean area, boldly manifest themselves through folk art which is usually colorful and often frightening to foreign eyes. Ex-voto sculptures found throughout northeastern Brazil, although largely Portuguese in origin, may also have roots that are both Indian and West African.[13]

Asian influences are also strong. Starting in the colonial period with the Manila Galleon, a system of Spanish trade was based in Manila and designed to move materials from mainland China to the west coast of Mexico, most notably through the ports of San Blas and Acapulco. From there, cargo was moved overland to Veracruz where it was shipped to Europe. Ivory carving, lacquer, woven silk textiles, wood and shell inlay, and a host of other Latin American folk forms owe their origins to this Asian connection.

After the establishment of independence in the early nineteenth century, Latin America experienced a tremendous tide of immigration from Italy, Germany, Japan, France, and other places, and these new populations enriched the folk pot of that region substantially.

European dress, decorative folk arts, toys and games were often integrated and joined already existing New World forms to create hybrid forms of folk expression. One of the strongest forces influencing the face of Latin American folk art is the United States. Protestant missionaries, the introduction of U.S. manufactured goods, North American films and publications, and a host of other items emanating from the United States have had a tremendous effect on the form and function of folk art in Latin America. Kuna molas (appliquéd blouses) frequently demonstrate Latin America's fascination for the heros of U.S. pop culture, Disney characters, film stars, and astronauts, and carnival figures in the Caribbean and elsewhere frequently single out U.S. politicians for attack for their Latin American foreign policies. Folk artists of Caruaru (Brazil), Oaxaca (Mexico), and Ayacucho (Peru), who once made their art exclusively for local markets, now tailor their products for tourists and North American collectors.

Since folk art is an accurate reflection of the society of those who make and use it, folk art incorporates new and foreign elements just as society incorporates new populations. New folk forms are introduced, change, and adapt to meet new challenges. They evolve as political, religious, and social situations require. Among the countless number of pan–Latin American folk themes that have evolved there since the sixteenth century, the beginning of that region's most traumatic and significant change, two motifs stand out as good examples of the plastic nature of folk art and the evolution of form and meaning over time: the image of Santiago (Saint James the Elder), and the jaguar. The image of Santiago was brought to the New World with the very earliest conquistadors. Once there, it was quickly adopted by Indian communities who made it their own, ascribing to it entirely new powers that responded to their own particular needs. The motif of the jaguar, of pre-Columbian New World origin, has evolved and adapted to the needs of different times and regions, and, in some instances, it has become integrated into Latin American Christian ritual and custom.

Santiago

One of the most widely revered European images in Latin America is that of Santiago, Saint James the Elder. According to Christian tradition, Santiago, brother of Saint John the Evangelist, preached in Spain from A.D. 40 to 42, was martyred in the Holy Land, and his body was returned to Spain and interred in Compostela.[14 15] In the Battle of Clavijo in northern Spain against the Moors in 834, Santiago's miraculous apparition astride a magnificent white horse led the Christians to a decisive victory. Since that time, Santiago, particularly Santiago Mata-

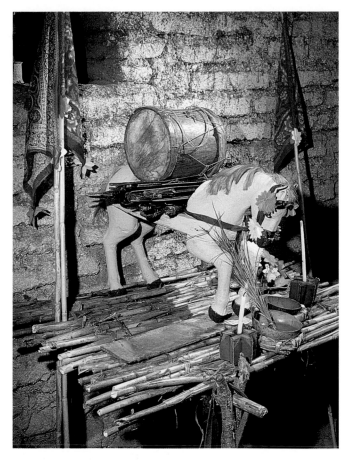

Fig 13. *Santiago's Horse*, c. 1972, Tlacoapa, Mexico.

houmfors (cult temples) or on ceremonial banners *(Plate 7)*. In Sololá, Guatemala, the image of Santiago is dressed in traditional indigenous attire before being paraded through the streets. In other parts of Guatemala, he is part of a mythical kinship system and is considered the husband of Santa Ana (mother of the Virgin Mary). During religious processions in another Guatemalan village, San Pedro Necta, images of the Virgin and Santiago must follow separate routes since it is believed that they might slip off and become lovers.[17]

From the earliest part of the colonial period, the Catholic Church recreated the miraculous deeds of Santiago through masked dance dramas in order to teach Indian populations Christianity. Divided into distinctively clad groups of Christians and Moors, these lively dance troupes still perform on ceremonial occasions all over Latin America, usually in fulfillment of religious vows *(Fig. 13, Plates 2,6)*. Daringly played out with metal machetes and wooden horses tied around the waist, these dramas entertain as well as perform an important ceremonial function. Their story is one of Christianity's triumph over paganism and its outcome is predictable—Christ's army, led by Santiago, always prevails over forces of Islam. In some parts of Latin America, this drama changes from one of Santiago Mata*moros* to Santiago Mata*indios* in an attempt to associate pre-Christian Indians with the vanquished forces of Mohammed.

Versions of the Santiago drama vary tremendously from area to area. In Loiza Aldea, an Afro-American community in Puerto Rico, tradition requires that Spanish soldiers riding with Santiago wear devillike masks, made of coconut shells, to frighten the Moors. These masks are similar to those made and used in Africa. Pastora Ayala, a member of the town's most famous mask-making family, states that "in our celebration of Santiago's feast, we mix our African roots with Spanish history."[18] Frances Toor, the great Mexican folklorist, reports that "in the Cora Indian village of San Juan Peyutan, during the fiesta on January 1, a group of Moors come out on horseback, in ordinary clothes, carrying wooden lances pointed with tin. All day long they ride up and down one street, pursuing a Saint James, also on horseback, wearing a red cape adorned with gilt paper, and a white cloth cap. He carries a lance and fights the heathen soldiers valiantly. However, in the end, they make him prisoner, contrary to the Catholic intention of the dance."[19]

Santiago Matamoros, introduced to the New World almost five hundred years ago, with very specific attributes and functions, has since evolved and changed to meet the varying needs of individual communities all over Latin America *(Plates 3,4,5)*. He has, in essence, been adopted by Latin Americans and made a part of their community and their lives.

moros, the killer of Moors, has been the most important saint in Spain and Compostela has been one of the most important pilgrimage shrines in Europe.

Santiago came to the New World as patron saint of Spain and of Spanish soldiers. According to legend, during the seige of Mexico, "*Santiago y a ellos!*" ("Santiago, and after them!") was the battle cry of Cortes's army, and his assistance was a major factor in the conquest of Mexico *(Plate 1)*. Similarly, we are told that Santiago Matamoros miraculously appeared in Peru in 1534 and saved the Spaniards from certain death during the Indian seige of the fortress of Sacsahuaman, near Cuzco *(Fig. 12)*. In spite of his dramatic association with the victors, Santiago quickly impressed native populations who soon adopted him as their own. He was made patron saint of at least a dozen major cities in Latin America and countless small towns and villages. He became patron of mares, cattle, protector of pastoral life, and, in Guatemala, he is still invoked by men looking for a wife.[16]

It is common for Santiago and other religious images to assume the physical or cultural traits of the local populations they serve. In Haiti, Saint Jacques (Ogoun) is black and has become inextricably tied to voodoo. His impressive image can frequently be found painted on the walls of

The Jaguar

Another widely recognized theme in contemporary Latin America, and one which originates in the New World, is the feline, particularly the jaguar (*Panthera onca*). Stretching back over three thousand years to the early Olmec in Mesoamerica and the culture of Chavin in the Andean region, the jaguar was considered noble and proud . . . the lord and ruler of animals.[20] It was also associated with the night, the underworld, and fertility. Its "spotted black on gold hide was interpreted as the starry sky and helped relate the animal to the night sun."[21]

On the eve of their encounter with Europeans, the complex cultures of the Americas feared, revered, and emulated the jaguar, and their warriors, kings, and priests showed their respect by dressing in jaguar skins (*Plate 10*). The jaguar was admired for his cunning and success as a hunter, and this quality was sought by warriors in warfare. Among the Aztec, the "jaguar was believed to control both the rains and lightning bolts."[22] One of the great warrior societies of the Aztec was associated with the jaguar, and one of the most important months in the Aztec calendar was named "jaguar." Those born under the jaguar sign were thought "to possess the characteristics of this feline—they were courageous, daring and proud, and willing to fight for any good cause."[23]

All over the New World, where the jaguar was used to symbolize the old religious, military, and political structures, the Spanish forbade its use. In 1631, in Tumulté, Mexico, Indians were notified that they must immediately cease performing a jaguar dance "in which participants dress as such, dance, and commit all types of acts against the Faith." Offenders were given "100 lashes and banishment from their village and ex-communication."[24]

In spite of tremendous pressures throughout the colonial period to abandon the jaguar theme in Latin America, it survived, evolved, and persisted. Today, the jaguar motif is found all over Latin America. It can be seen in secular and religious parades in La Paz, Bolivia. It plays a central role in the Deer Dance of Huehuetenango, Guatemala, where the jaguar is considered a threat not only to the deer but to human hunters as well. It is associated with rain in southern Mexico, and each year, in dozens of small, ancient communities in the states of Oaxaca, Guerrero, and Puebla, young men dress in traditional costumes and masks of the jaguar to assure the arrival of rains. Perhaps the most dramatic representation of this theme today is in the jaguar fights which take place in Zitlala and Acatlán, Guerrero. Each year around the first of May, dozens of young men don thick leather helmet-masks painted to resemble jaguars and act out a form of ritualized violence which is indisputably pre-Hispanic in origin (*Fig. 14*).

But the present-day portrayal of the jaguar in Latin America is an evolution of the image first encountered by the Spanish and Portuguese in the sixteenth century and represents an accommodation to the political and religious realities of contemporary life. Today, the jaguar is Indo/Christian. It represents a blend of native and European elements. The jaguar fights in Zitlala, for example, are held on the Day of the Holy Cross, and several times throughout this special day, jaguar warriors offer prayers at the foot of a Christian altar. These dramatic "Christian" activities overlay a deeper pre-Columbian meaning associated with fertility and rain. Just as the blood of Aztec jaguar warriors once appeased their deities, so, too, does the blood spilled today by Zitlala's young males. The impressive jaguar mask from San Marcos, Guatemala, with its clearly dominant pre-Columbian features, but accented by a Christian cross on the forehead (*Plate 11*), is another good illustration of the syncretic nature of folk art.

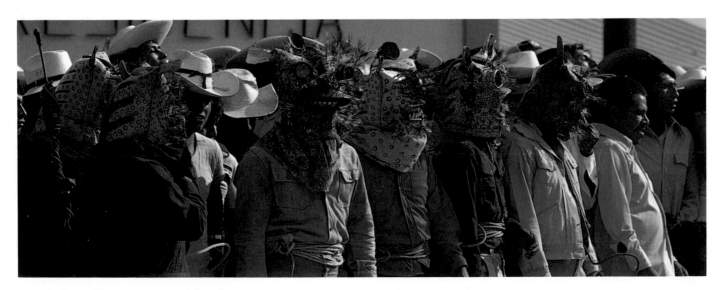

Fig. 14. *Jaguar Warriors*, c. 1983, Zitlala, Mexico.

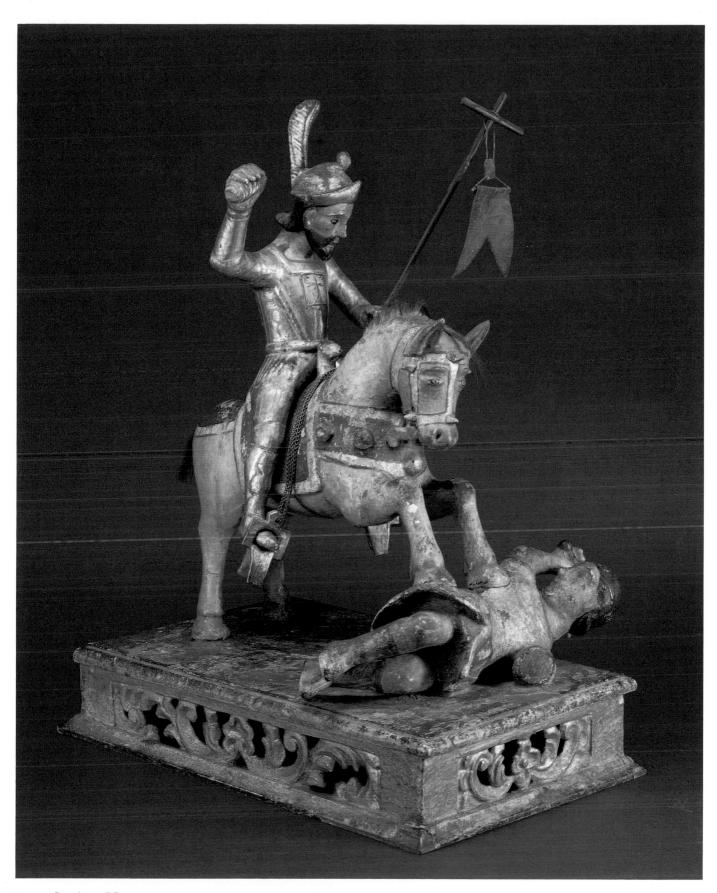

Plate 1. **Santiago Matamoros,** ARTIST UNKNOWN, Mexico, 18th century, Polychromed wood, metal, glass, cloth; 22" x 17" x 13". (Collection of Gloria Galt, San Antonio, Texas)

Plate 2. **Santiago Matamoros Mask,** ARTIST UNKNOWN, Mexico, late 19th century, Painted wood; 8^1/$_2$" x 7^1/$_2$". (Collection of the San Antonio Museum Association; purchased with funds from Friends of Folk Art)

Plate 3. **Santiago Matamoros Nicho,** ARTIST UNKNOWN, Highland Bolivia, mid–20th century, Polychromed wood, metal; 13" x 7" x 7". (Collection of Martha Egan, Santa Fe, New Mexico)

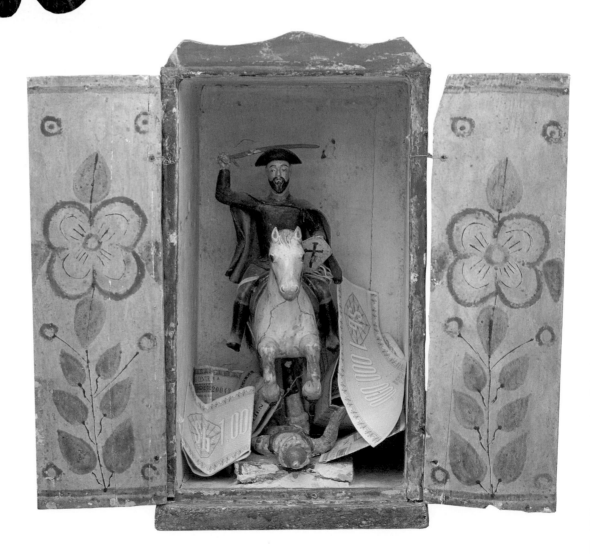

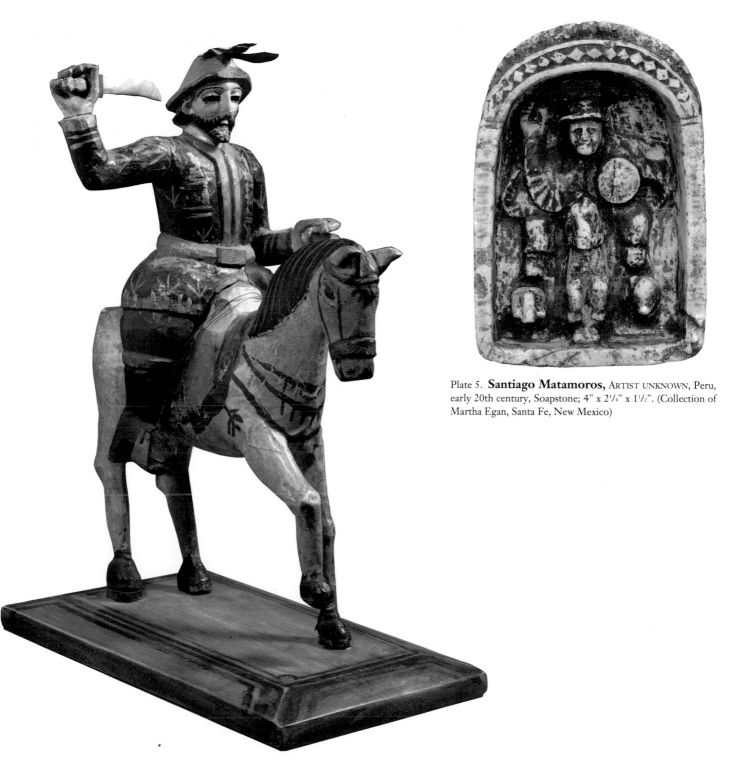

Plate 5. **Santiago Matamoros,** ARTIST UNKNOWN, Peru, early 20th century, Soapstone; 4" x 2³/₄" x 1¹/₂". (Collection of Martha Egan, Santa Fe, New Mexico)

Plate 4. **Santiago Matamoros,** ARTIST UNKNOWN, Guatemala, c. 1950, Polychromed wood, tin; 13" x 9" x 5¹/₄". (Collection of Martha Egan, Santa Fe, New Mexico)

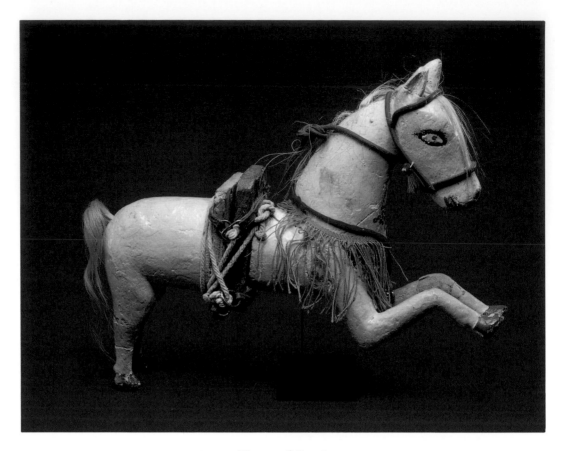

Plate 6. **Horse of Santiago,** ARTIST UNKNOWN, Mexico, c. 1950, Painted wood, metal, leather, horsehair, synthetic fibers; 16" x 19" x 4¼". (Collection of Tom and Alma Pirazzini, Encinitas, California)

Plate 7. **Chacana,** ARTIST UNKNOWN, Lake Titicaca Region, Bolivia, c. 1950, Bamboo, cotton string, feathers, paint; 6" x 19½" x 1". (Collection of the San Antonio Museum Association; purchased with funds from Friends of Folk Art)

14

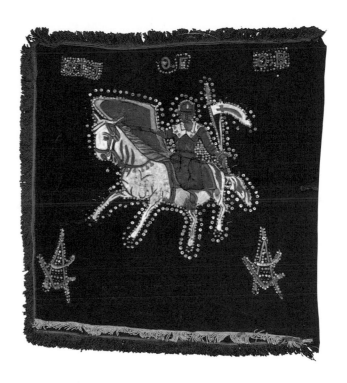

Plate 8. **Saint Jacques Banner,** ARTIST UNKNOWN,
Haiti, c. 1970, Satin appliqué, paint, sequins; 33" x 34".
(Collection of Virgil Young, Los Angeles, California)

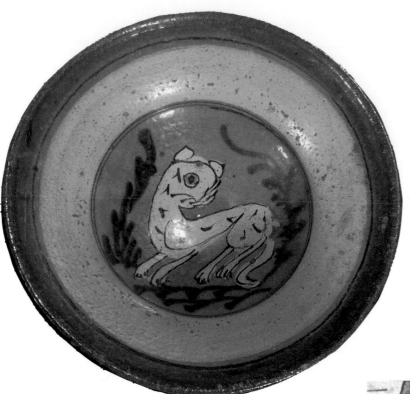

Plate 9. **Bowl with Jaguar Motif,** MONTIEL FAMILY, Antigua, Guatemala, late 19th century, Glazed earthenware; 9" diameter, 2½" deep. (Collection of the San Antonio Museum Association; gift of Mrs. A.A. Seeligson, Sr.)

Plate 10. **Jaguar Warrior, Codex Tudela** (facsimile), ARTIST UNKNOWN, Mexico, 16th century, Paint on European paper; approx. 8" x 6". (Private Collection, San Antonio, Texas)

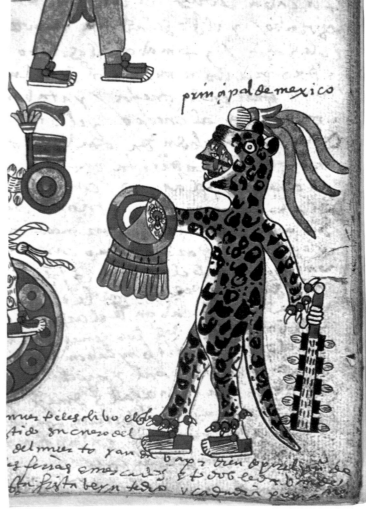

16

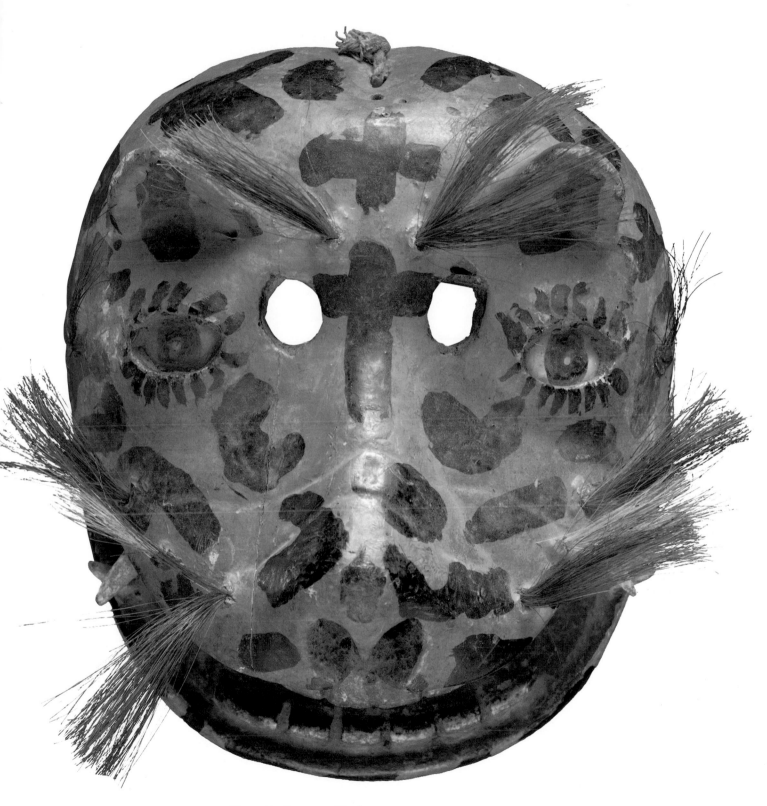

Plate 11. **Jaguar Mask,** ARTIST UNKNOWN, San Pedro Sacatepecuuez, San Marcos, Guatemala, c. 1940, Polychromed wood, glass, animal hair; 8¼" x 7" x 5½". (Collection of Gordon Frost, Benicia, California)

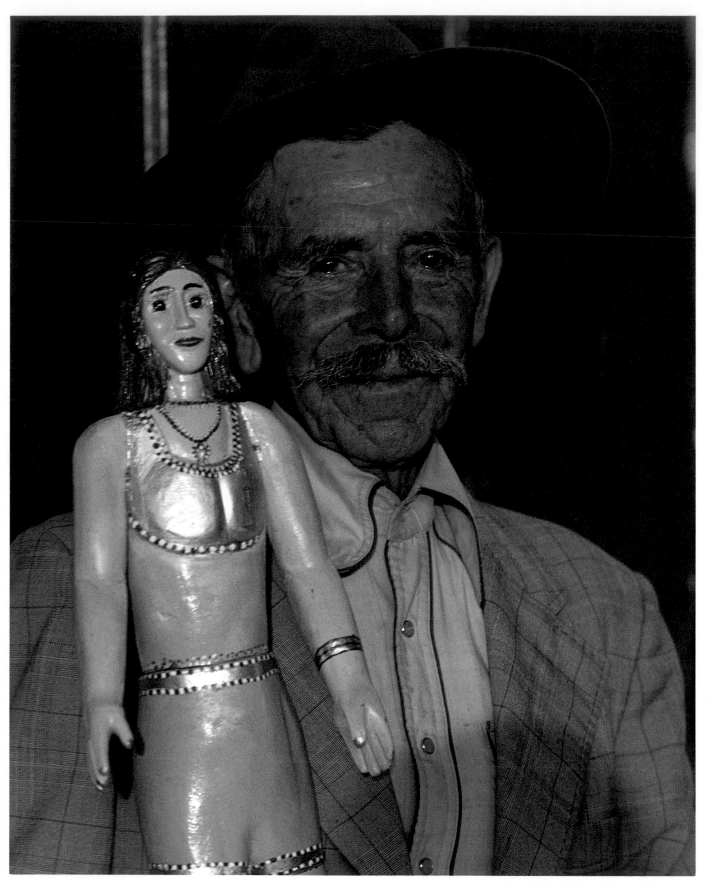

Fig. 15. *Venezuelan Wood Carver, José de los Santos*, c. 1989,
Mérida, Venezuela..

THE MAKERS OF FOLK ART

God made paradise,
And redeemed man.
To each man He left
A living through his work.
Some are fitted to do damage,
Others are good Christians,
Others, card in hand, gamble to
support themselves.
And I can be grateful
That I am a maker of saints.

—FLORENCIO CABÁN HERNÁNDEZ,

PUERTO RICAN *SANTERO*[1]

olk artists are found all over Latin America. They are old and young, men and women, Indian and non-Indian. They live in noisy cities, busy regional market towns, sleepy coastal fishing villages, and thousands of small, semi-isolated, farming communities all over Central and South America. Most are economically marginal. In spite of their relatively low economic status, folk artists are usually held in high esteem by their neighbors because they are seen as vital links between the past and the present and are looked upon as the caretakers of traditional life.[2]

Many Latin American folk artists are part-time specialists who spend most of their time performing duties not related directly to folk art production. Some are peasant farmers who spend their days in the fields. Others work as herdsmen, housewives, carpenters, brick masons, and in other occupations. Andrés Serrano is a barber in the town of Huejotzingo, Mexico. Every day he can be found cutting the hair of boys and men, and his reputation as a barber is a good one. When not cutting hair, Andrés spends much of his free time making leather dance masks for the annual festivities associated with carnival, particularly those used in a dramatic reenactment of the Mexican

defeat of the French in 1862. Through a special arrangement with the owner of a beauty parlor in nearby Puebla, he obtains cut human hair that he cleans, curls, and uses to create the eccentric pork-chop sideburns and beards of the French soldiers.

Another interesting part-time folk artist is Roberto Rivera, a fireman who lives in Corozal, Puerto Rico, a small town just outside of San Juan. He is also a *santero* and represents the fifth generation of the Rivera family to make wooden saints in a traditional manner. Each day, when Roberto goes to the firehouse, he takes with him a small portable box containing his tools and pieces of wood. While his colleagues play cards, he works on popular religious images that he sells to tourist shops in San Juan or to neighbors for their home altars. His production is small and only allows him to augment his fireman's salary in a modest way, but he derives tremendous pleasure from being a part-time *santero* through which he keeps the family tradition alive.

Other folk artists are full-time specialists who use their art as a main source of financial support for themselves and their families. Almost all of the creative figural ceramists from Caruaru, Brazil, work full-time at the production of charming genre figures, which are sold all over Brazil and exported to the United States and Europe. The Tistoj family of San Miguel, Totonicapan, Guatemala, is another good example of full-time dedication to folk-art production. It has successfully operated a *moreria* (dance costume shop) for many generations. It is currently run by Jorge Tistoj Santiago, his wife Ruth, and their three sons.[3] The family works as a unit, and day in and day out, it produces and rents its now-famous, elaborate dance costumes to villages all over the highlands for use in the celebration of their patron saints. Similar family-operated costume and mask shops can also be found in Ecuador and Bolivia, each run by extended families, some over many generations.

Often, part-time folk artists, upon achieving a certain degree of success, evolve into full-time craftsmen. Many of the exciting full-time potters and wood carvers from the Valley of Oaxaca made this transition during the past two decades because of an increased worldwide popularity of their handsome folk art and the realization that they will be able to make a better living with full-time folk art than tilling their fields and working with folk art on a part-time basis. Typically, part-time artists tend to be found in more conservative settings and seem to be less motivated by economic considerations than those engaged in full-time production. Often, part-time folk artists make no money at all on the objects they produce, but instead, they donate their time and talents to the community. This allows talented people, with little money, to participate in communal activities in a meaningful way. A village carpenter, for example, might offer to make dance masks for use in celebrations honoring the patron saint of the community in which he lives. A folk artist's gift might be prompted by a feeling of civic pride or to fulfill a vow to a local saint made during the year.

Some folk artists work full-time on the same types of objects. Others work in different mediums, producing different objects for a variety of functions. Some tailor their work so that it conforms with a ritual calendar, as in the case of the famous Linares family of Mexico City who are masters of papier-mâché production. When Pedro, the family patriarch, was asked what his family did in between Holy Weeks when their marvelous Judas figures are exploded, he responded: "But there are no in between times. We are always busy. We make toys for Christmas and the Day of the Three Kings. From January to August we make toys for Mexico City markets. In September we make masks and helmets for the independence holidays. In October we prepare for November 2, the Day of the Dead."[4]

All over Latin America there is a strong sexual division of labor among folk artists. Generally speaking, throughout Mexico and Central and South America, male and female activities are clearly delineated. This is especially true in agrarian communities where men spend the majority of their time away from home tending fields and animals. Women, who care for children and maintain the home, often engage in supplementary folk-art production such as weaving and potting, both of which can be carried out within the family courtyard. Usually, economic life is a cooperative effort with complementary tasks being performed by members of each sex. In Zacualpa, Mexico, for example, pottery production is a family affair with duties strictly divided among males and females. Zacualpan men gather the clay and firewood, while women do the actual forming, decorating, and firing of the pottery. Together, they take their pottery to market in Tlapa, about a two-hour walk from Zacualpa.[5]

In the San Blas Islands of Panama, Kuna men work as fishermen or wage laborers, and women are in charge of activities in the home. As a general rule, women produce the beautifully appliquéd blouse panels (molas) for which the Kuna are famous. There are a few exceptions, however. The incidence of albinism among the Kuna is the highest in the world. Albino men, whose delicate skin prevents them from doing work in the sun, often do women's work and may even cut their hair as women do and wear feminine attire. It is acceptable for these men to cut and sew molas alongside village girls and women.[6] In highland Bolivia, women always weave on pre–Hispanic-style looms and men weave *bayetta* on Spanish-style treadle looms. Again, effeminate men are often invited to join women in their gender-specific folk-art production.

Throughout Latin America being good at a gender-specific trade is frequently a strong criterion for selection as a bride or groom. In the Quechua-speaking community of Bolívar, Bolivia, young women parade around the weekly market with examples of their weaving conspicuously spilling out of their carrying cloths. Their message is essentially "Look! These textiles are from my loom. Marry me, and they are yours."

Latin American folk artists learn their art from a variety of sources. Many learn from parents or grandparents. Others serve lengthy periods of apprenticeship under village masters. Still others are self-taught. When skills are passed on within a family, socialization usually begins very early. Initially, children are encouraged to work as their parents, differing only in degree. Frequently, they are given informal supervision by their family mentors who exercise patience and understanding as their children wrestle with the complexities of a loom or the speed of a potter's wheel. As children get older, however, expectations rise. One weaver from the Tzotzil village of San Pedro Chenalho, Mexico, recalls her own socialization: "When I was about fifteen, I began to use the spindle. . . . 'Do it this way,' my mother would say. 'Don't make it too soft or too hard.' When my spindle didn't turn right she would hit me with it. . . . My mother

would say, 'Where did you come from, woman, that you don't know how to handle your spindle? Women have to learn. You'll probably have a strict mother-in-law who knows how to weave very well and she'll scold you. She'll hit you on the head with the spindle and whorl if you don't know how to use them.'"[7]

The late Jacinto Rojas, an itinerant photographer and painter of backdrop scenes, learned to paint from his younger brother, Enrique. When his brother died prematurely from alcoholism, Jacinto took over the business, full-time. For years, he painted backdrops for itinerant photographers all over central Mexico and his charming works can still be seen at the Villa de Guadalupe, Xochimilco, the Alameda Park, and other popular spots in and around Mexico City. Juan de Dios Rojas, the thirty-four-year-old son of Jacinto, started an apprenticeship with his father at the age of fifteen and has taken over the business since his father's death in 1991 (Fig. 16).

Other folk artists do not come out of a long artistic tradition, but, instead, seem simply to stumble into their work. José Belandria, the master wood carver from Mérida, Venezuela, worked as a farmer until one day, while clearing a field of tree stumps, he developed an inguinal hernia and almost died. It was while recuperating in Mérida that Belandria began seriously to carve reli-

Fig. 16. *Mexican Backdrop Painter, Jacinto Rojas and Son,* c. 1989, Mexico, D.F., Mexico.

gious and historical images, a skill he had acknowledged only half-seriously prior to his accident. Belandria's countryman, the late Rubén Manzanilla, also seems to have sort of drifted into his life as a folk artist: "I started to paint and carve figures in the later years of my life. I can't remember just exactly how, but it was little by little. All of my life I have asked God for help, and, likewise, I asked him to help me in my carving. 'Give me a sign, God,' I would say. . . . I have lived here in this house for over twenty years, and little by little, little by little I make my figures, just as I live my life, little by little." [8]

José Francisco Borges, the Brazilian folk poet and graphic artist, started out selling chap books on market day by singing songs related to the stories he sold. Later, he realized that if he, too, could make the wood print images on the covers of these books, he would be able to produce these popular pamphlets himself, thereby cutting his costs considerably. Today, he is one of Brazil's most illustrious folk artists, and he makes a wide variety of chap books and other graphics that are bought in local markets or sold to foreign collectors and museums (Fig. 17).

Traditional knowledge about folk art is often passed from person to person in settings normally considered unlikely. All over Latin America and in many other parts of the world, prison inmates apply and receive body tattoos, a traditional act of incorporation in a prison environment. These tattoo skills are informally passed on from generation to generation and are now institutionalized forms of communication in such places. In south Texas, Mexican-American prisoners, using handkerchiefs and sheeting, draw pictures of the Virgin of Guadalupe and other sacred images and dedicate them to their mothers or girlfriends, possibly as acts of contrition. Again, this is a tradition that was casually born and is informally passed on from generation to generation of prisoners.

Another interesting form of jail folk art can be found in small towns all over Mexico, Ecuador, Brazil, and elsewhere in Latin America. To earn extra money for their families on the outside, inmates learn to weave, knit, sew, paint, and to do other skills, all of which are unknown to the prisoner prior to jail. In Guerrero, Mexico, prisoners learn to decorate recycled rum bottles from older generation prisoners. These are displayed in front of the jail or in local shops, in hopes of being sold, In the nearby Isthmus of Tehuantepec, prisoners make plain and gaily decorated hammocks highly sought by local residents. In Cañar, Ecuador, people looking for the handsome warp-face woven sashes for which the area is famous know to visit the local jail where male prisoners, working on indigenous looms, weave traditional sashes with designs hundreds of years old. Usually, this knowledge remains in a jailhouse setting, passed from one group of prisoners to the next. But occasionally, prisoners recognize an earning

potential for what has been learned in jail and take such knowledge with them back to their peasant community where, in turn, new skills eventually become a part of traditional folkways.

Although traditional folk artists in Latin America seldom sign the objects they make, their works are by no means anonymous to other folk artists nor to those who buy and use them. Usually, members of an artist's community are able to identify which hands made which pieces. The shape of a pot's handle, the facial features of a carved image, or the color combination of a weaving all provide clues to authorship. Among neighbors and clients, folk artists develop good or bad reputations, depending, of course, on the degree to which their works stand up to the standards established by the community itself. A folk artist's main critics are usually those who live around him or her and with whom the folk artist relates on a day-to-day basis. When a folk artist is in charge of producing ceremonial art to placate a village saint in whose hands resides the community's future, the pressure

Fig. 17. *Brazilian Chap-book Artist, José Francisco Borges*, c. 1990, Bezerros, Brazil.

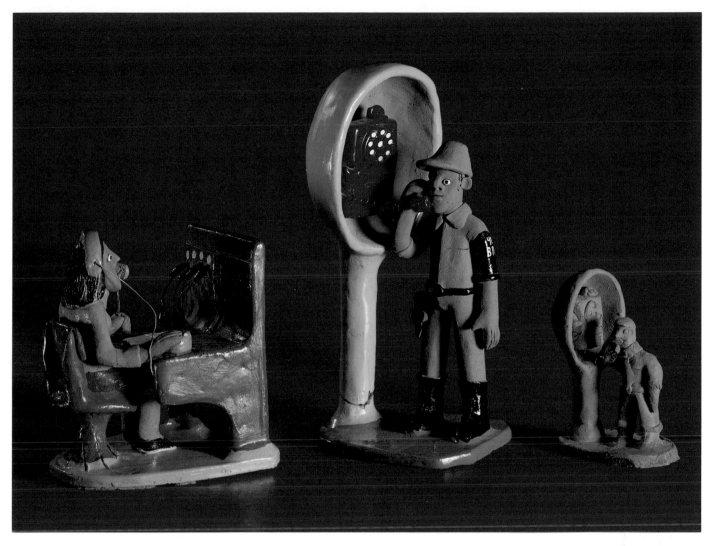

Plate 12. **Objects by Three Generations of the Vitalino Family,** Caruaru, Brazil, c. 1989, Painted and unpainted earthenware, wire: 3¼" tall to 7¼" tall. (Collection of the Museum of American Folk Art)

can be tremendous. A traditional floral artist from Patamban, Mexico, has commented on anxieties caused by the heavy responsibility of doing things correctly: "As the [festival] day approaches, and as I am getting behind in my work, I start worrying and can't sleep. In the middle of the night I think up an arch. Should the top be pointed or squared off? Should the circles on the sides be larger or smaller? In my mind I make the changes, then I go back to my original design, and then I start making changes all over again." [9]

In the case of Brazilian votive objects, a folk artist's judgment may be subordinate to the needs of the patron. Mestre Joaquim, a carver of wooden body parts offered to saints in thanks for miracles his clients have received, recalls being asked to carve the head of a woman with her tongue protruding from her mouth as it had during her ailment. "I made [the image] with the tongue sticking out. . . . It looked somewhat ugly. But she asked that it be that way, so I had to comply." [10]

Standards of production and boundaries of acceptability are set by traditions of the communities in which a folk artist works and lives. Because most folk art is relatively slow to change, folk artists are conservative and usually introduce changes in style and content after great thought. When asked why they do things a certain way, the response is likely to be *"por qué es costumbre"* (because it is custom). Of course, some latitude is allowed, but the folk artist understands the limits beyond which he cannot take his or her work. Communities always allow for some degree of individualism, and it appears at familial, village, and regional levels. The five figures shown here of Dr. José Gregorio Hernández, a much revered "saint" from

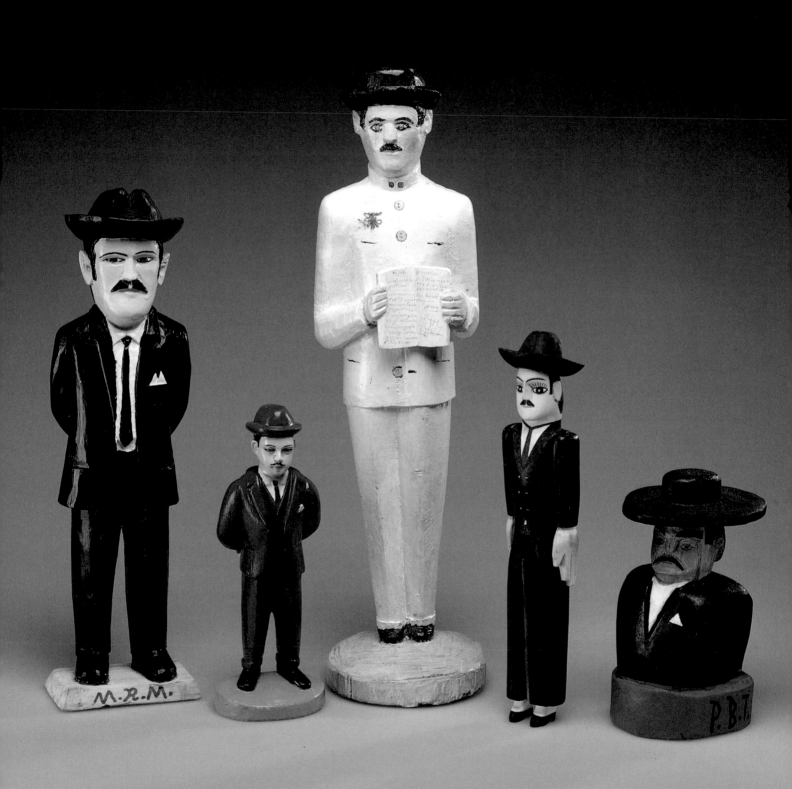

Venezuela, reflect both conformity to a particular set of attributes and individuality of artistic expression *(Plate 13)*. Each of these artists, four from Venezuela and one from Ecuador, knew the traditional attributes that had to be included in order to adhere to standards set by their local communities, but their works also reflect the individual personalities of each artist.

One of the unique qualities of folk artists is their ability to reflect local values and perspectives using objects which are taken from the immediate environment. It is no accident, for example, that many families who make figural ceramics are from communities that produce pottery made from local clay and fired with local fuel. For a variety of reasons, many folk artists are not able to purchase manufactured materials from regional market centers, but must rely on optional procurement tactics. One strategy is the use of discarded materials. All over Latin America, folk artists comb through materials thrown away by other sectors of society and recycle them through their own activities. The wife of Heculano López, a tin toymaker from Salamanca, Mexico, speaks of their use of recycled materials: "Once, when we were low on money, I thought about how much waste the Petroleum and Fortaleza factories throw away and I found ten tons of discarded tin near the river. I talked to my husband and we brought it all back and began to think what we could do with it, and my husband thought of making little baskets to sell."[11]

Although there is increasing pressure on folk artists to abandon their professions for more lucrative factory jobs, many folk artists tenaciously defend themselves and their work. Many are content to live on meager incomes as long as they can continue to work at what they love best. Larry Peña, a traditional tilemaker in San Antonio, Texas, learned his art in Mexico over fifty years ago. He makes no bones about his preferences in life:

"Every time I work, it's beautiful. It's life. I prefer to go to work than to go out, and I used to be a pretty good dancer. . . . I used to love to polka and everything . . . but work is beautiful. I'm all alone. You know what time I start to work? At three o'clock in the morning. Because it's cool and no one bothers me. And by noon I'm all used up. It's beautiful . . . Believe me, I'm a very happy man. . . . I never wanted to go to school because I wanted to learn this trade."[12]

And so, folk artists are alive and well all over Latin America where they serve as keepers of tradition and links between the past and the present for themselves, their families, and their communities. They also serve as brokers between their communities and the outside by representing community values and concerns to the world through their vital creations.

Plate 13. **Dr. José Gregorio Hernández: Variations on a Theme,** Nabor Terán, MRM, Roberto Belandria, Pedro Briceño, and Miguel Herrera, Venezuela and Ecuador; c. 1985–1989, Painted wood, glass, asserin paste; 8" tall to 20 1/4" tall. (Collection of the Museum of American Folk Art)

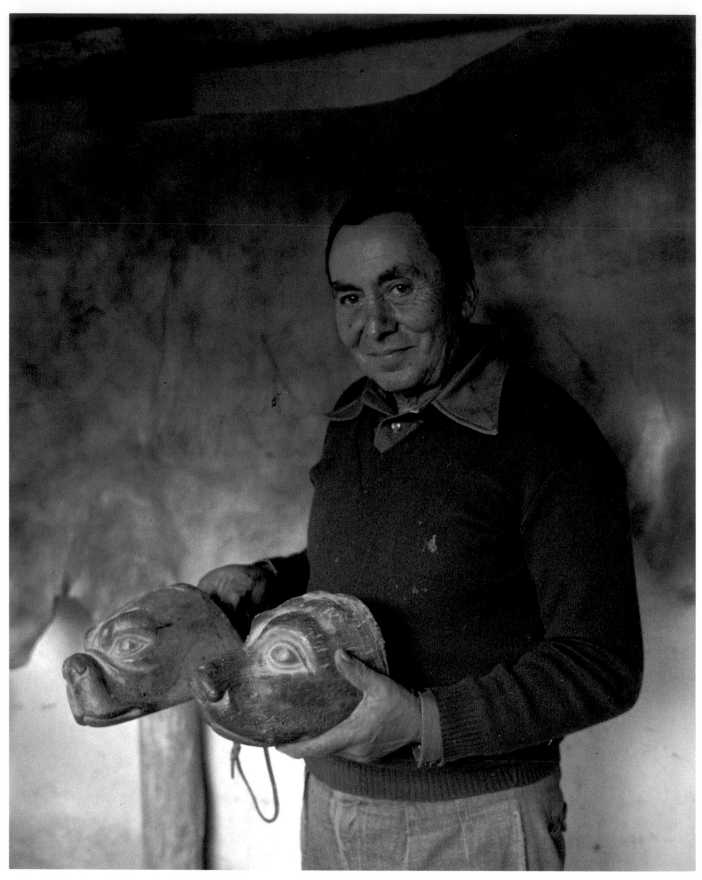

Fig. 18. *Ecuadoran Saddle-maker, Maestro Luís Rolando Ubando*, c. 1990, Esperanza, Imbabura, Ecuador.

THE MANY FACES OF LATIN AMERICAN FOLK ART

"So varied as to be unclassifiable, so cheap as to be despised, so close to all, so thrust under everyone's eyes as to become invisible."

—JEAN CHARLOT[1]

3

Today, as in the past, folk art is found in every corner of Latin American society, where it manifests itself in forms far too numerous to list. It appears in all imaginable colors and hues, and comes in every shape and size. Folk art is found in private homes, quietly adorning the family's altar and in public ritual spaces where it often speaks boldly of the hopes and values held in common by the community. It is found in the toys parents lovingly make for their children, hand-crafted objects that amuse, delight, and stimulate young minds as they embark on the difficult journey into adulthood. It is seen in the small decorative details of a peasant hut, a fisherman's boat, or a bus driver's dashboard. Elements of folk expression are constantly incorporated into local architecture, everyday and ceremonial attire, market activities, and food preparation and presentation. It is woven into every fabric of Latin American life and society. The French painter, Jean Charlot, an important chronicler of the Mexican art scene of the early twentieth century, keenly observed the integral nature of folk art and remarked that "in the Mexico of the 1920s, the concept of a fine arts market was still meaningless in terms of a 57th Street of velvet-lined displays. Yet art was everywhere: devotees bribed saints with ex-votos, lovers melted the hearts of their beloveds with portraits; artisans and merchants hired the painter to beautify their shops with murals and thus increased business. Sculpture existed for specialized aims—dark pieces, idols of secret worship,

semblances used for black magic; innocent pieces, those marvelous toys worth a few cents, beautiful as Han tomb figures. The output was so varied as to be unclassifiable, so cheap as to be despised, so close to all, so thrust under everyone's eyes as to become invisible."[2] Charlot's perceptive observations are still relevant to contemporary Latin America.

Latin American folk art lends itself to many systems of classification—by materials, techniques, age, place of origin, sex of maker, and other categories. In order to connect folk art to the societies that make and use it, however, a more contextual classification is needed. Therefore, we have organized the folk art in this publication and exhibition according to the functional role it plays in Latin American society: ceremonial, utilitarian, recreational, and decorative. Some objects clearly belong to only one category; others fit into two or more. These categories are intended to be broadly applied and are used to emphasize the primary functions of each piece included.

Fig. 19. *Santero, Maestro Antonio Suplicuicha*, c. 1990, Gualaceo, Ecuador.

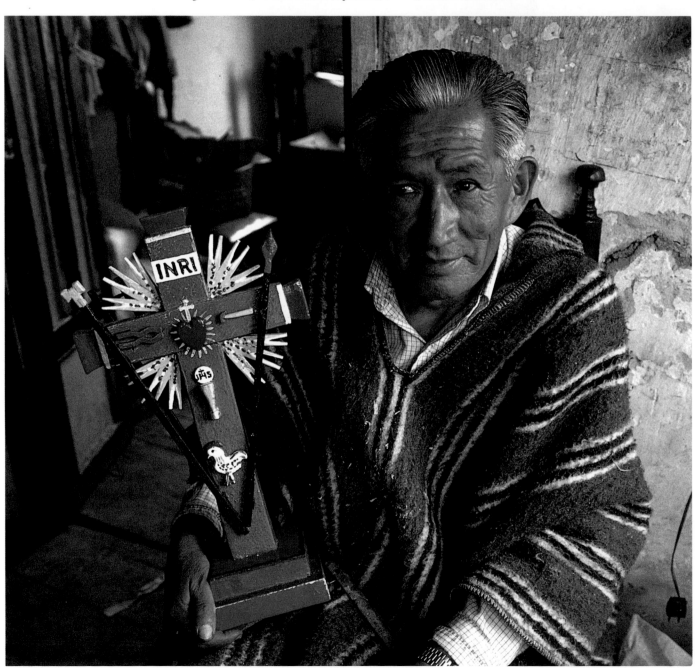

Ceremonial Folk Art

The most visible and dramatic form of folk expression in Latin America is that which is associated with ceremony, both secular and religious. Using traditional objects, carefully loaded with symbolic meaning, people all over Latin America commune with their saints, maintain continuity between the living and the dead, acknowledge the passage from one stage of life to another, and strengthen ties with family, community, and nation.

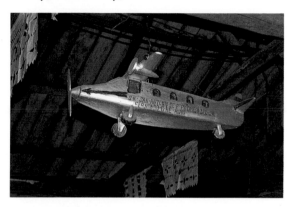

Fig. 20. *Airplane Ex-voto*, c. 1989, Tabasco, Mexico.

Fig. 21. *Ex-votos*, c. 1990, House of Miracles, Canindé, Brazil.

Occasions recalling important secular events, such as popular dates of historical events related to the foundation of nations, states, and villages and those staged to honor the deeds of armies and their leaders, yield colorful parades and reenactments of the events themselves through various forms of traditional visual and performing arts. Each year, for example, citizens of the ancient town of Huejotzingo, Mexico, don masks and costumes representing French and Mexican troops to recreate the 1862 Battle of Puebla in which Napoleon's army was vanquished and banished from Mexican soil forever. Folk art in the form of masks, costumes, and related paraphernalia are part of an annual folk drama used to strengthen Huejotzingo's sense of community and to bind it to a larger image of nationhood. Popular statues and portraits honoring the Cuban revolutionary, Che Guevara, or Simón Bolívar, the great Liberator of South America, are often very powerful forms of secular folk expression that are used, ceremonially, to reinforce political and nationalistic ideology. Secular ceremonial folk art has always been very important throughout Latin America and will continue to be so in the years to come.

Most ceremonial folk art, however, is religious. All over Latin America, there is a sacred geography, known mainly to the faithful, and it is at these sacred places that religious folk art comes into play in such a vital way. Sacred

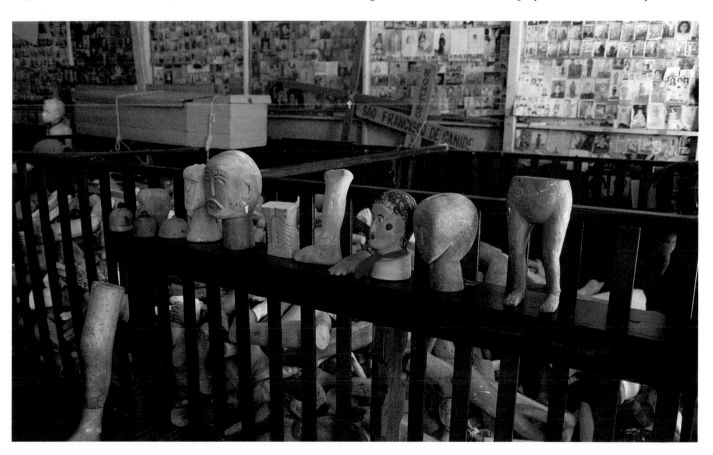

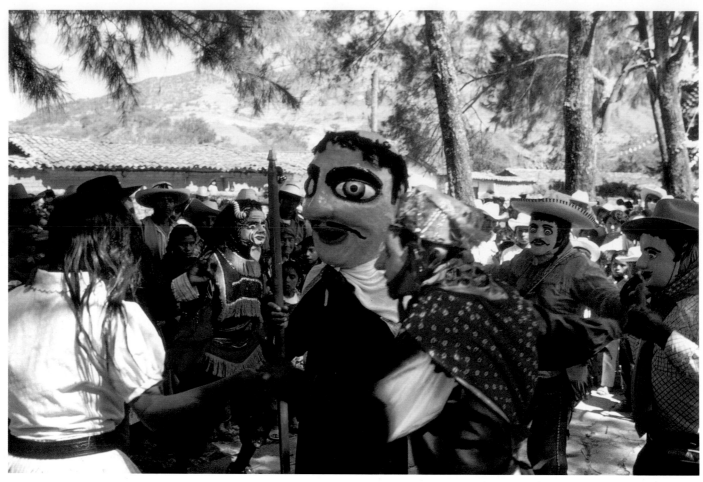

Fig. 22. *Dance of the Eight Crazies*, c. 1983, Atzacoaloya, Mexico.

caves and mountaintops in Mexico and Peru, roadside shrines in Venezuela, dusty pilgrimage centers in Brazil, quiet family altars in Guatemala, silent graveyards in Ecuador, quaint churches in rural Argentina, and exotic voodoo huts in Haiti all share one thing in common: For those who believe, they are the sacred arenas where the constant dramas of life and death, sickness and health, and hope and despair are played out according to local traditions, some of which are thousands of years old. Usually, these rituals are part of Latin American folk religion associated with the Catholic Church, especially in honor of the saints. Throughout a village's ritual calendar, there may be as many as a dozen saints honored annually through traditional ceremony, many of which call upon folk art to provide visual proof of spiritual dedication. Home altars are constructed to appeal to the tastes of individual saints whose favors are being curried, giant floral arches at the entrances to peasant villages announce their adulation of a specific patron saint, and dance dramas, hundreds of years old, are performed in front of sacred images who hold in their hands the well-being of the community *(Fig. 8)*.

At the heart of most religious folk art in Latin America is the concept of *la promesa*, a vow between a believer and members of the spiritual world who hold sway over individual, familial, and communal destiny. This contract is based on reciprocity. For example, *milagros*, small votive objects which are testaments to a saint's effectiveness, are found all over Latin America and are placed on altars in fulfillment of a *promesa* or vow. Small silver eyes, legs, and breasts testify to a saint's healing powers *(Plates 29,30)*. A wooden airplane, hanging in the chapel of a small village in southeastern Mexico, offered by members of a family who experienced a harrowing flight, testifies to the miraculous intervention by San Antonio de Padua *(Fig. 20)*. But one's prayers are usually answered with strings attached, i.e., the fulfillment of a vow such as undertaking a lengthy pilgrimage, or by offering votive objects. All of these objects are visual proof of faith and shorten the distance between the devout and the powers they believe in. Conversely, saints are also expected to be receptive. If individual sacrifices go unheeded, images may be scolded or have their faces turned toward the wall as punishment.

Also popular throughout Latin America is performance votive art, usually in the form of masked dance dramas. Dance groups are organized, practice rigorously, and make annual pilgrimages to specific centers in order to give thanks for favors received or to curry the future favors of particular saints. Masks play central roles in these dance dramas, and their variety is limitless *(Fig. 22)*.

One of the most intense periods of ceremonial activity in Catholic Latin America is the short period immediately preceding Lent, the forty days of fasting prior to Easter, known as carnival. This time is ritual time, time set apart from the rest of the calendar, and it marks the culmination of months of intense preparation in which vast amounts of money, energy, time, and talent are spent. The products of these expenditures are seen in one wild week of ostentatious behavior during which food, drink, music, and other sensual pleasures are paraded, consumed, and performed in unnatural proportions. It is the final fling before the start of forty days of denial of worldly pleasures. Folk art is everywhere. In the northeastern Brazilian town of Olinda, thousands of masked and painted revelers parade up and down winding cobblestone streets singing traditional songs, throwing confetti and other things at those too old or shy to join in. It is also a time, unlike any other, when social values are turned on their heads, when black becomes white, male switches to female, good is all-of-a-sudden evil, and norms of human behavior are openly ignored and ridiculed. Giant cardboard figures of politicians, local folk heroes and other culturally loaded images are carried from plaza to plaza *(Fig. 23)*. Some are part of traditional dramas that deal with love, hate, sex, politics, justice, and other issues. In Trinidad, many carnival participants are organized into bands who pool their time and funds over the year to make one strong statement annually in the form of a parade float. Peter Minshall, whose band calls upon thousands of members each year, designs displays that make explicit statements on good and evil, war, and environmental pollution.[3] Many of these bold displays would be punishable at any other time of the year, but, during carnival, special license is given and behavior is unfettered. In Baranquilla, Colombia; Ponce, Puerto Rico; Veracruz, Mexico; Santiago, Dominican Republic; and literally thousands of other towns in Latin America, carnival is the strongest ceremonial event of the year. It is a time for the community to come together as at no other time—a time when tensions, built up during the year, can be vented, and latent feelings on sexuality, politics, and social structure can be freely expressed without fear of recrimination.

Rites of passage, both secular and religious, are other

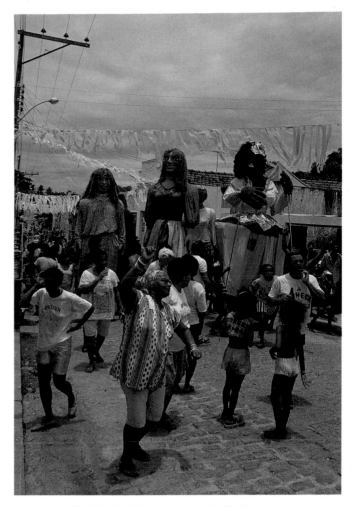

Fig. 23. *Carnival Giants*, c. 1990, Olinda, Brazil.

occasions for the use of ceremonial folk art. Rituals related to birth, baptism, puberty, marriage, and death call upon traditional folk art to assist in the often difficult transition from one stage of life to another. Wedding decorations, grave embellishments, and gifts given at "sweet fifteen" parties are good examples of this type of folk expression. In highland Bolivia, small dyed bread figures are exchanged between parents and godparents as a visual statement of their new relationship *(Plate 37)*. In Peru, godparents are sought to sponsor the construction of a new house, and they are expected to order and pay for the construction of a symbolic *viga matriz* (main housebeam) that is placed on the family altar *(Plate 35)*.

Ceremonial folk art provides us an opportunity to look at the very soul of Latin America and an important occasion to explore the fundamental beliefs of those who use it in their lives.

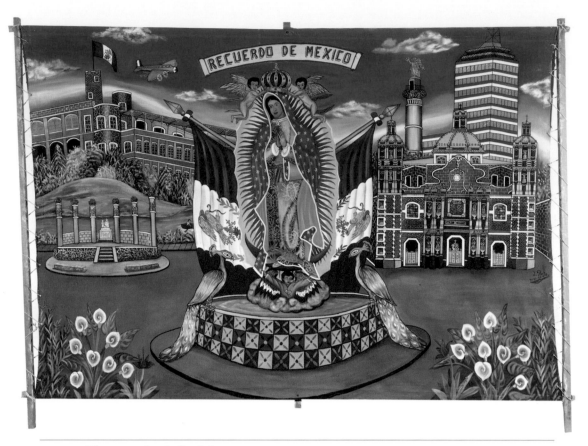

Plate 14. **Photographer's Backdrop,** Jacinto Rojas (1925–1991), Villa de Guadalupe, Mexico, D.F., Mexico, c. 1989, Oil on canvas; 7' x 9' x 2". (Collection of the Museum of American Folk Art)

Photographers' backdrops *(telones)* are still found all over Latin America, and their origins are rooted in the late nineteenth century. Used mainly by itinerant photographers *(ambulantes)*, these colorful canvases are usually found in the great pilgrimage centers of Mexico, Brazil, Guatemala, and elsewhere where they serve as backdrops for portraits of those who have visited important shrines in fulfillment of vows. Throughout most of the year, at the popular shrines of Our Lady of Guadalupe, just outside of Mexico City; São Francisco das Chagas, in northeastern Brazil; and Our Lord of Esquipulas in Guatemala, dozens of pilgrims a day line up to have their photographs taken as evidence that they have made the special religious trek in order to give thanks for a favor received—rains for crops, health for a parent, spouse, or child, a lover's affection, or a successful business venture. Although usually religious in content, secular themes can also be found, especially when used at popular urban recreational centers, such as Alameda Park in Mexico City. In Joyabaj, a small town in the Quiché region of highland Guatemala, during the festival honoring the Assumption of the Virgin in 1988, only secular backdrops were used, one representing a street scene from eastern Guatemala, the other a romantic view of Lake Atitlán showing the two great volcanoes and a side-wheel steamboat gliding peacefully from shore to shore.

Since many of those who have their portraits made in this fashion are from rural peasant communities, backdrops often incorporate well-known elements of the city, thereby providing proof that the pilgrim has also been to the city and experienced the fast life there firsthand. In the magnificent backdrop shown here, the artist has flanked the image of the Virgin with examples of famous landmarks of Mexico City such as the Independence Monument, the Chapultepec Castle and the Torre Latinoamericano, one of Mexico City's tallest skyscrapers. A four-prop airplane dangles precariously overhead, adding yet another modern touch to the scene.

Often these itinerant photographers will work with other props as well, such as toy horses or fancy chairs. At the shrine marking the place of burial of Padre Cicero, a much-revered holy man in northeast Brazil, pilgrims can be photographed in front of a handpainted backdrop, sitting on a powerful motorcycle that belongs to the photographer.

Two recent publications on Latin American itinerant photographers and their backdrops are *Los Ambulantes: The Itinerant Photographers of Guatemala* by Ann Parker and Avon Neal and *¡El que se mueve, no sale!* by the National Museum of Popular Cultures in Mexico City.

May 22, 1989 . . . *"At the bottom of the hill of Tepeyac, on the edge of the grounds of the Basilica of Guadalupe, I finally found the small plaza used by* fotógrafos ambulantes *(itinerant photographers) to photograph pilgrims visiting the Shrine of Our Lady of Guadalupe, the spiritual mother of Mexico. I had come to see (and hopefully purchase) a painted backdrop against which pilgrims are photographed. There were eleven brightly painted backdrops from which to choose. All were powerful statements of folk belief and perspective. One showed the Virgin of Guadalupe framed by the national emblems for every country in the Americas. Another offered, in one view, the Castle of Chapultepec, the Basilica of Guadalupe, the Torre Latino, and the Independence Monument. At the center of this composite of symbols of urban life was the Indian Juan Diego reverently kneeling before the Virgin of Guadalupe, recalling her apparition in 1532. Still another backdrop depicted an idyllic country scene, with snow-capped volcanoes and a speeding train passing by charming peasant huts and gardens.* UN RECUERDO DE LA VILLA *read the lettering above each backdrop. Clients stood stiffly in front of these beautiful tableaux, some wearing* charro *hats and colorful* sarapes *belonging to the photographers. Others sat astride life-size plaster horses. All seemed anxious to have visible proof that they had gone to the city, visited the most famous shrine in Mexico, and completed their pilgrimage vow to the Virgin."* (From the author's journal)

This inviting angel was probably made to be used in a nativity scene. Certainly its physical attitude, with outstretched arms and spread wings, is suggestive of angels placed above the Christ Child as He lies in the manger. Nativity scenes have been popular throughout Latin America since the earliest days of the colonial period. Originally displayed in convents and used to teach the story of Christmas, today they are found in private homes as well as in churches. Convents in Ecuador still make and display nativity scenes consisting of hundreds of objects; many characters are dressed in local Ecuadoran attire acting out scenes of typical Ecuadoran life.

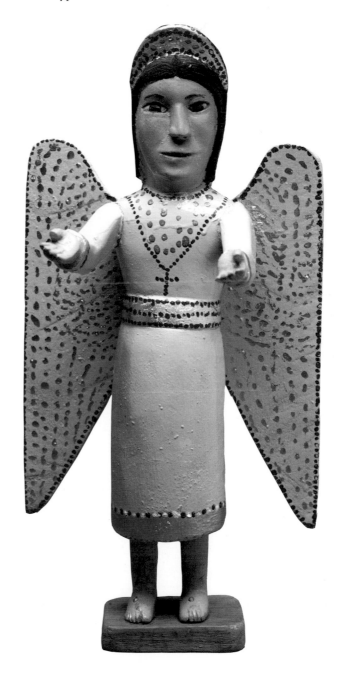

Plate 15. **Angel**, JOSÉ DE LOS SANTOS, San Rafael de Tabay, Mérida, Venezuela, c. 1989, Wood, paint; 13" x 6 ½" x 4 ½". (Collection of the Museum of American Folk Art)

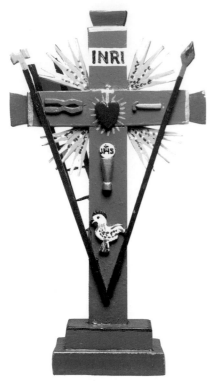

Plate 16. **Santa Cruz,** Antonio Suplicuicha, Gualaceo, Ecuador, c. 1985, Polychromed wood, 19" x 10" x 5". (Collection of The Museum of American Folk Art)

Throughout most of Latin America, on May 3, the Day of Santa Cruz, villages pay special homage to the cross on which Christ was crucified. In Zitlala and Acatlán, Nahua Indian communities in the state of Guerrero, Mexico, crosses are decorated with flowers, bread, and doves while young men, dressed as jaguars, reminiscent of pre-Hispanic times, don leather helmets and slug it out in honor of Santa Cruz. In Macha, a Quechua-speaking community in highland Bolivia, similar battles (called *tinku*) are staged in front of large crosses that have been brought down from the hills where they normally delineate land holdings. In villages around Lake Titicaca in highland Peru, metal crosses are placed on house roofs on May 3, and a house's age can sometimes be identified by the number of crosses displayed. Other communities celebrate this date in different ways, most frequently by decorating home altars honoring the Holy Cross. The handsome cross seen here was used in that way. Made by the last traditional *santero* (saint-maker) in Gualaceo, a town just outside of Cuenca, Ecuador, the cross was used for five years, and was returned annually to the artist for repainting or touch-up. Attached to the cross are elements of the passion of Christ—the cock that crowed after Peter's denial of his association with Christ, the spear that was thrust into Christ's side, the ladder for lowering the body, the hammer and pliers, and other elements from the Easter story.

Plate 17. **San Isidro Labrador,** Artist unknown, Ecuador, c. 1940, Polychromed wood; 12" x 8" x 10 ½". (Collection of the Museum of American Folk Art)

Saint Isidore, the plower, is widely revered throughout Latin America where his help is sought in matters affecting livestock, farming, and the weather. Sometimes he is depicted plowing in front of a church assisted by an angel. As legend tells us, Isidore, a hardworking farmer from outside of Madrid, could not attend church services on the Sabbath because he had too much work to do in his fields. The Lord, recognizing Isidore's plight, sent an angel to assist with his plowing.[4]

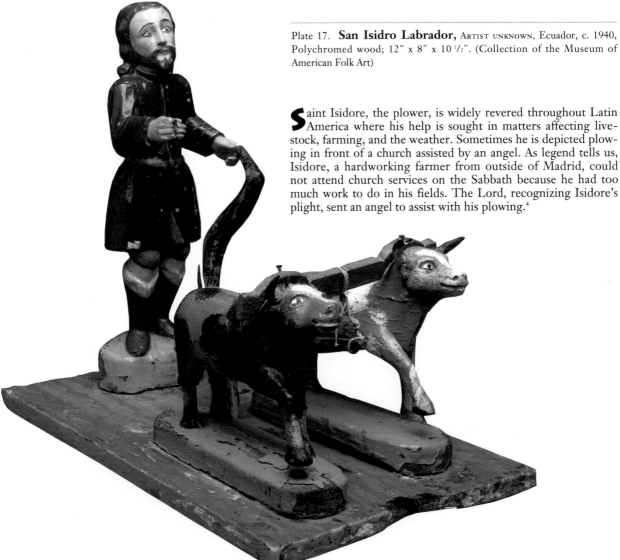

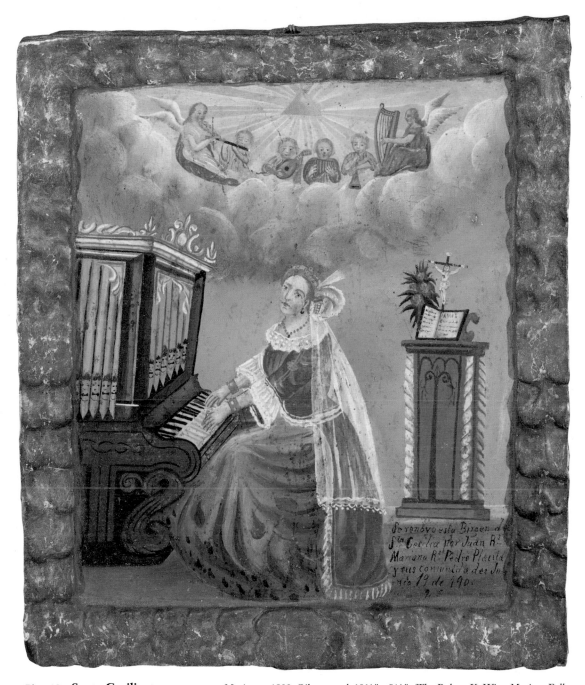

Plate 18. **Santa Cecilia,** ARTIST UNKNOWN, Mexico, c. 1900, Oil on wood; 10³/₄" x 9¹/₄". (The Robert K. Winn Mexican Folk Art Collection of the San Antonio Museum Association)

The frame and the background for this charming painting are one continuous piece of wood, and are polychromed in a manner typical of the eighteenth and nineteenth centuries in Mexico. Santa Cecilia, the patron saint of music and musicians, is rarely seen in *retablo* art of Latin America. Her accompaniment by a celestial orchestra beneath the triangulated symbol of the Holy Trinity is also unusual but not completely unknown. The pipe organ, Santa Cecilia's attire and the bookstand in the right side of the painting are evocative of nineteenth-century Mexico.

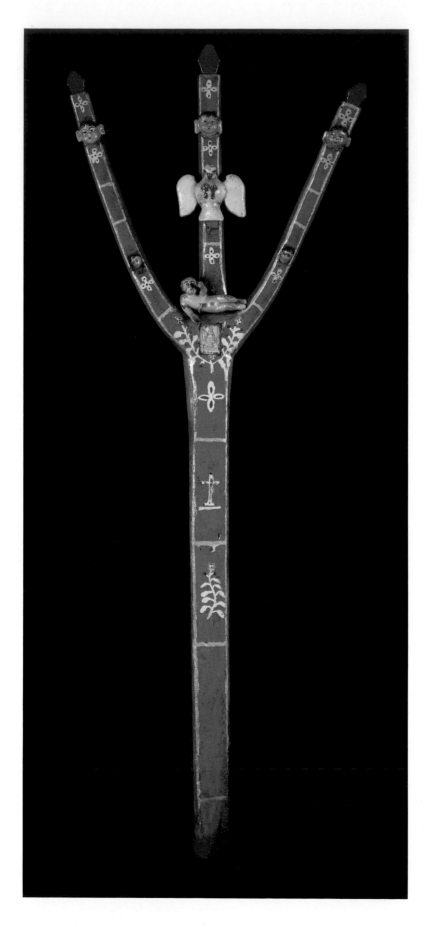

Plate 19. **Natural Branch Cross,** ARTIST UNKNOWN, Pomasqui, Ecuador, c. 1950, Polychromed wood, metal, glass, paper; 56" x 19¼". (Collection of Peter P. Cecere, Reston, Virginia)

This unusual cross is probably from Pomasqui, just north of Quito, and was modeled after the original cross dedicated to El Señor del Arbol. Painted green with floral motifs that call to mind other foliated crosses in Latin America, this vertically oriented piece is an assemblage of forms. The focal point of the cross is comprised of three Christian symbols. At the confluence of the three branches of the cross and inset behind glass, is a small engraved image on paper of the Virgin. Just above and reclining on His side, is an image of the Christ Child with one arm extended toward the viewer in an inviting manner. The Holy Spirit is represented by the white dove. The association of these three images together on a cross is rare in Latin America but may have been inspired by a more commonly associated trinity comprised of the Dove, Christ, and the Holy Father. The five small cherubs are crudely fashioned but add another dimension of charm to the cross.

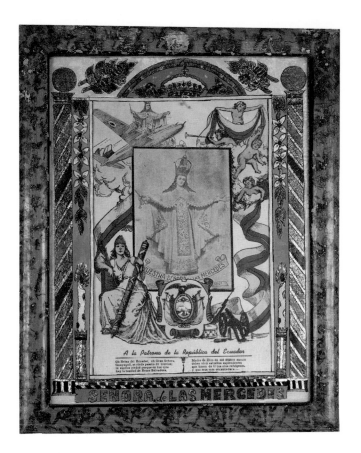

Plate 20. **Virgin of Las Mercedes**, Artist unknown, Ecuador, c. 1940, Tinsel, paint, glass, printed paper; 20¼" x 16½". (Collection of the Museum of American Folk Art)

Plate 21. **San Miguel Arcangel**, Artist unknown, Guatemala, c. 1920, Polychromed wood, tin, glass; 19" x 11" x 4". (Collection of the San Antonio Museum Association. Purchased with funds from Friends of Folk Art)

Saint Michael, the Archangel, captain of the heavenly host, is widely revered throughout Latin America. He is always winged and usually dressed in a variant of a Roman warrior's costume. He frequently assumes a rather bellicose stance with metal sword held high. In Guatemala and elsewhere, he is shown with scales in his left hand, which he uses to weigh souls at the Last Judgment. People seek help from St. Michael to fight off temptation and at the hour of death.[6]

The example shown here is exceptionally good. The carving and decoration are superb. The insertion of glass eyes from behind the face is a traditional technique that has all but disappeared in Latin America. The vanquished devil, crushed underfoot, is not dragonlike, as is usually the case, but rather it is anthropomorphic, suggesting that the evil we must confront is of this world.

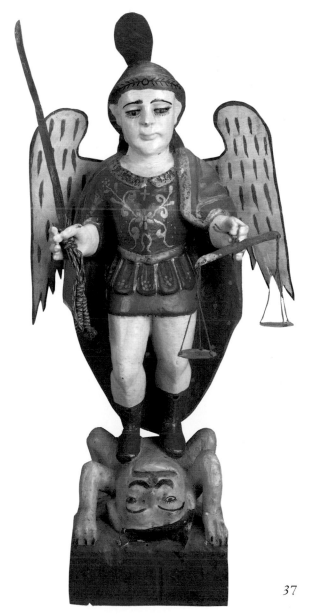

This rare presentation of images associated with the Virgin of Las Mercedes, Ecuador's patroness, is a combination of old and new forms and techniques. The central image is a blend of religious and nationalistic themes printed on yellowing, inexpensive paper. A four-engined airplane of the Ecuadoran Air Force speeds through the air, straddled by the Virgin, while cherubs frolic in the clouds waving national banners. Below is the nation's official emblem, military paraphernalia, and a seated woman, probably the personification of Ecuador. At the bottom of the print is a poem in honor of the Virgin. Of equal interest to us here is the reverse painting and tinsel decoration surrounding the print. Striped columns, lit candles, floral designs, and the name of the Virgin are all presented in brightly colored fashion. Reverse painting and tinsel decoration date back to the thirteenth century in Italy and were popular in the United States and Europe during the first half of the nineteenth century when it was probably introduced into parts of Latin America.[5] Tinsel painting never enjoyed a wide popularity in Latin America, and because of the delicate nature of this colorful genre of folk art, few examples of this vibrant work have survived.

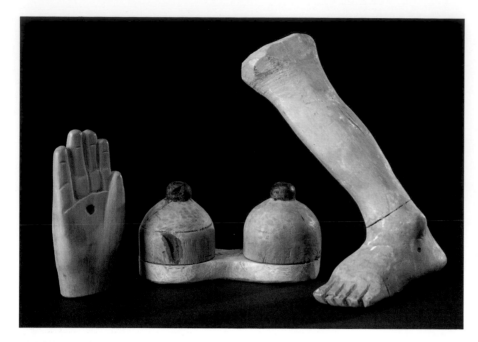

Plate 22. **Hand Ex-voto,** Artist unknown, Canindé, Ceará, Brazil, c. 1990, Wood; 6" x 3¼" x 1½". (Collection of the Museum of American Folk Art, gift of Roberto Emerson Câmera Benjamin)

Pair of Breasts Ex-voto, Artist unknown, Canindé, Ceará, Brazil, c. 1990, Wood; 3¾" x 7" x 3". (Collection of the Museum of American Folk Art)

Foot and Leg Ex-voto, Artist unknown, Canindé, Ceará, Brazil, c. 1990, Wood; 11" x 6" x 3¼". (Collection of the Museum of American Folk Art)

In northeastern Brazil, ex-votos, called *milagres* in Portuguese, can be found at hundreds of important shrines where pilgrims bring them in fulfillment of vows. The three *milagres* shown here are all made of wood and are from the popular shrine of São Francisco das Chagas in northeastern Brazil. Each shows the particular affliction that prompted the pilgrimage—a wounded hand, recovery from breast surgery, a twisted ankle. Although this community is visited by pilgrims throughout the year, during the October week in which the patron saint is celebrated, hundreds of thousands of pilgrims make the long trek to Canindé, many dressed in the rough brown garb of pilgrims. Tens of thousands of ex-votos are offered, most similar to those shown here, others taking the form of before/after photos of burn victims, children injured in automobile accidents, and people shot during domestic squabbles. Politicians offer campaign posters as testaments to São Francisco's help in the race for local offices.

São Francisco das Chagas, like most other important shrines in Brazil, has a Casa dos Milagres, House of Miracles, where *milagres* are displayed. Those which are very special in some way are gleaned for the church's small museum on the other side of town. Most are eventually destroyed to make room for new offerings.

At the rural shrine devoted to São Severino dos Ramos, in the State of Pernambuco, *milagres* are "rented" to pilgrims as they enter the church. "I'll take an arm," "Give me a foot, please." Devotees then line up to place their ex-votos on the altar. A few minutes later, a small sliding door opens next to the altar and a hand appears to gather up the accumulated pile of objects for recycling. Rental income is divided between the church and the owners of land on which the shrine is located.

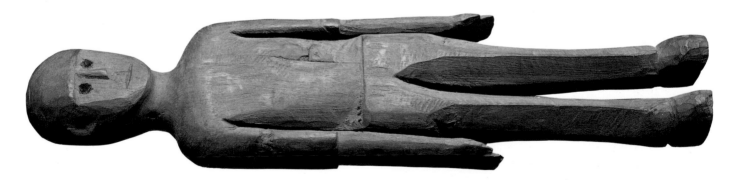

Plate 23. **Reclining Man Ex-voto,** Artist unknown, Garanhuns, Pernambuco, Brazil, c. 1980, Wood; 2¼" x 10¼" x 1½". (Collection of the Museum of American Folk Art; gift of Roberto Emerson Câmera Benjamin)

This unusual *milagre* is from the shrine honoring Santa Quiteria in Garanhuns, Pernambuco. It recounts the return to life of a man who had been given up for dead following a serious illness. Prayers to Santa Quiteria offered by members of his family were heard and, to everyone's delight, he arose from his deathbed and was restored to good health.

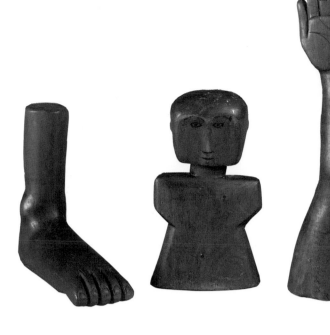

Plate 24. **Foot and Ankle Ex-voto,** Artist unknown, Patos, Paraíba, Brazil, c. 1980, Wood; 4¼" x 4½" x 1¼". (Collection of the Museum of American Folk Art; gift of Roberto Emerson Câmera Benjamin)

Bust of Man Ex-voto, Artist unknown, Patos, Paraíba, Brazil, c. 1980, Wood; 5" x 2¼" x 1¼". (Collection of the Museum of American Folk Art; gift of Roberto Emerson Câmera Benjamin)

Hand and Arm Ex-voto, Artist unknown, Patos, Paraíba, Brazil, c. 1980, Wood; 8¼" x 1¼" x 1¼". (Collection of the Museum of American Folk Art; gift of Roberto Emerson Câmera Benjamin)

Brazilian *milagres* come in all sizes and reflect a wide range of craftsmanship. Many are life-size, others are quite diminutive. Some are realistic, and others are abstract. The three *milagres* shown here are all relatively small and reflect a high degree of sophistication. Careful attention has been paid to details such as the toenails and lines in the palm of the hand. The torso, although somewhat abstract, is crisply executed, and the facial features have been heightened with an ink pen.

Plate 25. **Head Ex-voto,** Artist unknown, Northeast Brazil, c. 1988, Wood; 12" tall. (Collection of the Museum of American Folk Art)

This simple but powerful *milagre* is not only a statement attesting to the effectiveness of the saint it honors, but it is also a testament to the strong influence of African sculpture on the folk art of many parts of Latin America, particularly that of Brazil where the African presence was a major one. The economy of design and the angular character of the face are particularly reminiscent of West African art.

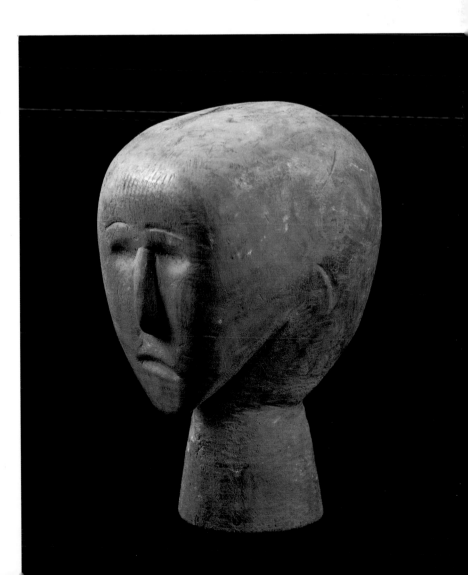

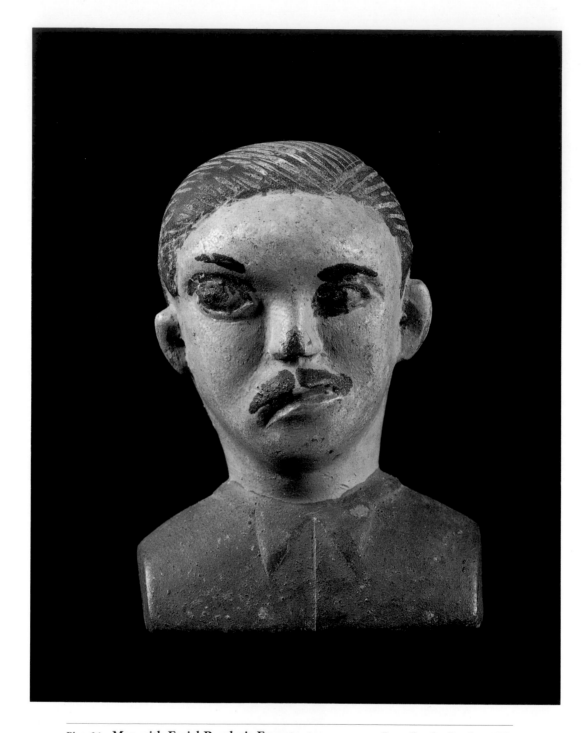

Plate 26. **Man with Facial Paralysis Ex-voto,** ARTIST UNKNOWN, Patos, Paraíba, Brazil, c. 1977, Wood, paint; 4¹/₂" x 2³/₄" x 2¹/₂". (Collection of the Museum of American Folk Art; gift of Roberto Emerson Câmera Benjamin)

This touching *milagre* shows a man who has apparently recovered from a stroke. His facial paralysis is effectively shown, and the artist has gone to great lengths to pay considerable attention to dress, hair, and facial features. The person who offered this *milagre* left his initials and date on the bottom of this small sculpture.

Plate 27. **Head of Man with Red Scarf Ex-voto,** ARTIST UNKNOWN, Canindé, Ceará, Brazil, c. 1990, Wood, paint, cloth; 9" x 4½" x 4½". (Collection of the Museum of American Folk Art)

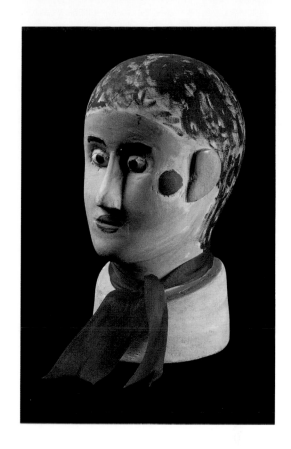

This *milagre* is unusual because of the realistic manner in which it was made. Although not entirely unknown, painted ex-votos are relatively rare. The man shown here had apparently been suffering from a facial infection, prominently represented here on the upper left cheek. The red scarf probably came from a piece of clothing belonging to the devotee and therefore carries with it some of the essence of that person.

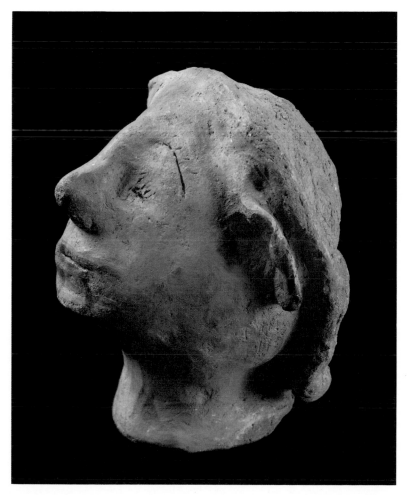

Plate 28. **Head of Woman Ex-voto,** ARTIST UNKNOWN, Rio Grande do Norte, Brazil, c. 1980, Earthenware; 6¾" x 5¼" x 4¾". (Collection of the Museum of American Folk Art, gift of Roberto Emerson Câmera Benjamin)

Most Brazilian ex-votos are made of wood, but wax, metal, plastics, and other materials are also used. This portrait, remarkably reminiscent of one of Degas's bronze ballerinas, has been fashioned from clay. The modeling is very free and the results pleasingly expressive.

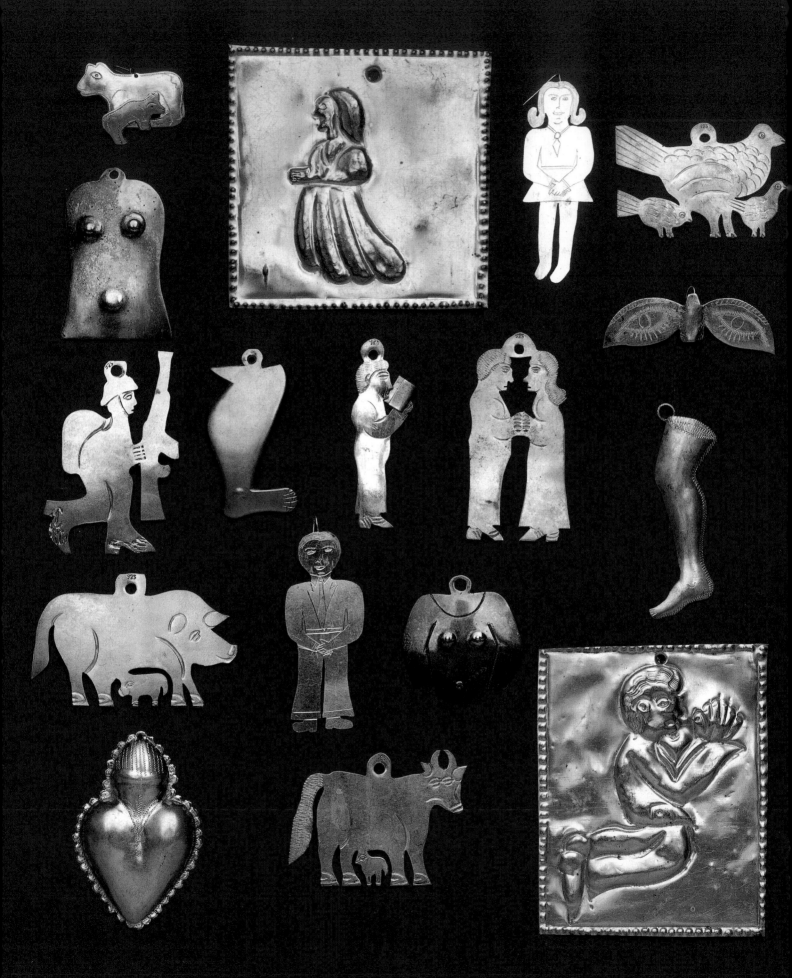

Since Etruscan times in Europe, devout people have fashioned miniature ex-votive objects in wood, wax, bone, and metals, to acknowledge favors received from spirits who control human destiny. Buried near shrines or placed on altars, these objects are testaments to prayers answered and petitions heard. Legs, arms, eyes, breasts, and other body parts attest to the return of health. Cows, horses, pigs, and other domesticated animals testify that these creatures have been saved from disease or injury. Corn, rice, and other crops witness bountiful harvests. Today, throughout all of Latin America, one can find these objects in great abundance. They are usually referred to as *milagros* in Spanish.

Milagros are made of wax, bone, wood, silver, gold, and other materials. Sometimes they are made by those who give them, but usually they are produced by part-time specialists or full-time jewelers. Mold-made *milagros* are sold for the equivalent of pennies at the entrances to churches all over Latin America. Others are made-to-order and frequently bear the name or initials of those who offer them to the saints in return for favors received. Most *milagros* are pinned on a saint's clothing or attached to a piece of cloth to one side of the altar, but others are squeezed in between the cracks of the vitrine holding the saint's image.

All of the *milagros* shown here are custom-made instead of mold-made, as is so often the case. They are fashioned of low-grade silver or silver-plated copper, and most are incised. Some are forms that have been used for generations such as animals, eyes, and legs. Others are quite contemporary, such as the student, the soldier, and the married couple. Other contemporary objects, not shown here, are sewing machines, houses, and automobiles.

Once the accumulation of *milagros* has outgrown space available, priests collect them for display in other parts of the church or sell them to local jewelers who reclaim the usually small amounts of silver. In recent years, *milagros* have become popular objects of fashion in the United States and parts of Europe where they are worn as earrings or on necklaces.

Martha Egan's recently published *Milagros: Votive Offerings from the Americas* is the best treatment of this traditional form of folk expression.

In many parts of Latin America, travel, particularly in remote regions where roads are poor, can be hazardous. Ex-votos documenting this danger can be found in every major pilgrimage site. Walls of the Shrine of Our Lady of Guadalupe on the edge of Mexico City are plastered with tin paintings showing overturned trains, head-on crashes between bicycles and cars, and buses tumbling down steep mountainsides. Along roadside passes in the Venezuelan Andes, remarkably realistic model tractor-trailer trucks and oil tankers made of tin mark the spots where these vehicles ran off the road and crashed. Silver and wooden *milagros* are also offered in thanks for a tragedy averted or the safe return from a trip.

The eight small *milagros* shown here are all from Peru. Cut from low-grade silver and stamped to add details, these charming ex-votos reflect the rich variety of transportation methods found in Latin America and the concerns of those who use them on a daily basis.

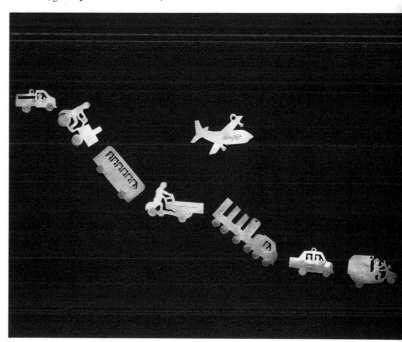

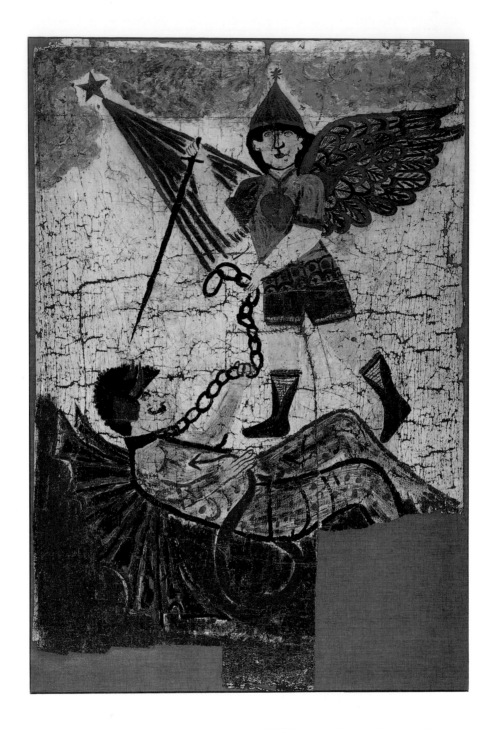

Plate 31. **San Miguel Vanquishing the Devil,** Artist unknown, South Texas, U.S.A., c. 1920, Oil on domestic oil cloth; 68" x 44". (Collection of the San Antonio Museum Association; gift of the San Antonio Conservation Society)

These two impressive paintings were probably used as banners in "Los Pastores" (The Shepherds), a Christmas play performed in Mexico and parts of the U.S. Southwest for over two centuries. Clearly of European origin, the pageant reenacts the pilgrimage of the shepherds to Bethlehem in search of the Christ child.[7] During their pilgrimage, shepherds are met by various temptations cleverly concocted by Satan. Their mission

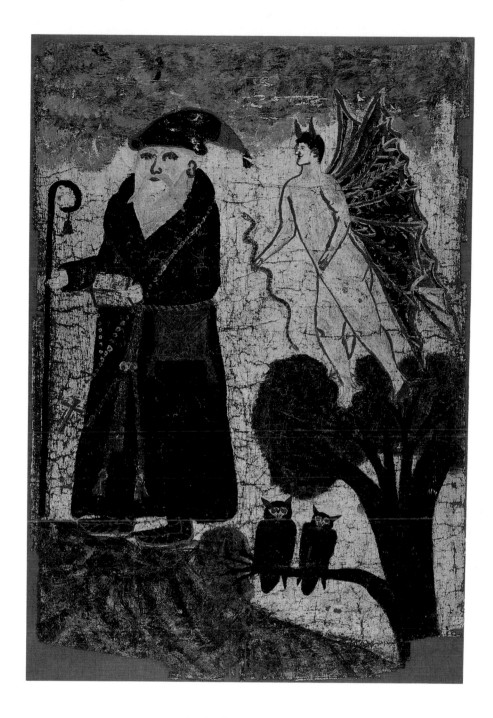

is finally realized with the help of the Archangel Michael, who eventually outwits the devil and vanquishes him into shame as shown in *Plate 31*. The Hermit, seen in *Plate 32*, is a popular character in Los Pastores, and is shown here being tempted by the devil to abandon his life as a religious aesthetic. Los Pastores continues to be a rich tradition in South Texas, where it is performed annually in San Antonio by members of the parish of Our Lady of Guadalupe.

Plate 32. **Temptation of the Hermit,** ARTIST UNKNOWN, South Texas, U.S.A., c. 1920, Oil on domestic oil cloth; 68" x 44". (Collection of the San Antonio Museum Association; gift of the San Antonio Conservation Society)

The word *retablo* comes from the Latin *retro tabula,* behind the altar.[8] In connection with Mexican popular art, it refers to small paintings on tin, wood, or canvas, which are found on walls behind altars to saints or other sacred figures. Some are portraits of individual saints, others serve as testaments to the efficacy of a saint who has been asked to intervene to save a marriage, cure a child, find a lover, or improve a crop or business. Although found all over Latin America since the early part of the colonial period, *retablo* painting, mostly on tin, reached its height in Mexico during the middle of the nineteenth century. Many *retablos* were painted by itinerant artists who traveled from town to town filling individual orders. Others were done by artists who set up stalls in front of important shrines on feast days, where they were visited by pilgrims much as illiterate rural folks sought out public scribes in towns on market day. Most *retablo* painting has been supplanted by inexpensive prints and photographs, but subject matter often remains basically the same.

The *retablos* seen here are ex-votos and served as grateful acknowledgment of the successful intervention by the Virgin of Guadalupe during times of personal crisis. The 1944 painting was offered by María Refugio Garza as thanks for the safe return of her son who had gone to the United States to work as a bracero, field hand. These *retablos* and thousands like them are important elements in the folk histories of peasant communities all over Mexico, and they provide important keys to a better understanding of the health, fears, and hopes of people who made and used them.

Gloria Gifford's *Mexican Folk Retablos: Masterpieces on Tin* is the best published description and analysis of this form of devotional art.

Plate 34. **San Sebastian,** The Cornelio Family, San Antonino, Oaxaca, Mexico, c. 1950, Wood, bamboo, bamboo shavings, dried flowers, cardboard, banana bark, paint; 45½" x 26" x 2". (Collection of the San Antonio Museum Association; purchased with funds from Friends of Folk Art)

This painting of San Sebastián was used as a *calenda*, a religious standard carried in procession through the streets of the small Zapotec community of San Antonino. Made by members of the Cornelio family, this standard and others like it were owned by the artists and rented, annually, to religious brotherhoods *(mayordomias)* for use in ceremonies honoring their patron saint. Because of the ephemeral nature of these impressive paintings, they are continually repaired and frequently replaced with new examples, as in the case of this piece.

San Sebastián is widely venerated in Latin America. As in this example, he is always shown as a young man and is usually depicted in the manner of his martyrdom—lashed to a tree with his body transfixed by arrows. During the Middle Ages in Europe, the plague was believed to have been caused by Apollo's arrows. San Sebastián, therefore, became one of the chief saints invoked against that dread disease. In Latin America today, San Sebastián's assistance is sought for a wide variety of dilemmas.

Plate 35. **House Beam** (detail), Artist unknown, Sarhua, Ayacucho, Peru, c. 1956, Wood, gesso, paint; 107" x 6¾" x 3". (Collection of the San Antonio Museum Association. Purchased with funds from Friends of Folk Art)

In the isolated village of Sarhua, Peru, there is the custom of building houses with the communal labor of neighbors. Furthermore, the owners usually choose another couple to serve as ceremonial sponsors for the new house *(compadres de la casa)*. Upon completion of the house, the sponsoring couple commissions the carving and painting of a symbolic *viga matriz*, the main support beam of the house. This beam is signed by the sponsors, duly witnessed, and placed inside the house. Although there are stylistic variations in these beams, most have a sun or moon painted on the top and an image of the Virgin on the bottom. In between, there are small painted scenes showing family members carrying out everyday domestic chores and participating in village festivals. Usually, these family members are identified by name and dressed according to their status or rank in the family and community.[9]

These beams, charming and provocative, provide us with yet another valuable opportunity to peer into the daily and ceremonial lives of Latin Americans through the art they produce.

Plate 36. **Chacana,** ARTIST UNKNOWN, Lake Titicaca Region, Bolivia, c. 1950, Bamboo sections, feathers, wood, paint, cotton string; 5¹/₂" x 21" x ¹/₂". (Collection of the Museum of American Folk Art)

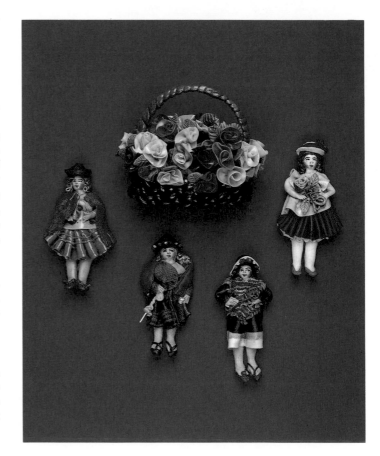

Chacanas are part of traditional dance costumes worn by the Aymara-speaking inhabitants of the Island of the Sun and neighboring communities around Lake Titicaca to celebrate important saints' days. These costumes play central roles in the performance of the Dance of Quena-Quena and the Dance of the Chacanas.[10] They are usually worn over the shoulder or across the chest in bandolier fashion. Feather mosaic work is deeply rooted in pre-Hispanic times and is rarely seen today in other parts of Latin America. The figures on this *chacana*—the lion, mermaid, Hapsburg eagle, and other exotic creatures—are curious blends of European and New World elements.

Plate 37. **Bread-dough Figures,** ARTIST UNKNOWN, Padilla, Chuquisaca, Bolivia, c. 1988, Bread-dough, food dye; tallest is 3". (Collection of the Museum of American Folk Art)

These tiny, delicate objects are still made in Bolivia today. The miniature human figures are dressed in traditional costumes of the region where they were produced. These pieces are exchanged by couples to cement the formation of a godparent relationship, known as *compadrazgo.*

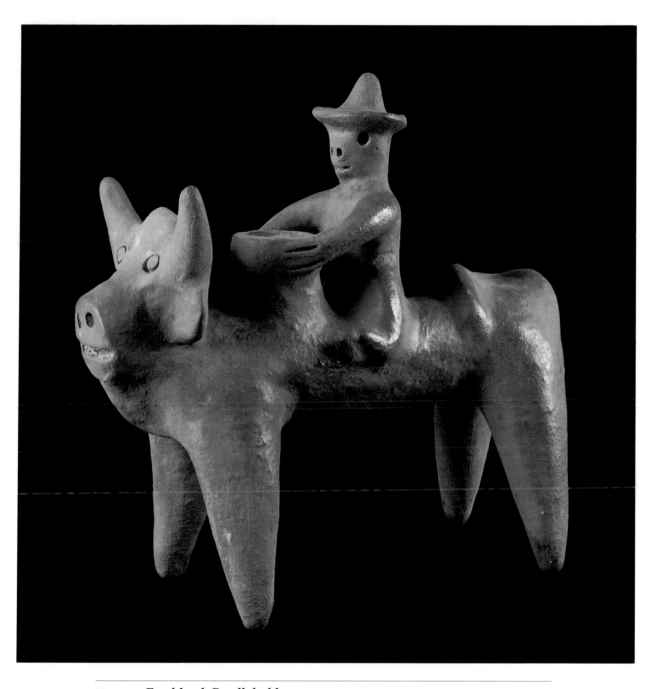

Plate 38. **Earthlord Candleholder,** ARTIST UNKNOWN, Chamula, Chiapas, Mexico, c. 1990, Earthenware; 13¹/₂" x 13¹/₄" x 5¹/₄". (Collection of the Museum of American Folk Art)

This impressive bull and rider is reminiscent of pre-Columbian sculpture in form and European in content. The elongated body of the bull, and the joining of rider and bull, produce a feeling of fantasy in this piece, suggesting something from another world, which, in fact, was exactly the aim of the artist.

asking is an ongoing tradition in most parts of Latin America. It is deeply rooted in pre-Columbian periods where masks were worn for protection during battles, and during religious rituals by shamans to symbolize the spirits the masks represented. During the colonial period, many masks were prohibited, but later, as the colonists saw how effectively they had been used in indigenous ceremonies, masked dramas were used to teach Christianity to Indians. Dramas recounting the reconquest of Spain and Christian victory over the forces of Islam were introduced as early as the sixteenth century and are still performed today in Mexico, Guatemala, and other parts of Latin America. Masked morality plays are also frequently performed espousing the eternal tug between good and evil.

Frequently, dance dramas have a clown or buffoon figure whose task it is to remind the public what is good and sacred in society by behaving in an opposite manner. These buffoons, often ugly by local standards, insult local officials, make normally inappropriate sexual gestures to women, and act out scandalous acts in front of the church and saints. Masks provide the wearer tremendous license to stretch or break local convention, and such behavior serves as a release for accumulated community tensions. Most masking takes place during the celebration of saints' days and other important dates in the Catholic calendar. Carnival festivities all over Latin America are important occasions for masking.

The masks shown here are from all over Latin America and represent a broad range of artistic expression. Animals, men and women, children, clowns, fantastic creatures, and historic characters are represented and serve to illustrate the tremendously rich variety of cultural experience in Latin America today.

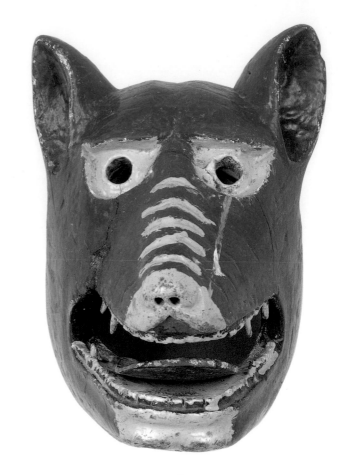

Ecuador

Plates 39–49. **Masks,** ARTISTS UNKNOWN, Mexico, Bolivia, Peru, Ecuador, Venezuela. 1955–85, A variety of materials including tin, wood, papier-mâché, animal skin and hair, paint. (Collections of the Museum of American Folk Art, the Girard Foundation in the Museum of International Folk Art, a unit of the Museum of New Mexico)

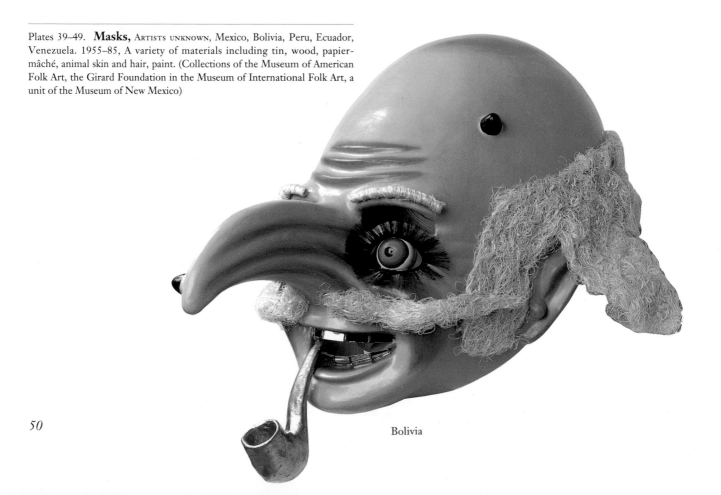

Bolivia

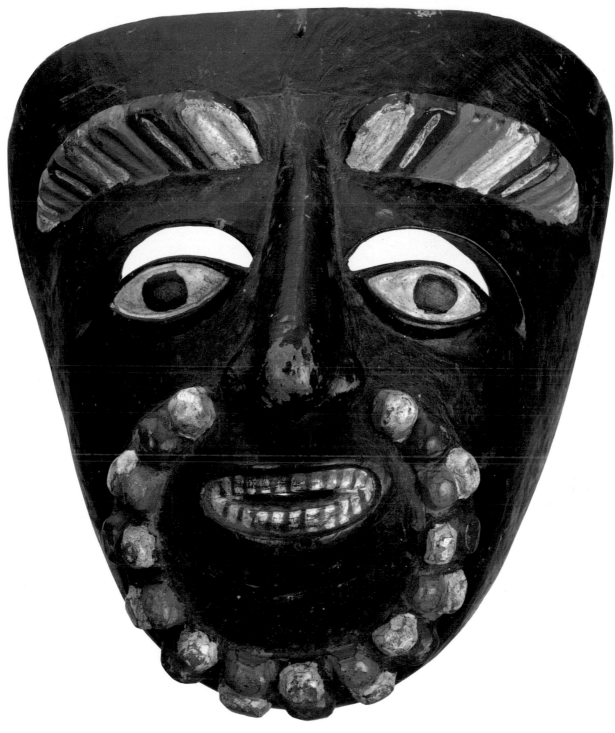

Peru

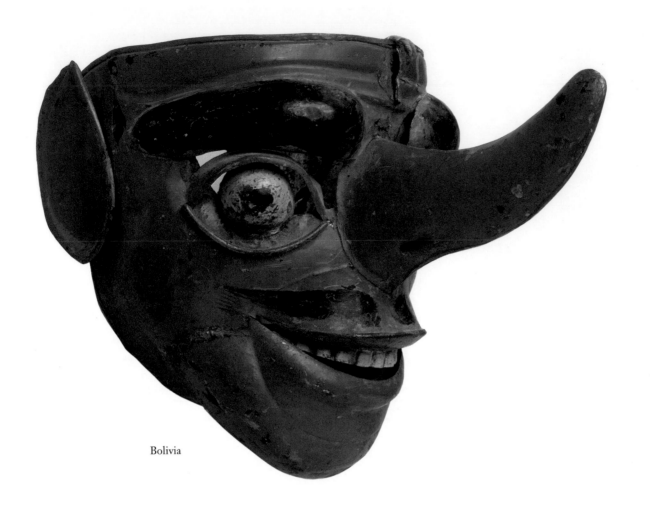

Bolivia

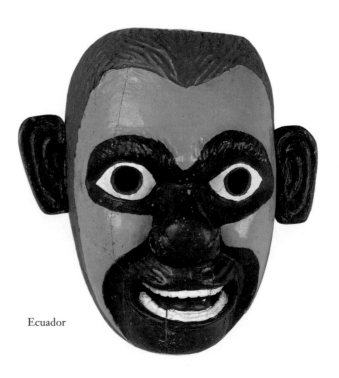

Ecuador

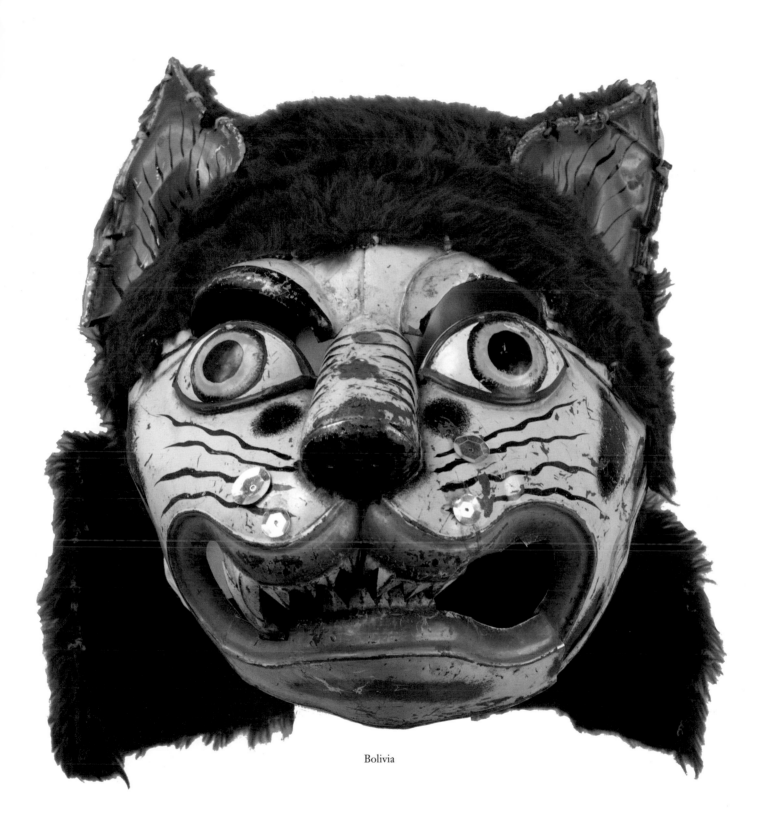

Bolivia

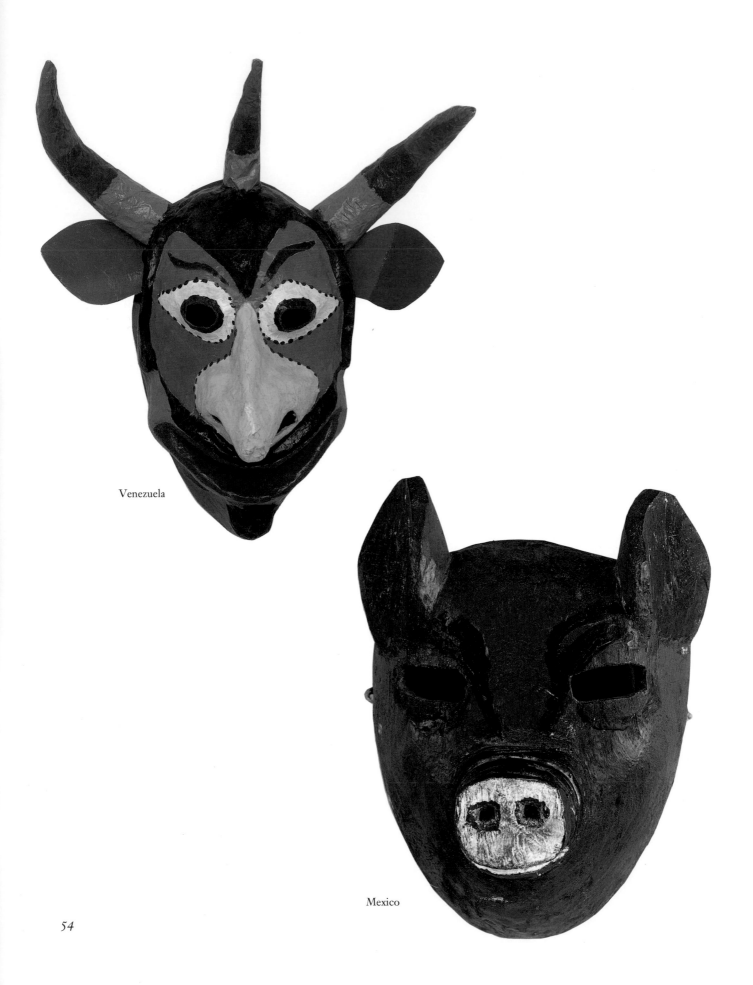

Venezuela

Mexico

54

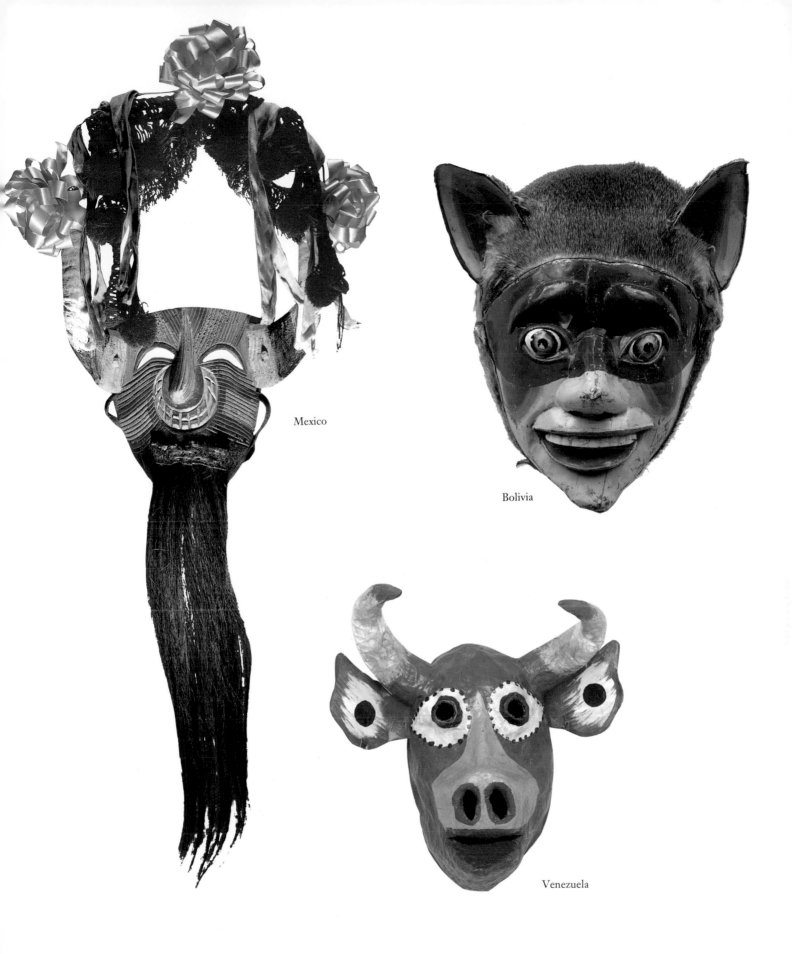

Mexico

Bolivia

Venezuela

Puppets and marionettes (*títeres*) have been used in Latin America for hundreds of years. Although figures with articulating limbs have been found in various locations in the pre-Hispanic world, puppetry as it is seen today in Latin America seems to be the result of European and Asian influences. Today, marionettes are still made and used in such places as Puebla, Mexico, and Pernambuco, Brazil, and folk artists usually draw from traditional techniques and forms.

During the colonial period and well into the nineteenth century, puppets and marionettes were used by the Catholic Church to teach doctrine. Christmas dramas and plays associated with the passion of Christ's death are common themes. In Mexico, marionettes were used as late as the mid–twentieth century to re-create the apparition of the Virgin of Guadalupe. Of course, many puppet and marionette performances were secular in nature and designed primarily for their entertainment value. Most of these dramas were done before hand-painted backdrops depicting scenes appropriate to the theme at hand.

In northeastern Brazil, on public market days and at regional fairs, vendors of medicinal herbs and other things use puppets to attract a crowd. Often bawdy and scandalous, puppeteers have great license to break with ordinary convention and use language not permitted elsewhere. Like masked performers during carnival festivities, a puppet can make off-color remarks about women, politicians, and priests and get away with it. Once the crowd has assembled, vendors bring out merchandise that is often woven right into the dialogue.

The splendid group of Ecuadoran marionettes shown here are probably part of an ensemble used to re-create the story of Easter. Roman soldiers and ordinary townsfolk are readily identifiable. Unfortunately, their maker and history have been lost. It is quite clear, however, that the artist of these important pieces was a person of great talent, capable of representing a full range of human facial expression. The artist's polychrome technique reminds one of church statuary, suggesting that he or she probably also worked as a *santero*. Mexico's greatest marionette artist, the late Rosenda Aranda of Puebla, worked in a similar style, and his figures still are of great importance because of their extraordinary quality and for what they tell us about the people who used and viewed them.

Plates 50–56. **Marionettes,** ARTIST UNKNOWN, Ecuador, c. 1920, Polychromed wood, cloth, straw, paper, paint; 36" tall. (Collection of Peter P. Cecere, Reston, Virginia)

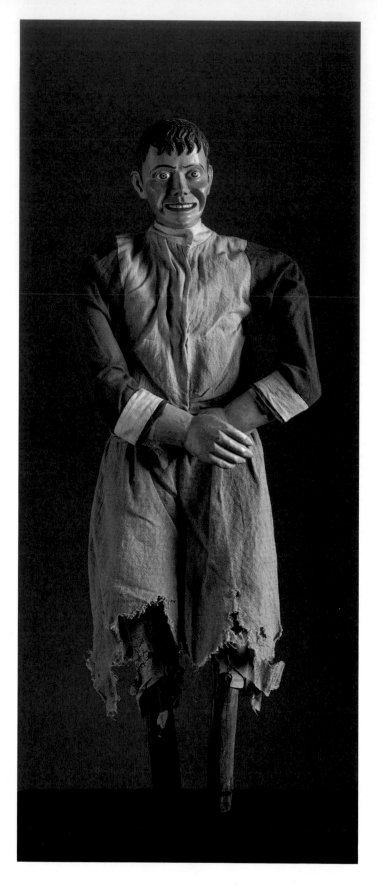

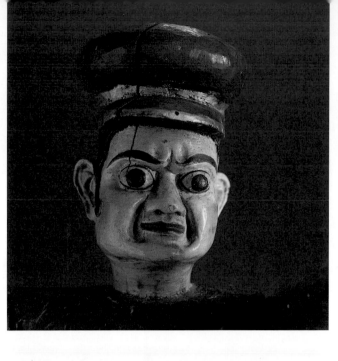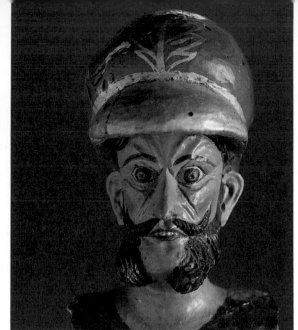

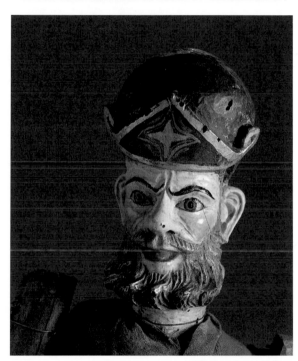

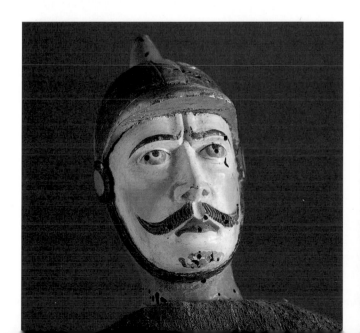

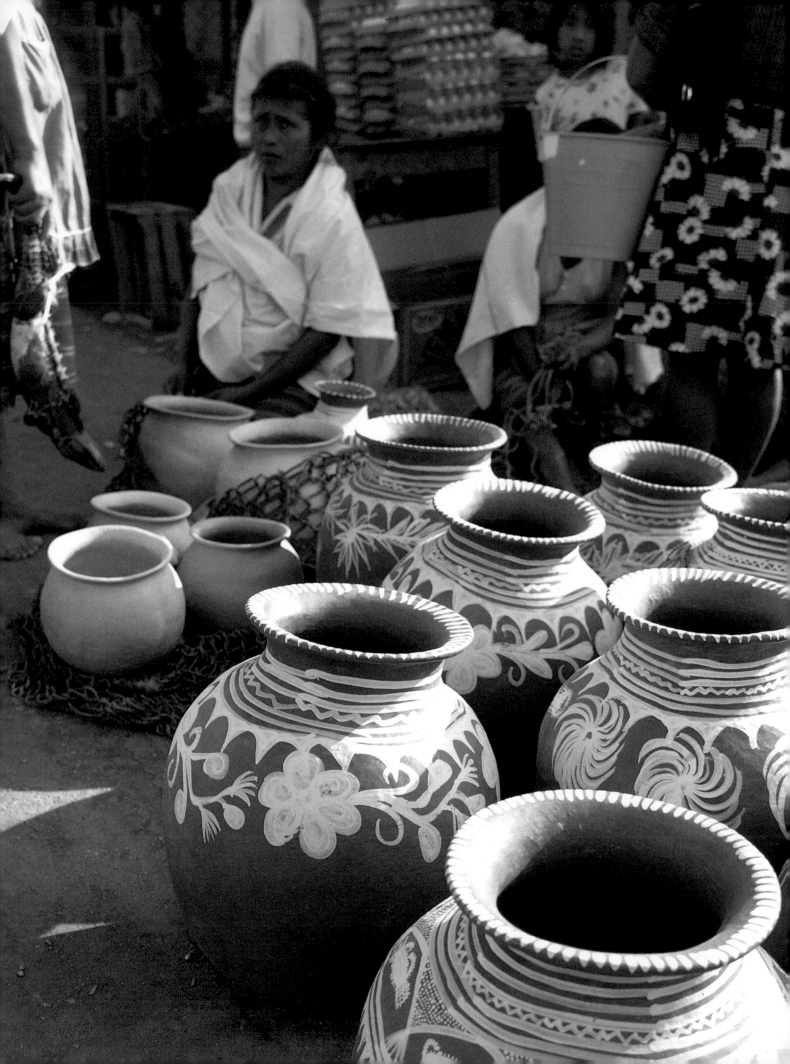

Utilitarian Folk Art

As in all parts of the world, most folk art of Latin America is, first of all, utilitarian—made to satisfy the daily practical needs of those who produce and use it. Clothing, household furnishings, cooking utensils, tools, farming and fishing equipment, equestrian gear, objects associated with a trade, and other functional objects are still made in great quantity according to long-tested, local folk traditions.

Each of the objects in this section was made in response to the needs of individuals, families, or communities. Each is uniquely designed to meet specific requirements arising from the physical, social, or economic environments. The heavy leather costume worn by Brazilian vaqueros (cowboys) of the Sertão region is a good illustration. The long coat, dickey, and chaps were developed in response to the rough and thorny brush of the region. The narrow-brimmed hat permits the vaquero to twirl a lariat overhead, unimpeded. The enclosed stirrups protect the feet from brush and animals, while at the same time, they prevent the feet from slipping through the stirrups and becoming entangled. Every aspect of the costume is a cultural response to the job at hand and is an adaptation to environmental conditions of the outback in northeastern Brazil (Fig. 26).

Although utilitarian considerations are at the core of most Latin American folk art, few artists are content to let their talents and imaginations rest there. Wooden trunks, after solving their primary utilitarian requirements as containers, are embellished and decorated in accordance with traditional aesthetic tastes (Plate 59). Strong, functional walking sticks become entwined with serpents and vines, or they are topped with human or animal figures, thereby going beyond their utilitarian function to become objects filled with humor, charm, and meaning (Plate 72). The interesting pots and jars from Zacualpa, Mexico, for example, are built primarily to carry and store water, and most aspects of Zacualpan ceramics strive to resolve those challenges—the porous clay allows water to cool through evaporation, the small orifice lessens spillage, and the sturdy but diminutive handles permit these pieces to be carried over the shoulder or hung from the wall of a peasant hut. But, again, the artist was not content to rest after the resolution of utilitarian problems. Static pots become bloated goats, hefty bulls, or buxom women. Consequently, Zacualpan ceramics delight the eye and satisfy utilitarian requirements.

Textiles, particularly those used for dress, are among the most common forms of utilitarian folk art. Again, most textiles go beyond the fulfillment of utilitarian requirements to serve other functions as well. In the

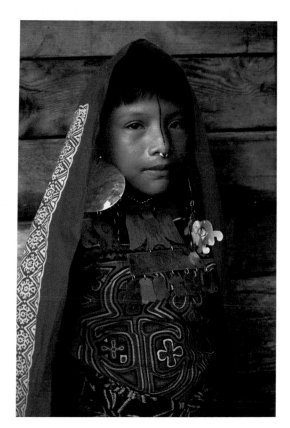

Fig. 25. *Kuna Girl*, c. 1975, San Blas Islands, Panama. Photo by Ann Parker.

Fig. 26. *Cowboys*, c. 1990, Northeast Brazil.

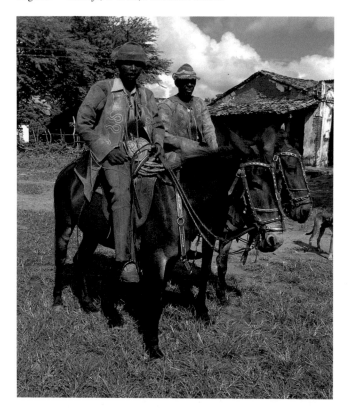

Fig. 24. *Pottery Sellers*, c. 1979, Coastal Oaxaca, Mexico.

59

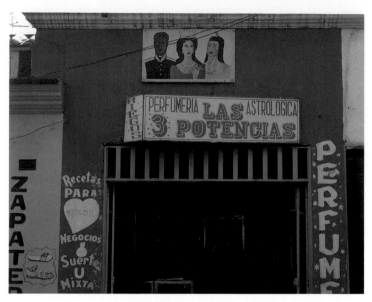

Fig. 27. *Shop of the Three Powers*, c. 1989, Mérida, Venezuela.

Andean region, where textile production has been important for many hundreds of years, sashes, headbands, and other forms of clothing contain traditional symbols associated with status, rank, lineage, or some other social phenomena *(Plates 68, 69)*.

Kuna blouses are worn by women to cover the upper parts of the body, in keeping with tenets of decency, probably introduced by Europeans in the early nineteenth century. These blouses, however, go far beyond their utilitarian needs and are boldly enhanced by mola panels that are colorful and filled with realistic or abstract motifs related to rank, status, religion, politics, and other areas of Kuna life *(Fig. 25)*.

Identical in function to the nineteenth-century cigar store Indians and other shop signs of New England, many Latin American stores still commission the painting of special signs to advertise their products. Bread stores, auto repair shops, and stores that sell religious paraphernalia call upon local folk artists to paint idiosyncratic signs telling the public about their offerings. Some use stencils of widely used designs, others are custom-tailored to meet the needs of individual merchants. All are considered important parts of good business practices. Few, if any, are considered art by those who make or use them *(Fig. 27)*.

Utilitarian folk art is perhaps the most subtle form of folk expression. The matter-of-fact manner in which it is used, and the degree to which it is integrated into the normal daily routine of life, make utilitarian folk art almost invisible.

January 5, 1988 . . . *"After inquiring at Bogotá's fabulous Museum of Gold about good shops selling authentic, noncommercial folk art, I grabbed a rickety cab, and we wound our way through La Candelaria, Bogotá's charming, but abandoned, eighteenth-century district now on the verge of a rebirth. I arrived at the suggested spot only to find it filled with unappealing kitsch—ashtrays and pot holders testifying to a tourist's visit to Colombia (*UN RECUERDO DE COLOMBIA*) and handmade genre figures, romantically depicting Colombian peasants carrying coffee on their backs or weaving palm hats—all objects made for tourists and not for the Colombian people themselves. Dismayed, I decided to walk back to my hotel via a public park near the center of town. As I arrived on the edge of the Plaza Santander, my eyes were drawn toward two long lines of uniformed shoeshine boys, all standing or squatting behind handcrafted and gaily painted boxes that advertised their profession. Eureka! Apparently, shoeshine boys purchase retangular boxes from the central market and adapt them to their own tastes. The idea of decoration is to include shapes and colors that will quickly attract the attention of customers. Second-class buses, taxis, portraits of Indians with feathered headdresses, human skulls, and words such as* amor *(love) created by a mosaic of Colombian coins, are popular motifs. To one boy's surprise, I offered to purchase his box. A price was stated, negotiated, and restated. A deal was struck. 'You'll be able to shine a lot of shoes in the United States with this box,' I was told. I strutted away to my hotel, delighted in the knowledge that, at last, I had found something worthy of the museum's permanent collection."* (From the author's journal)

Shoeshine boxes such as the one shown here can still be found on the streets and in the public parks of Bogotá. Usually made by the shoeshine boys themselves, these boxes display great individuality and creativity. Often, shoeshine boxes are inlaid with Colombian coins or glass marbles, and many display portraits of historical and popular folk personalities. Such vibrant decoration is done to attract the eyes of potential customers.

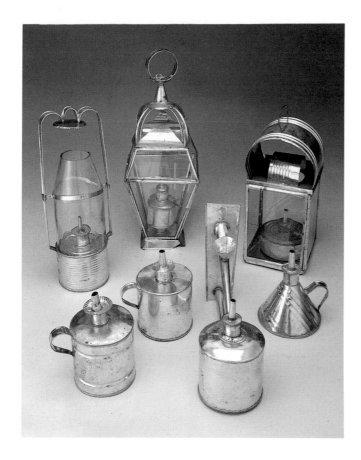

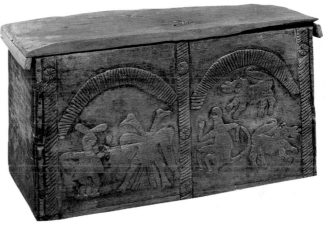

Plate 57. **Lanterns,** ARTISTS UNKNOWN, Northeast Brazil, Ecuador, c. 1989, Glass, tin, wire; tallest is 13". (Collection of the Museum of American Folk Art)

One of the most interesting and admirable characteristics of folk artists is their use of discarded materials. The ingenious tin and glass kerosene lanterns shown here, called *faroles*, *lámparas*, or *quinques*, were all made from materials which have been recycled, primarily from discarded tin cans and bottles. In many parts of rural Latin America, where electrification is absent and natural gas unavailable, kerosene is used to light the night and for cooking. The forms shown here, many reminiscent of past centuries in our own country, are traditional to Latin America and can still be purchased inexpensively in small market towns all over Central and South America. They are usually made by tinsmiths who produce a wide range of utilitarian items.

Coulter and Dixon's recent publication, *New Mexico Tinwork (1990)* is a good source for understanding the history and current status of tinwork in Latin America.

Plate 59. **Trunk,** ARTIST UNKNOWN, Nahualá, Guatemala, c. 1930, Wood. (Collection of Martha Egan, Santa Fe, New Mexico)

This trunk, called a *baúl* or *arco*, is a splendid example of woodworking still found in highland Guatemala. It is made of six hand-hewn boards, only one of which is decorated. The top has no back or front face so that the trunk can be opened by sliding the top forward or backward. The imagery carved into the front of the trunk is a mixture of European and indigenous motifs. The jaguar and monkey are animals that have been important symbols among the Maya since early pre-Columbian times and are still used in modern indigenous ritual. The two-headed eagle was introduced to the New World in the sixteenth century by the Spanish as a symbol of Hapsburg power. The arched hatching and side hatching are common decorative motifs in highland Guatemala. Household trunks such as this are used for storing special clothing and important papers.

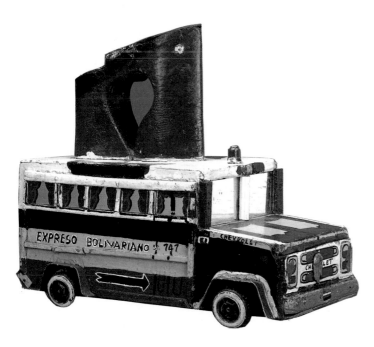

Plate 58. **Shoeshine Box,** ARTIST UNKNOWN, Bogotá, Columbia, c. 1983, Wood, paint, plastic, glass, metal; 13¹/₂" x 16". (Collection of the San Antonio Museum Association)

61

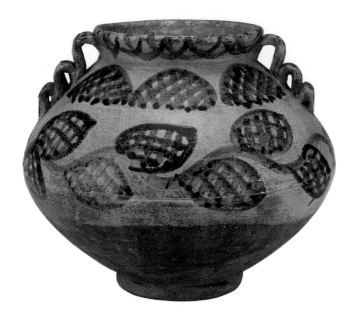

Plate 60. *Jar* (tinajera), Artist unknown, Chordeleg, Ecuador, c. 1940, Glazed earthenware; 7³/₄" x 8¹/₄" x 8¹/₄". (Collection of the Museum of American Folk Art)

Plate 61. *Water Jar* (cántaro), family of the late Doña Rosa Real de Nieto, San Bartolo Coyotepec, Oaxaca, c. 1987, Burnished earthenware; 18" x 16¹/₄" x 16". (Collection of the Museum of American Folk Art)

Coyotepec is internationally famous for its black pottery, which has been collected by museums and collectors since the early part of this century. Characteristic of Indian-type pottery all over Latin America, these ceramic pieces from Coyotepec are started on a basal mold which is spun on a movable platform. Then they are coiled. The simple graceful lines and their highly functional qualities make these pieces highly valued by inhabitants of the Valley of Oaxaca. Surface burnishing, often in geometric and floral designs, takes place prior to firing. The blackness of this pottery is achieved through a process of reduction firing, a technique in which carbon residue is bonded to clay in an airtight kiln. After being removed from the kiln, pieces are polished using animal fats or wax, and this technique also seals the carbon residue to the surface.[11]

Glazed pottery was not produced in Latin America until after the arrival of Europeans in the first part of the sixteenth century. One of the earliest examples of glazed ceramics in Latin America was based on a type of majolica produced in Talavera de la Reina, Spain. Twice-fired glazed tiles, household plates, flower pots, water jugs, wash basins, and other utilitarian objects were being made by the end of the sixteenth century in Puebla, Mexico, and, later, many of these forms were diffused throughout Latin America. Unlike the indigenous pottery of Latin America, this type of ceramics is made on a potter's wheel. Most of the forms are European-inspired as well. Today, majolica-style pottery can still be found in Mexico, Peru, Guatemala, Ecuador, and other countries in the region. Frequently, the makers of these ceramics can be identified by hallmarks on the bottoms, and frequently, these symbols can be traced to the colonial period. The Uriarte pottery in Puebla is one such case.

The handsome *tinajera* shown here is from Chordeleg, a traditional ceramic production center just outside of Cuenca, in southern Ecuador. Its shape, green glaze, and floral decorative elements are of European origin. Although still being produced today in Chordeleg, the majolica pottery from there is inferior in quality to earlier pottery and will probably die out unless steps are taken to revive the craft.

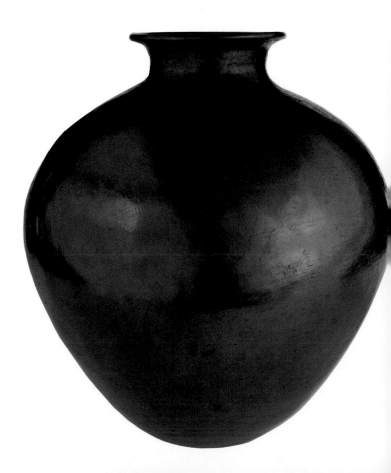

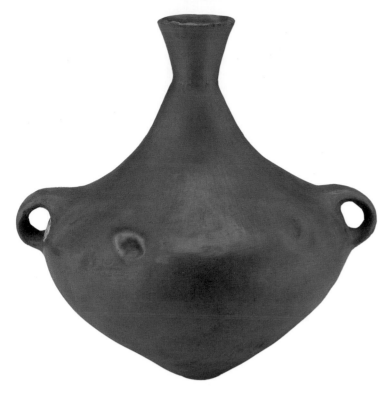

Plate 62. *Water Jar* (tinaja), Artist unknown, San Miguel Acatán, Guatemala, c. 1980, Earthenware; 18" x 18½" x 15½". (Collection of the Museum of American Folk Art)

This type of elegant *tinaja* is still made and used in the Kanjobal-speaking region of highland Guatemala. A perfect example of how form follows function, every aspect of the construction of this vessel deals with the transportation and storage of water. Acatán Indians carry water jars on their backs, and the small orifice and elongated neck prevent spiillage during uphill treks back from local water sources. The two sturdy handles are laced with tumplines for carrying and hanging above dirt floors. The porous clay allows water to cool through evaporation and the pointed bottom concentrates the runoff.

Made by using a basal mold to establish trajectory for the jar and later coiled to completion, these traditional jars are then burnished before firing.

Plate 63. *Container,* Artist unknown, Acatlán, Puebla, Mexico, c. 1987, Earthenware; 24" x 20" x 20". (Collection of the Museum of American Folk Art)

The small town of Acatlán has hundreds of potters who produce thousands of ceramic pieces each year that are used in the region or exported. They use a variety of techniques, including press-molding, coiling and slab-building. The large *barril* shown here was probably made as a container for water to be used for drinking, bathing, washing dishes, etc. [12]

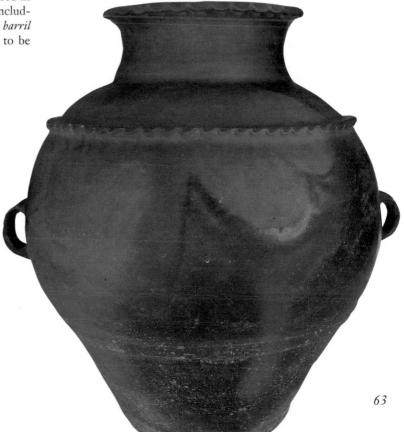

63

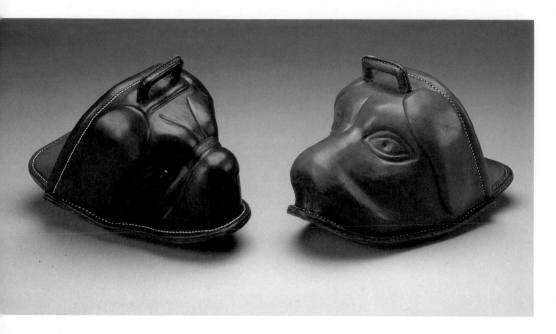

Since the introduction of the horse to the New World by the Spanish in the early sixteenth century, objects related to equestrian activities have been produced in great variation. Spurs, saddles, bridles, lariats, chaps, and other objects are still made all over Latin America. Each object is highly specialized and represents a cultural response to the immediate environment.

The dog stirrups shown here are good examples of utilitarian objects made in response to the rough environment of highland Ecuador. The first task of these stirrups was to provide support for the rider and to protect the feet from rough brush, rocks, and other animals. Typically, the artist was not content to stop with utility, and he or she went on to carve and mold these stirrups into amazing likenesses of canines. The origins of these decorative features are obscure, but they probably represent the fierce mastiffs brought by the Spanish conquistadors to frighten and attack the Indians. When worn by mounted riders, these stirrups surely must have created great fear in the minds of the embattled Indians.

These leather stirrups were made by one of Ecuador's last great saddle-smiths, Maestro Luis Obando, a gentle man in his sixties who works, with his wife, in a modest shop not far from the city of Ibarra. Formed over wooden molds, these sturdy and striking stirrups are of a style made and used about thirty years ago.

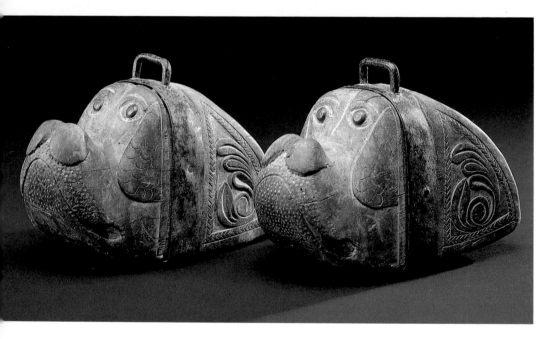

Plate 64. **Dog Stirrups,** Maestro Luis Leopoldo Obando, Esperanza, Imbabura, Ecuador, c. 1990, Leather; 7½" x 11" x 6". (Collection of the Museum of American Folk Art)

Plate 65. **Dog Stirrups,** Artist unknown, Ecuador, c. 1910, Wood, metal; 7" x 9" x 5". (Collection of Peter P. Cecere, Reston, Virginia)

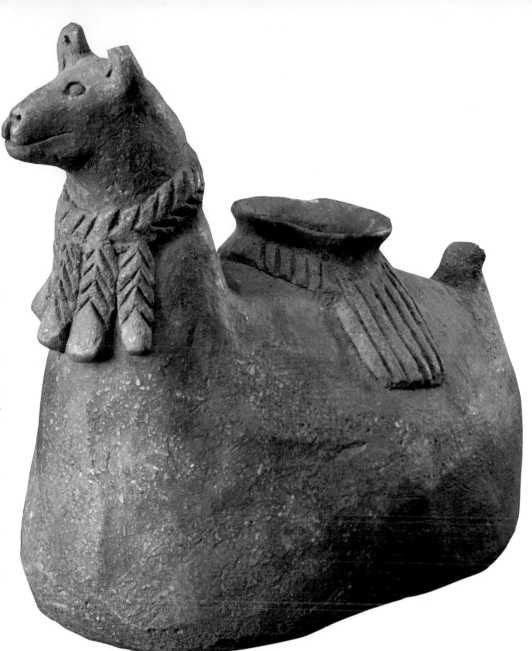

Plate 66. *Llama Drinking Vessel,*
Artist unknown, Peru, first half of the
20th century, Earthenware; 5¾" x 6¼" x
4". (Collection of the Museum of
American Folk Art)

This hand-modeled llama ves-
sel was used to drink *chicha*.
The tassels hanging from the
back and neck of the llama repre-
sent decorative elements used on
these animals during village festi-
vals. This flat-base drinking ves-
sel, known as a *canopa*, is probably
from the southern mountainous
region of Peru.

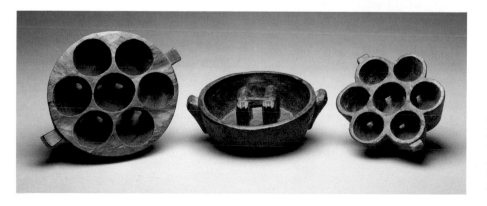

Plate 67. **Chicha Vessels,** Artists
unknown, Toropalca, Bolivia, first half of the
20th century, Wood; largest is 2½" x 10½" x
8¼". (Collection of the Museum of American
Folk Art)

In many parts of rural Latin America, the consumption of
alcohol is highly ritualized. The three vessels shown here
are of a type used in the southern part of Bolivia to drink *chicha*
(corn beer) during important ceremonial occasions. Made from
a single piece of wood, these containers are richly carved and
show signs of frequent use. Although still made and used today,
vessels of this type have their roots in pre-Columbian times
when they were known as *keros*.

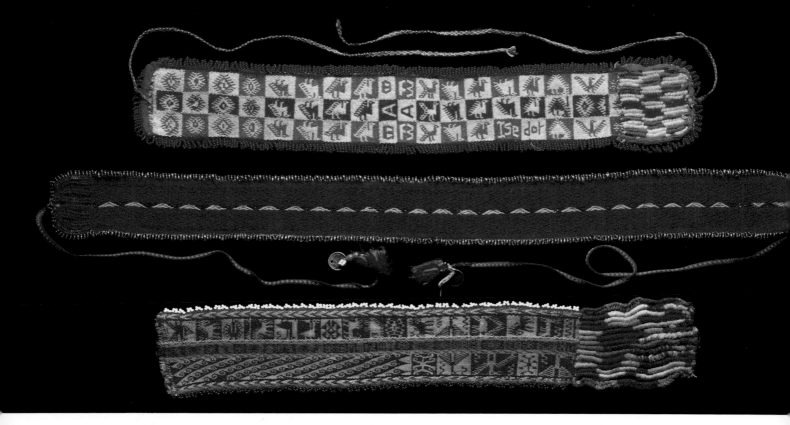

Plate 68. **Headbands (winchas),** ARTISTS UNKNOWN, Highland Bolivia, c. 1980, Alpaca fiber, synthetic dyes, glass beads; longest is 57½". (Collection of the Museum of American Folk Art)

Bolivian headbands, or *winchas*, are pre-Columbian in origin and can still be seen in a few parts of highland Bolivia where they are worn only by women. Made on horizontal ground looms, these strikingly handsome headbands illustrate the highly developed weaving skills still found in Bolivia today.

These *winchas* are excellent examples of warp-faced weaving that produces mirror designs when reversed. The glass beads are strung on the weft threads. Joseph Bastien has written about the ritual and symbolic qualities of Bolivian *winchas*. Headbands are often passed down from mother to daughter and contain animal and plant motifs that impart power to those who wear the headband. Women also hang their *winchas* around the neck of the statue of Jesus during the feast of the Ascension and feel as though their headbands absorb part of the spirit that is passed on to the wearer.[13]

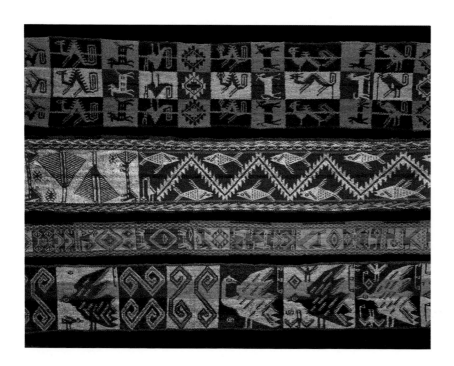

Plate 69. **Sashes,** ARTISTS UNKNOWN, Highland Bolivia, second half of the 20th century, Sheep's wool, camelid fiber, synthetic dyes; longest is 78½". (Collection of the Museum of American Folk Art)

Andean clothing is an important form of communication. Since pre-Columbian times, textiles have sent messages about the sex, marital status, social rank, and community affiliation of the wearer. *Bayeta*, or ordinary yardage, is usually made by men on a European-style treadle loom, and is used to make pants, shirts, and dresses. Most complicated weaving, such as that used in the production of sashes, headbands, ponchos, and coca bags, however, is done by women on indigenous-style looms. In most parts of Indian Bolivia, women who are highly skilled as weavers are highly desirable as wives.

The sashes (*chumpi*) shown here are from different locations and represent a variety of weaving styles. Each design motif goes beyond the obvious and is usually a metaphor for something else, such as wealth, well-being, or sacredness.

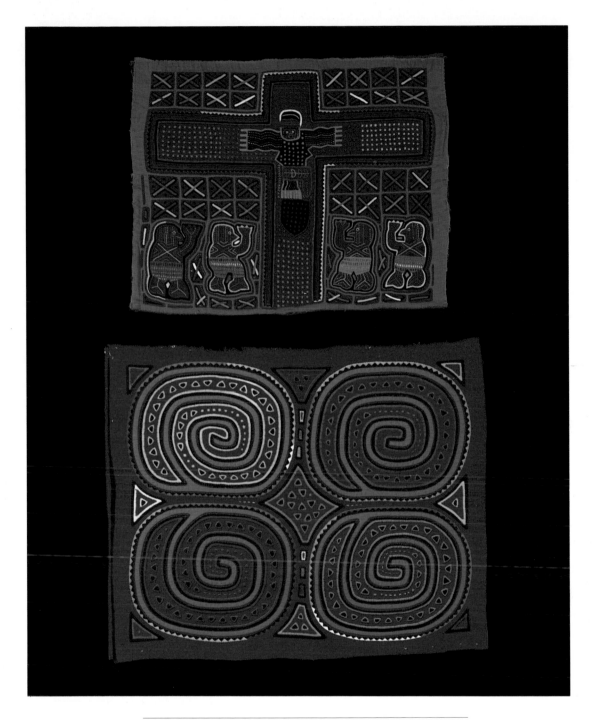

Plate 70. **Molas,** ARTISTS UNKNOWN, San Blas Islands, Panama, c. 1965, Cloth; 12½" x 16" and 16" x 19¼". (Collection of the Museum of American Folk Art)

One of the real values of mola art is what it tells us about traditional Kuna Indian society and culture. In these two molas, we see typical scenes related to Kuna illness and death. Both molas are from the front and back of the same blouse and were probably worn by a woman whose family had recently experienced the crises shown.

The illness mola shows the interior of a typical Kuna hut where a man lies sick in his hammock. He is being treated by a medicine man while his wife and child look on. The medicine man recites healing incantations and burns therapeutic hot pepper incense. The birds that hover above the hammock represent spirits. Apparently, the other mola suggests that the medicine man's treatment failed, and now we see the deceased man, wrapped in his hammock, being carried off for a wake and burial. Hanging above the body are food and the prized possessions of the deceased that will accompany him to the afterworld.[14]

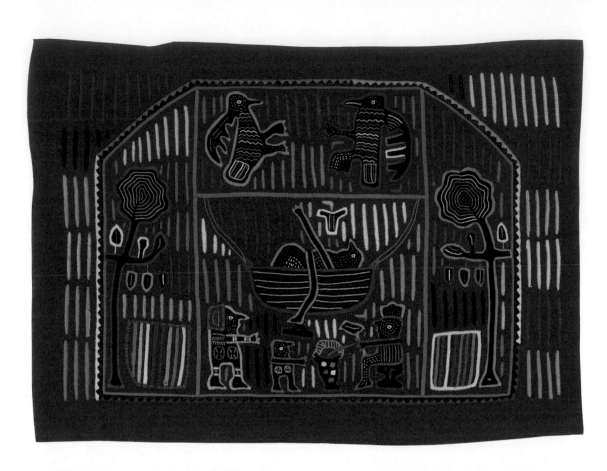

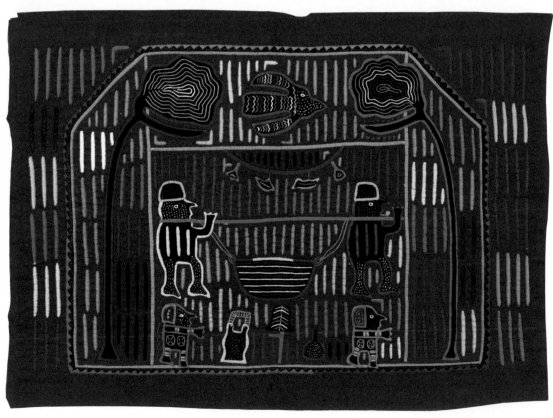

Plate 71. **Curing Scene Molas,** ARTIST UNKNOWN, San Blas Islands, Panama, c. 1965, Cloth; 14½" x 20¼". (Collection of the Museum of American Folk Art)

Plate 72. **Walking Stick**, ARTIST UNKNOWN, Highland Guatemala, c. 1950, Wood; 43" long. (Collection of the San Antonio Museum Association. Purchased with funds from Friends of Folk Art)

Plate 73. **Walking Stick**, ARTIST UNKNOWN, El Salvador, San Salvador, c. 1989, Painted wood; 34" x 2½" x 2¼". (Collection of Martha Egan, Santa Fe, New Mexico)

The two staffs at the right below, known as *orsualas*, are carried by important Kuna men in Panama. They are used in curing and other religious ceremonies, but, more frequently, they are used as symbols of authority for a particular office. Policemen, chiefs, and commissioners of shore and boats all carry canes. Those belonging to medicine men are usually entwined by a serpent.

Plate 74. **Staff of Authority**, ARTIST UNKNOWN, San Blas Islands, Panama, c. 1960, Wood, paint; 37" x 5" x 2". (Collection of Martha Egan, Santa Fe, New Mexico)

Plate 75. **Staff of Authority**, ARTIST UNKNOWN, San Blas Island, Panama, c. 1960, Wood, paint; 32" x 1½" x 1½". (Collection of the San Antonio Museum Association; purchased with funds from Friends of Folk Art)

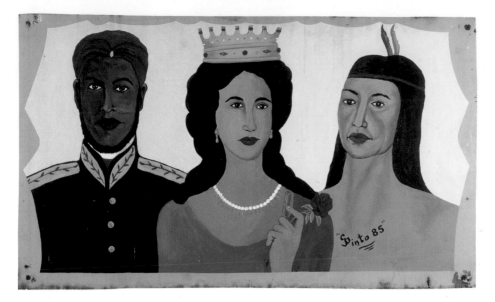

Plate 76. **The Three Potencies Shop Sign,** "El Negro," Mérida, Venezuela, c. 1985, Oil on tin; 24" x 39¼" x 1". (Collection of the Museum of American Folk Art)

One of the most popular cults in Venezuela and other parts of northern South America is that dedicated to "Las Tres Potencias." Central to this cult are three powerful spirits, El Negro Felipe, María Lionza, and El Indio Guaicaipuro. Each represents one of the races of Venezuela, and together, they symbolize that country's racial mixture, or its *mestizaje*. These spirits are thought to be in control of human destiny, and are particularly important to an individual's physical and psychological health. Household shrines, use of spiritual mediums, spirit possession, and pilgrimages to sacred places are all parts of this important folk tradition.

This sign was painted by an itinerant sign painter from the coast of Venezuela, known only as El Negro. It hung above the main entrance to a small store that sells medicinal herbs, scents, religious statuary, and other paraphernalia associated with the cult of The Three Potencies.

For an excellent explanation of this cult, see Mariano Díaz, *María Lionza: Religiosidad, Magica de Venezuela* and Angelina Pollak-Eltz's *María Lionza: Mito y Culto Venezolano.*

Plate 77. **Mortuary Sign,** Artist unknown Riobamba, Ecuador, c. 1960, Painted wood; 24" x 33¼" x 3½". (Collection of Peter P. Cecere, Reston, Virginia)

It is rare today to find an example of hand-carved wooden shop signs as excellent as this one. The quality of carving is exceptionally fine and must have attracted a large number of clients during the time this serene carving was mounted above the entrance to a funeral home in Riobamba.

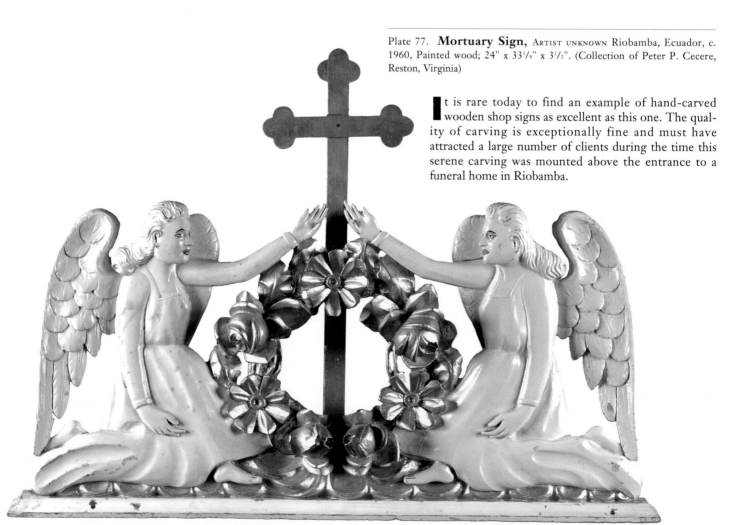

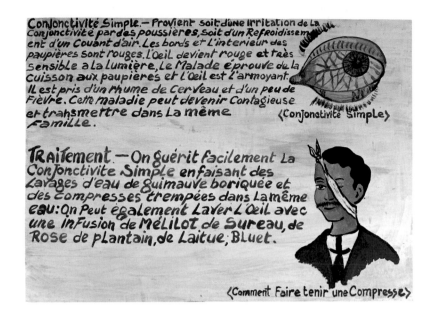

Conjonctivité Simple.—Provient soit d'une irritation de la Conjonctivité par des poussières, soit d'un Refroidissement d'un Couant d'air. Les bords et l'intérieur des paupières sont rouges. L'Oeil devient rouge et très sensible à la lumière, Le Malade éprouve de la Cuisson aux paupières et l'Oeil est l'armoyant. Il est pris d'un rhume de Cerveau et d'un peu de Fièvre. Cette maladie peut devenir Contagieuse et transmettre dans La même Famille.

⟨Conjonctivité Simple⟩

TRAITEMENT —On guérit facilement La Conjonctivite Simple en faisant des Lavages d'eau de Guimauve boriquée et des Compresses trempées dans Lamême eau: On Peut également Laver L'Oeil avec une Infusion de Mélilot de Sureau, de Rose de plantain, de Laitue, Bluet.

⟨Comment Faire tenir une Compresse⟩

Plate 78. **Medical Treatment Sign,** Workshop of Marcel Isaac, Port-au-Prince, Haiti, c. 1985, Oil on masonite; 24" x 33" ⅛". (Collection of the Museum of American Folk Art)

Most of the folk painting today in Haiti is made for galleries with an international clientele. Occasionally, however, one can still find paintings made by Haitians for Haitians. Most of these are related to commercial advertisement. Hand-painted billboards, shop signs, walls on the sides of houses and other buildings can be seen everywhere, and are often done by artists who also paint for galleries.

The medical treatment painting shown here was done by a man who works for Marcel Isaac, the founder and owner of Laboratoire Panacée, an alternative health center in the center of Port-au-Prince. This particular sign illustrates and describes, in Creole, the symptoms of conjunctivitis and the recommended method of treatment. Other paintings in the Laboratoire Panacée show, in vibrant color, the digestive system, the respiratory system, the causes and cures for dandruff, and other things related to the human condition.

Plate 79. **Meat Shop Flag,** Artist unknown Chichicastenango, Guatemala, c. 1986, Embroidered cloth; 24" x 36". (Collection of the San Antonio Museum Association)

In Guatemala, meat shops fly red flags to announce they have fresh meat for sale. In Chichicastenango, these flags are brightly painted and often depict images associated with the shop's name. The meat shop of Saint Thomas is owned and operated by the Santo Tomás Cofradia, the town's most important religious brotherhood. Its flag shows an official of that brotherhood, gaily dressed in the costume of his office.

The flag shown here illustrates the type of meat being sold. La Buena Fe is probably the name of the *cofradia* that owns and operates the meat shop.

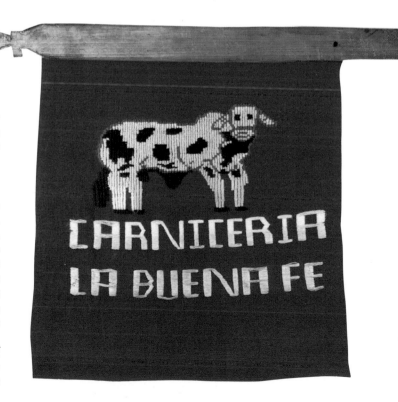

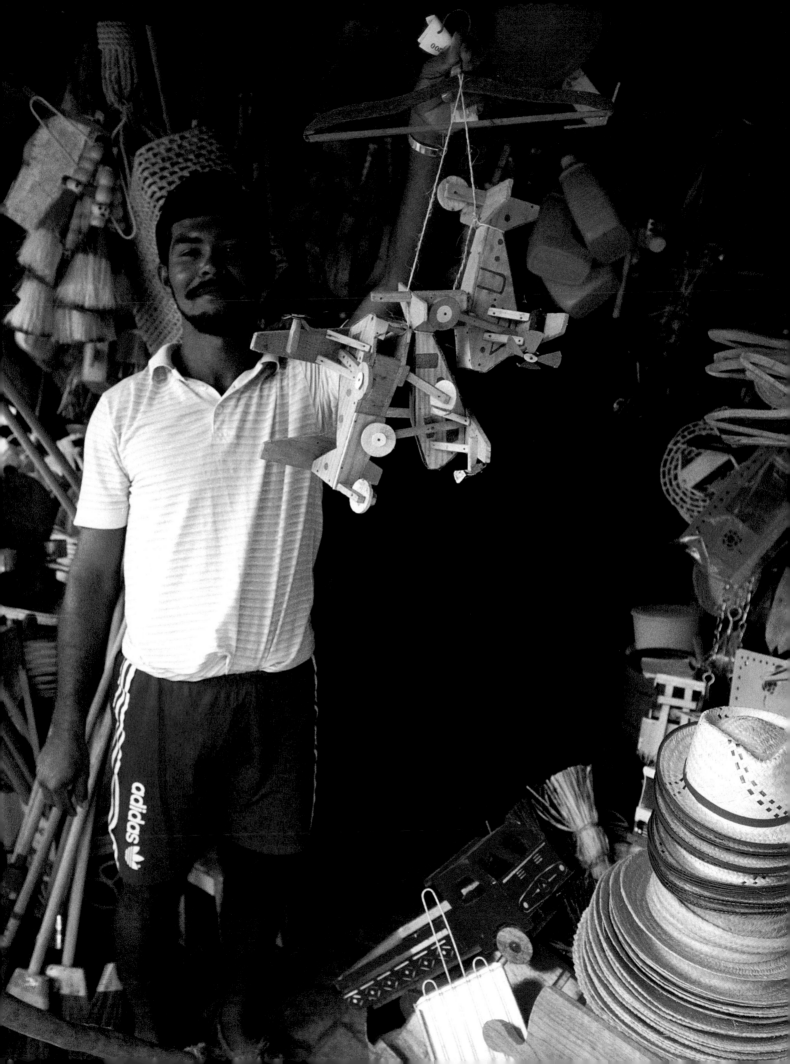

Recreational Folk Art

Usually costing no more than a few pennies, recreational folk art can still be found in every corner of Latin America—in small, regional markets, in the huts of peasant farmers, and in the congested streets of capital cities. It is made by children and adults alike, by full-time specialists and by part-time artists who carve, weave, or mold objects as tradition and the spirits move them. It is comprised of objects whose primary function is to entertain and amuse. Consisting mainly of toys, dolls, games, and miniatures, recreational folk art allows the maker and user to escape the world of the mundane and enter into the domain of dream and fantasy. Folk artists who work with this type of material seem to enjoy a freedom and spontaneity that is unique. Here, in the realm of recreational folk art, the "artists are at their best, being free to respond to the world around them both in traditional and in often delightfully spontaneous ways. A quickly whittled twig becomes a lurching iguana, a deftly pinched lump of clay changes a figure's facial expression, and a string transforms a bundle of cloth into a dancing rag doll."[15]

On the surface, these toys, dolls, and other recreational objects appear to be merely lighthearted and whimsical play things, devoid of deeper meaning. Under the surface, however, they frequently tell another, equally important, story. *Matuto*, the legendary Brazilian backwoodsman who is rendered in a host of different forms by folk artists of the northeast, is a great symbol of defiant pride for the people he represents. (*Plate 96*). The cavorting devils of Ocumicho, Mexico, are charming, but they also remind us of eternal conflicts between good and evil.

At another level, toys, especially miniatures, can be agents of socialization. All over Latin America, children are given toys with which they act out, through dreams and dramas, scenes from real life. Boys are handed miniature horses, plows, and machetes, not unlike those used by their fathers, so that they, too, might one day be able to perform the tasks that will be expected of them (*Plates 88, 89*). Likewise, little girls play with dolls, miniature furniture, and cooking implements so that they will be able to assume the roles of wife and mother one day. The dynamics of family, the difficulty of the workplace, the thrill of courtship, the violence of war, and the trauma of death are played out in surprisingly accurate detail by children using folk toys.

Toys and the diminutive worlds they create are sometimes microcosms of reality as well, and can often be seen as blueprints of Latin American society. The ceramic genre figures of Oaxaca, Mexico, and Caruaru, Brazil, and other regions frequently show peasant life as it is, emphasizing regional dress, occupations, local legends, and other folkways. The late Mestre Vitalino, Brazil's

great figural ceramist, charmingly led the world into the life of backcountry Brazil and accurately painted a portrait of his part of Latin America for thousands who have seen his figures in museums and collections around the world (*Plate 12*). Likewise, the Aguilar family of Oaxaca has recreated for Mexicans and foreigners alike special understanding of its world through miniature market scenes and local ceremonies marking life's great transitions such as weddings, baptisms, and burials. Because these objects often mirror so accurately cultural reality, these engaging pieces are valuable forms of ethnographic data.

Recreational folk art typically has a special quality of movement to it. Kinetic toys, such as those included here, are found all over Latin America and represent yet another form of folk expression. The delightful tin trucks, trains, and cars from Ecuador and Mexico, the simple wooden airplanes from Brazil that cost only a few cents, and the clever kinetic creations of Sauba, the ingenious folk artist from northeast Brazil, capture the minds and hearts of young and old alike (*Plates 83–87*). The squeeze toys by Venezuelan José Belandria are closely akin to squeeze toys from other parts of the New World, but they unmistakably bear the mark of the Belandria workshop (*Plate 80*).

Games of chance are also popular folk activities throughout Latin America and can be found mainly in

Fig. 29. *Game Operator*, c. 1990, Otovalo market, Ecuador.

Fig. 28. *Market Scene*, c. 1990, Recife, Brazil.

73

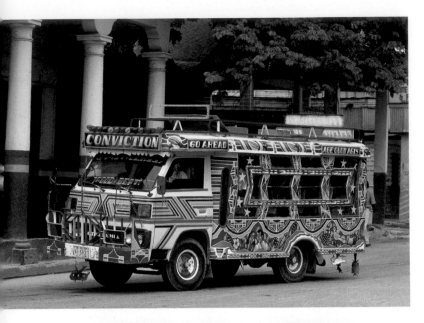

regional fairs or in weekly marketplaces (*Fig. 29*). Frequently, games are run by itinerant operators who travel from town to town, coaxing money from the conservative pockets of townspeople. In folk communities all over Central and South America, wealth is often seen as finite, and one's economic gain is only accomplished at the expense of others.[16] The concept of luck is widespread and is seen as an acceptable way of expanding one's individual wealth without taking from others in the community. In small regional markets all over the area, games of chance are perceived as good methods of increasing one's personal wealth. The hand-painted game boards from Ecuador and lottery cards from Mexico shown here are excellent manifestations of this form of recreational folk art (*Plates 90, 92*).

Finally, folk literature, in the form of chap books, was widespread in Latin America during the nineteenth century and is still found in many areas where it is a popular method of disseminating traditional folkways. In Brazil, they are called *fohetos* or *literatura de cordel*, and are used to entertain and educate ordinary folk. They pertain to popular romances, legendary catastrophes, folk medicine, provincial poetry, folk music, local history, and countless other topics. The examples included here represent a wide range of subjects by a half-dozen Brazilian folk artists (*Plate 94*).

Fig. 32. *Woman with Silver Tupos*, c. 1980, Amarete, Bolivia.

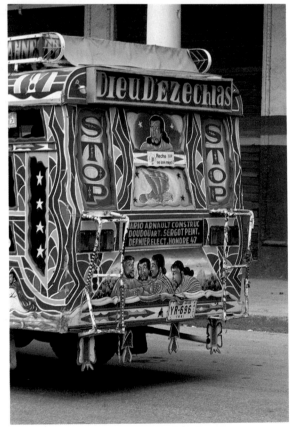

Figs. 30 and 31. *Tap-tap*, c. 1989, Port-au-Prince, Haiti.

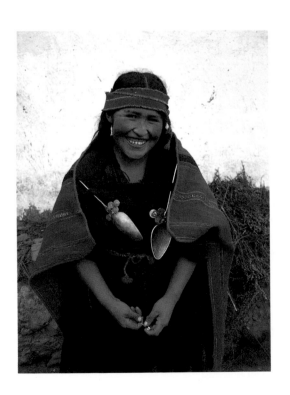

Squeeze toys such as these are found all over the world, and they have entertained children for generations. José Belandria, a wood-carver from the Andean city of Mérida, Venezuela, produces some of the finest toys in Latin America. He pays special attention to detail, especially in his rendering of facial features that are exceptionally fine and sharp. These three figures accurately represent his skills as a wood-carver and toy maker.

November 24, 1989 . . . *"I took a cab from the center of Mérida to the home of José Belandria. José's house is located in a middle-class subdivision just off Avenida de las Americas. It is untypically modern and quite comfortable. His gracious manner and inviting face put me right at ease. José's workshop is located out back, in a little covered section off the patio. His tools are primitive and the materials he uses are sparse. His work, however, is highly stylized and finely finished. One of his trademarks is his unusual rendering of hands, which are always oversized. He is also known for his attention to detail. Most of the characteristic fineness of his figures is not the result of the knife, but, rather, it is his effective use of crayons and the ballpoint pen. Great attention is always paid to the most minute details—fingernails, facial features, shoes, and jewelry. All of his religious figures, such as Santa Teresa and San Antonio, display carefully detailed features, and great attention is given to their saintly attributes. He showed me his kinetic toys, sort of jumping jacks I knew as a child, and I loved them. I bought a set of three, each one unique, each one pure Belandria."* (From the author's journal)

Plate 80. **Jumping Jacks,** José BELANDRIA, Mérida, Venezuela, c. 1989, Wood, string, crayon, ink, metal; 12½" x 3" x ½". (Collection of the Museum of American Folk Art)

Plate 81. **Slingshots,** ARTISTS UNKNOWN, Guatemala and Chiapas, Mexico, c. 1965–85, Wood, paint, metal; Tallest is 6". (Collection of the Museum of American Folk Art. Museum purchases and gifts from Gale and Bill Simmons of New York and Jonathan Williams of Austin, Texas.)

Slingshots are made in highland Guatemala and Chiapas by boys and young men for use in cornfields and to pass the time while tending animals on lonely hillsides. Immediately after seeds are planted, before they germinate and take root, *milpas* (cornfields) are vulnerable to rodents and birds. Men and boys often spend the first week after planting sleeping in their fields, armed with little more than a slingshot, to insure that birds don't carry away the tender seeds. Just prior to harvest, they return again to the same fields, this time to fight off damaging rodents.

The slingshots shown here represent a variety of styles and abilities. Most boys carve their own slingshots, copying favorite animals or birds in their immediate environments. Others will render their dreams, a shapely female nude, a brave soldier, or a figure from local folklore. All have an individual charm about them and show the continuing strength of Mesoamerican wood carving.

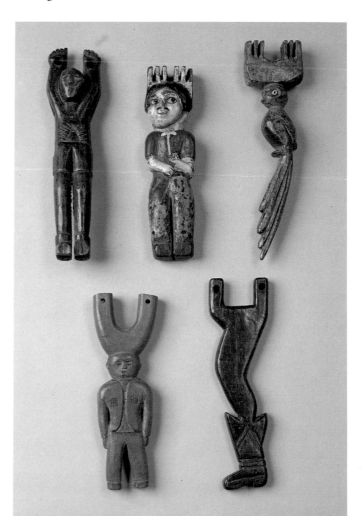

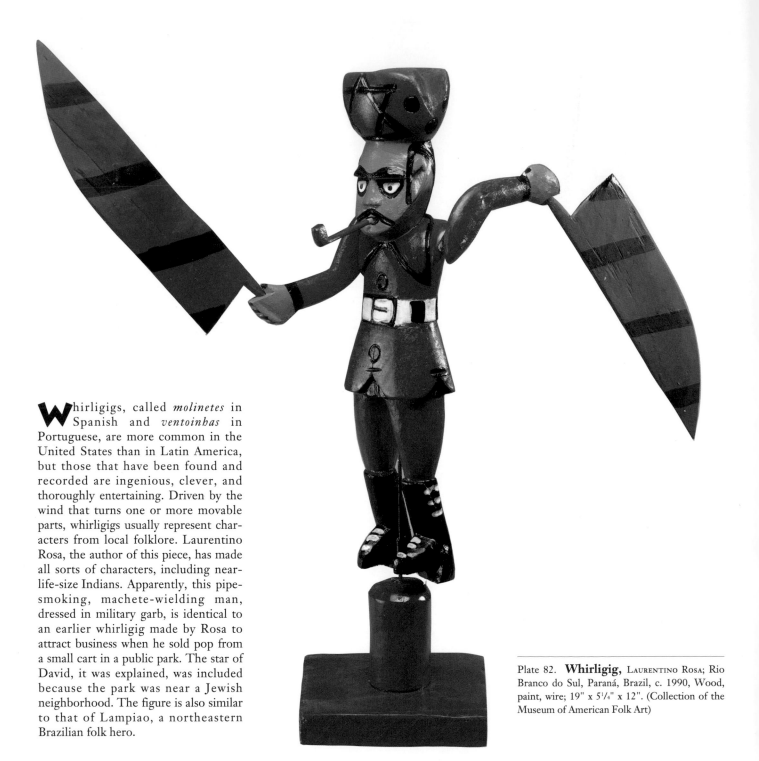

Whirligigs, called *molinetes* in Spanish and *ventoinhas* in Portuguese, are more common in the United States than in Latin America, but those that have been found and recorded are ingenious, clever, and thoroughly entertaining. Driven by the wind that turns one or more movable parts, whirligigs usually represent characters from local folklore. Laurentino Rosa, the author of this piece, has made all sorts of characters, including near-life-size Indians. Apparently, this pipe-smoking, machete-wielding man, dressed in military garb, is identical to an earlier whirligig made by Rosa to attract business when he sold pop from a small cart in a public park. The star of David, it was explained, was included because the park was near a Jewish neighborhood. The figure is also similar to that of Lampiao, a northeastern Brazilian folk hero.

Plate 82. **Whirligig,** Laurentino Rosa; Rio Branco do Sul, Paraná, Brazil, c. 1990, Wood, paint, wire; 19" x 5¼" x 12". (Collection of the Museum of American Folk Art)

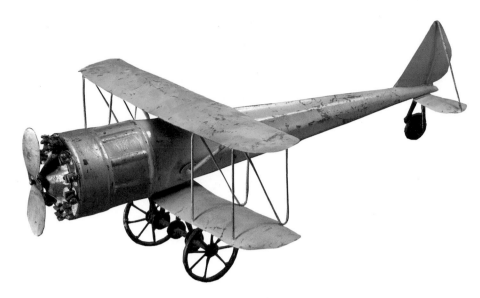

Plate 83. **Biplane,** Artist unknown, Mexico, c. 1965, Metal; 8½" x 23". (The Joe Nicholson Mexican Folk Art Collection of the San Antonio Museum Association)

This toy, like many other objects in this exhibition, is made from recycled materials. Nuts, bolts, and other items, originally made for another purpose, have been salvaged and incorporated into this charming biplane.

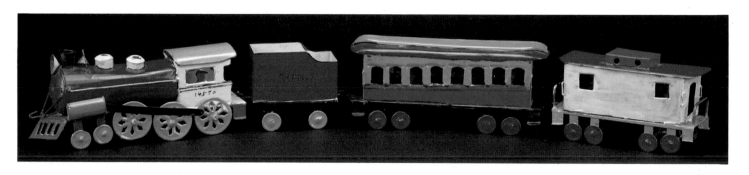

These superbly crafted tin toys made by Alfonzo Suárez are among the best still found in Latin America. His skills as a tin cutter and solderer are clearly advanced. Suárez, who was an elderly man when these things were made, also produced a charming assortment of miniature furniture and cooking utensils. Characteristic of most tin toy makers in Latin America, Suárez used recycled materials in his work.

Plate 84. **Train,** Alfonzo Suárez, Guanajuato, Mexico, c. 1980, Painted tin, 2¾" x 23". (Collection of the San Antonio Museum Association; Gift of Dr. and Mrs. Virgilio Fernández in honor of Robert K. Winn)

Plate 85. **Racing Car,** Alfonzo Suárez, Guanajuato, Mexico, c. 1980, Painted tin; 3" x 11". (Collection of the San Antonio Museum Association; Gift of Dr. and Mrs. Virgilio Fernández in honor of Robert K. Winn)

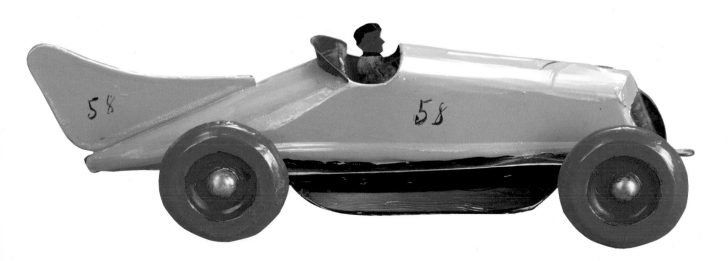

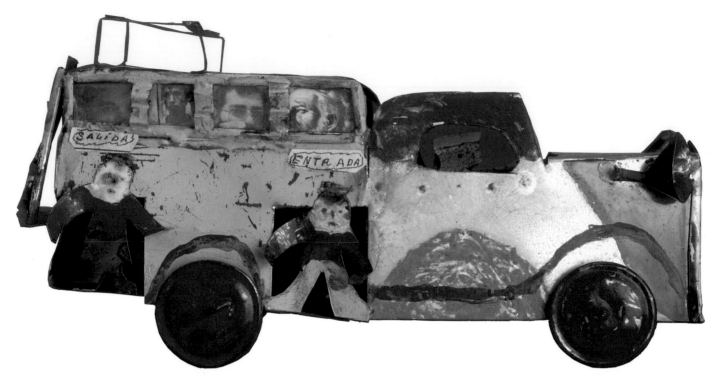

This extraordinary bus was made several years ago by the late Maestro Bustos, a tinsmith from Cuenca. Bustos worked into his eighties, but was still able to create clever, often with fantasy elements, toys that delighted children and adults in southern Ecuador. Using recycled materials, Bustos made toy trucks, boats, cars, buses, merry-go-rounds, and other things found in Ecuador's environment. This crudely crafted bus has a charm rarely found in manufactured toys. Bustos has complemented his tinwork with small portraits cut from magazines. Passengers entering and leaving the bus add a special dimension that mirrors that found on the streets of Cuenca.

Plate 86. **Bus,** Maestro Bustos, Cuenca, Ecuador, c. 1985, Painted tin, magazine photographs; 4³/₄" x 10¹/₄" x 2¹/₂". (Collection of the Museum of American Folk Art)

Plate 87. **Dumptrucks and Boat,** Maestro Bustos; Cuenca, Ecuador, c. 1985, Painted tin, wire; 4" x 6" x 2" (boat) and 2¹/₄" x 5" x 1¹/₂" (trucks). (Collection of the Museum of American Folk Art)

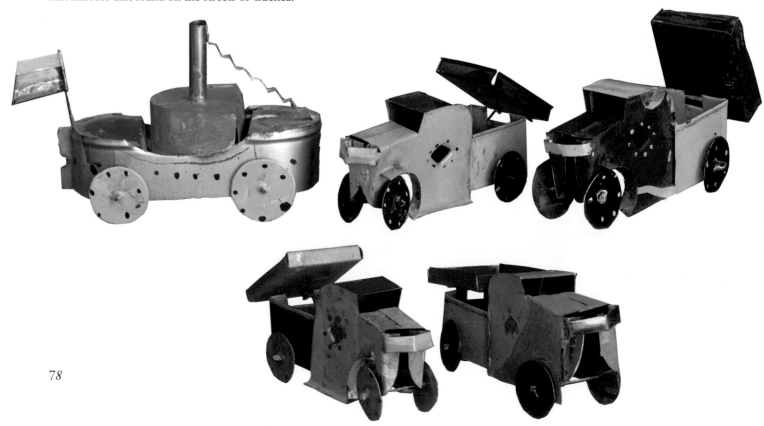

78

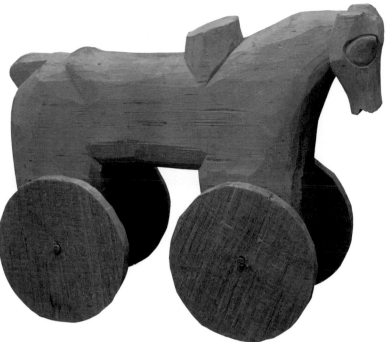

Plate 88. **Horse with Wheels,** Artist unknown, Guatemala, c. 1979, Wood; 5¾" x 7½" x 2½". (Girard Foundation Collection in the Museum of International Folk Art, a unit of the Museum of New Mexico)

Despite the barrage of acculturating influences from the United States and elsewhere, Guatemala continues to be very Indian with a strong folk culture. Wood carving is well-developed, and many of the toys used by children are still hand-carved by their parents or others, much in the same way as generations before them had done. This toy is typical of the wheeled objects still made in the Guatemalan highlands and are sold in a variety of sizes. Usually unpainted and simply carved, these toys still capture the imaginations of children all over the country.

Plate 89. **Horse with Wheels,** Artist unknown; El Salvador, c. 1980, Painted wood; 10" x 9½" x 3½". (Girard Foundation Collection in the Museum of International Folk Art, a unit of the Museum of New Mexico)

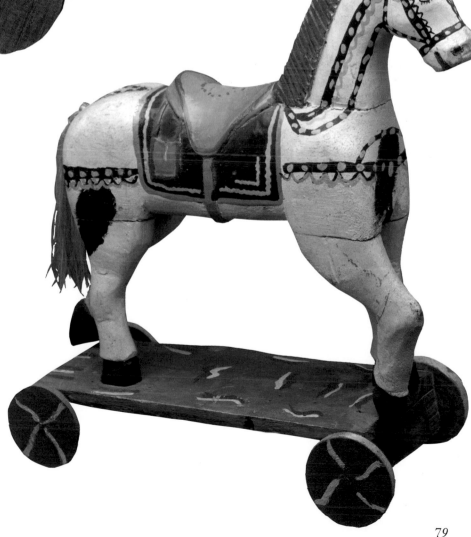

Plate 90. **Lottery Card,** Artist unknown, Mexico, c. 1920, Watercolor on paper; 8¼" x 9". (Collection of the San Antonio Museum Association. Purchased with funds from Friends of Folk Art)

Bingo, called *lotería*, is played all over Latin America and can be seen most frequently on feast days and during regional fairs. Frequently, games are owned and operated by itinerant game masters who travel from town to town in accordance with the festival calendar. In the past, lottery cards were hand-painted on tin, wood, or paper, as in this rare example. Today, however, most are machine made in great quantities. Lotería seems to have been introduced into the Americas from Europe, and we have evidence of the game being played in Mexico and Guatemala during the eighteenth century.

The game is played by renting a board and waiting until five of your images are called aloud before those of other players. They must form straight or diagonal lines or be located at the four corners and the center of the board. When features are called out, frequently they are part of a rhymed passage. The mermaid is a good example:

"La Sirena"
La sirena en la mar cantaba
luciendo su coton pinto;
Yo a niguno le hago mal
ni tampoco me les hinco,
traigo versos "pa" cantar
docientos sententa y cinco.

"The Mermaid"
The siren singing in the sea,
Sporting her best frock;
I do evil to no one,
Nor do I bend the knee,
I carry verses to sing
Two hundred and seventy-five[17]

Plate 91. **Noisemaker,** Artist unknown, La Paz, Bolivia, c. 1980, Wood, paint, rubber; 5½" x 10¼" x 18½". (Collection of the Museum of American Folk Art)

Noisemakers, *matracas*, are made and used in almost every corner of Latin America. The most important occasion for their use is on Sábado de Gloria (Glorious Saturday) when masses are announced by noisemakers since church bells are silent through Holy Week until Easter Sunday. Noisemakers are also used during other secular and religious festivals, and are most popular during the pre-Lenten celebrations of carnival.

In highland Bolivia, noisemakers take many forms, each holding special meaning for the occasion. Some are used in dance dramas, and they are made to represent the form or sound of the character in the drama. Others might represent the occupations of members of trade unions. For example, during parades in La Paz, the Union of Petroleum Truckers carries noisemakers in the form of oil trucks. Others might carry noisemakers showing their favorite soccer team or the symbol of the academic faculty to which they belong. The noisemaker shown here is cleverly constructed and handsomely crafted in the form of a fish. Its exact use is not known, but it probably was carried by fishermen during a national parade, perhaps for May Day celebrations.

Plates 92 and 93. **Game board and Dice,** Artist unknown, Ecuador, c. 1960, Oil on wood; 39" x 26½" x ½". (Collection of Peter P. Cecere, Reston, Virginia)

Games of chance are found in weekly markets and regional fairs all over Latin America. They come in hundreds of different forms, ranging from shell games to canaries who are coaxed from their cages so they can peck out people's fortunes with their beaks. They are run by "Sunday gamblers" who operate games as a means of augmenting a meager income, or by full-time specialists who travel from town to town conquering audiences with their glib tongues and agile hands. Wherever they are found, large crowds surround them.

The gaily painted game board shown here was played with dice whose surfaces are painted with the same symbols on the board. The player places money on the feature he or she hopes will turn up with the roll of the dice. Quite naturally, game board owners become very attached to boards that have been lucky to them.

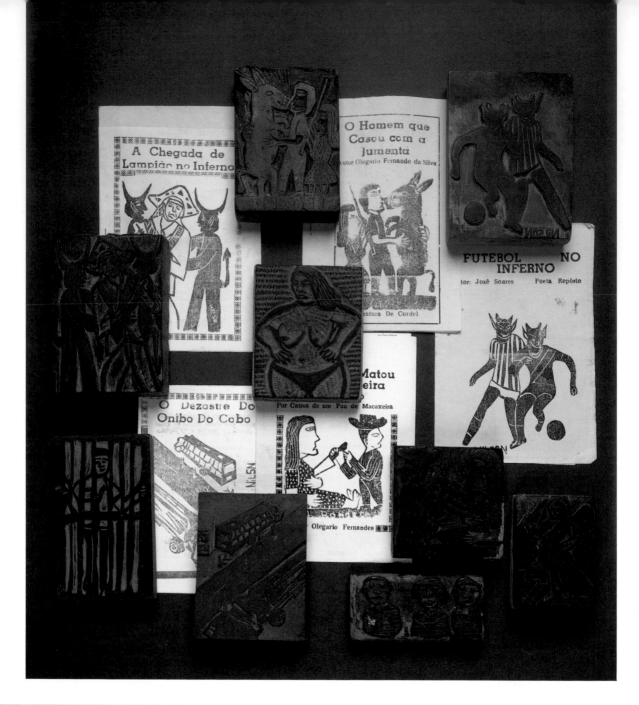

Plate 94. Chap Books and Print Blocks, Various Artists, Northeastern Brazil, c. 1980–85, Blocks: rubber, wood, ink; books: paper and ink; Approx. 4" x 3". (Collection of the Museum of American Folk Art)

Chap books, pamphlet stories in verse, are still found in many parts of Latin America today. Popular in Europe and England during the eighteenth and nineteenth centuries, this form of literature seems to have been introduced to Latin America in the last century. In Mexico, the great graphic artist of the late nineteenth century, José Guadalupe Posada, produced hundreds of chap books that were sold all over Mexico, mainly to the lower classes. In Brazil, where they continue to be used as major vehicles for Brazilian folkways, these pamphlets are sold by the thousands each week. There they are called *folhetos* or *literatura de cordel,* after the manner in which they are displayed by vendors—hanging over a string.

Brazilian chap books deal with popular poetry, accounts of local catastrophes, popular legends, famous crimes, and infamous love affairs. *The Man who Married a Donkey, The Son Who Murdered His Parents in Order to Get His Hands on Their Retirement Benefits, The Football Game in Hell,* and *The Overturned Bus Disaster* are examples of some of the alluring titles found in a typical marketplace. The front of these pamphlets usually contain wood-block illustrations of the book's contents, and they, in themselves, form a special type of folk expression. Sometimes the author of the story is also the artist of the illustration, but usually this is not the case. Frequently, chapbook vendors sing the songs in their books or read aloud the contents of their books to market crowds, many of whom are illiterate, and their voices usually draw enormous gatherings.

Candace Slater's excellent book, *Stories on a String,* is the best treatment in print on this fascinating subject.

Plate 95. Exodus of a Family from the Sertâo, José Francisco Borges; Bezerros, Pernambuco, Brazil, c. 1990, Wood block print. (Collection of the Museum of American Folk Art)

Plate 96. The Honeymoon of Matuto, José Francisco Borges; Bezerros, Pernambuco, Brazil, c. 1990, Wood block print. (Collection of the Museum of American Folk Art)

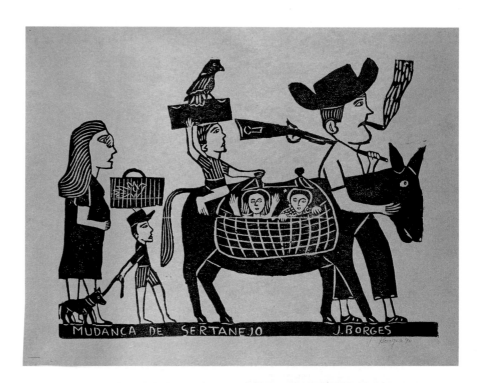

The success and popularity of José Borges have permitted him to expand his talents. Today, he not only continues to write poetry and make engaging prints for chap books, but he also prints many of these images in a format that is sold to galleries and museums in Brazil and abroad. These two wood-block prints are good examples of the amplification of his talents. The format is new, the content is very traditional.

In *The Honeymoon of Matuto*, we see Matuto, a defiant character who is an archtypical country bumpkin, passionately embracing his new bride beneath a canopy of leaves and stars. Matuto's horse cleverly conceals the necessary parts of the couple's anatomy and their clothes, instead of being scattered hither and yon, are neatly dangling from the tree limbs as if on hangers. The whole scene is ludicrously charming, and is part of the widespread legend of Matuto.

Exodus of a Family from the Sertâo is a touching illustration of the harsh life in the backlands of northeastern Brazil. Hot and dry, this region has experienced several devastating droughts in the past several decades, forcing hundreds of thousands of ranchers to abandon their native lands in favor of overpopulated cities nearer the coast. Borges's print poignantly illustrates the tragedy of a family forced to leave the lands they love so deeply.

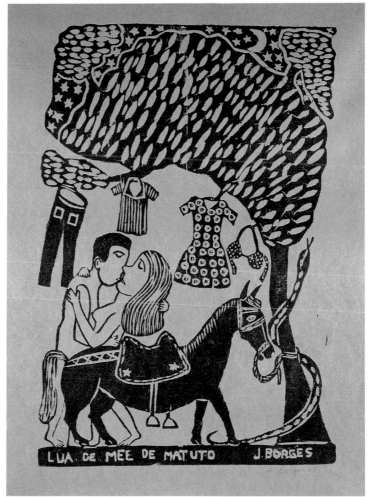

Decorative Folk Art

The smallest category of folk art in this exhibition is decorative. However, decorative folk art, like all art, is never completely devoid of secondary meanings that lurk just below the surface. The colorfully painted scenes on the sides of buses *(Tap-taps)* of Port-au-Prince, Haiti, have strong decorative qualities but, when examined more deeply, we see that these paintings often represent important aspects of Haitian social and religious life *(Figs. 30, 31)*. Although a strong chronicler of local tastes and preferences, the primary function of decorative folk art is to adorn the home or some other place. By contrast to other categories of folk art, the forms of these objects do not necessarily follow their functions. In this respect, they resemble much of "fine art" except that these objects are grounded in and bound by the traditions of the artisans' culture.

The delicate *Pair of Portrait Jars* from Tzintzuntzan, Mexico, are primarily decorative and, because of their fragility, were never intended to be used in a utilitarian fashion *(Plate 98)*. The silver *Animal Brooches* from Bolivia are primarily ornamental but may have some symbolic meaning similar to those found in design motifs of Andean textiles *(Plate 99)*.

Decorative folk art is usually made for use locally, but often, it is designed for sale outside of the community of origin. The *Woman in Yellow Dress with Boy* by José Belandria *(Plate 103)* and *Veterinary Scene* by Luis Antonio da Silva *(Plate 101)* are good examples. Both are traditional folk forms for their respective communities, but both were made to sell to nonparticipants of the local culture.

Some decorative objects are made as *recuerdos* (souvenirs), objects that provide proof of a visit or that call up an important event. José Rodriguez da Silva's *Carnival Figures* recall typical scenes from Brazilian carnival and remind the owner of that event each time he or she looks at this colorful horse, rider, and bull *(Plate 104)*.

Plate 98. **Pair of Portrait Jars,** Artist unknown, Tzintzuntzan, Michoacan, Mexico, c. 1960, Slipped and glazed earthenware; 6½" x 8" x 7¼". (Collection of the Museum of American Folk Art)

The production of portrait jars, cups, and pitchers is a widespread tradition going back to pre-Columbian times. As decorative objects, portrait jars can be traced back to the nineteenth century when they were sold at regional fairs and pilgrimage centers. Portrait jars of special individuals were produced as presentation pieces. In Mexico and the Andean countries, portrait pitchers used for serving ritual alcoholic beverages show faces of Indians, national founding fathers and mothers, or monkeys.

The rare pair of portrait jars shown here is from Tzintzuntzan, Mexico, a Tarascan Indian community located near the shores of Lake Pátzcuaro. Pottery from Tzintzuntzan is admired all over the world for its traditional shapes and engaging decorative elements. These earthenware vessels are decorated with a white slip covered by a tannish transparent glaze and embellished with brown-black designs. The high-relief faces, one male and the other female, are very unusual, suggesting that these jars were made for a special reason, perhaps to commemorate a wedding or some other rite of passage.

Plate 97. **Bust of Man with Hat,** Artist unknown, Guatemala, first half of the 20th century, Painted wood; 11½" x 5½" x 6½". (International Folk Art Foundation Collections in the Museum of International Folk Art, Santa Fe, New Mexico)

Plate 99. **Animal Brooches,** Artists unknown, Highland Bolivia, c. 1950, Low-grade silver; 2³/₄" x 3³/₄" x ¹/₄" (Average). (Collection of the Museum of American Folk Art)

Decorative metalwork is still very popular in highland Bolivia and Peru today. Necklaces, earrings, large stick-pins, called *tupus,* and brooches are proud possessions of peasant women all over the Andes.

These five decorative brooches were used on dresses and shawls by highland Bolivian women. Made of hand-cut, low-grade silver, with incised details, these animals probably have their origins in colonial Bolivia where they were symbols of wealth and well-being. The interesting style of these brooches and the unresolved problems of perspective, especially for the two bulls on the bottom, make these objects appealing forms of folk expression.

August 18, 1990 . . . *"We arrived at Alfonso's apartment building, located near the center of Mexico City, around seven o'clock in the evening. It was a massive, elegant building erected during the 1890s and bore the marks of strong European influence typical of the Porifiriato period. The ancient French-built lift was dilapidated and out of order, so we had to huff and puff up five flights of stairs to get to Alfonso's apartment. He greeted us with a smile and invited us inside where we found a series of high-ceilinged rooms, completely filled with folk art and Alfonso's contemporary paintings. The folk art was fabulous—rare nineteenth-century ceramics, extraordinary dance masks from all over Mexico, small religious paintings, and wax genre figures from the 1920s. I was totally taken in by his collection—one of the best I have ever seen. In one corner, on the floor, were two jars, unusual examples of white-ware from the Tarascan community of Tzintzuntzan, Michoacan. One had a portrait of a bearded man, the other of a woman with a beauty spot on her right cheek. Both were executed in low-relief and were unlike anything I had ever encountered before. Alfonso said they were for sale, we agreed on a price, and I bought them for the exhibition. I'm delighted!"* (From the author's journal; see *Plate 98)*

Plate 100. **Cup,** Artist unknown, Argentina, first half of the 20th century, Horn; 4" x 3³/₄" x 2³/₄". (International Folk Art Foundation Collection in the Museum of International Folk Art, Santa Fe, New Mexico)

One of the ingenious qualities of folk art is the artist's ability to exploit his or her immediate environment for ordinary things that can be transformed into expressive forms. Fishermen work with shells and driftwood, shepherds use wool and other animal parts to shape their imaginations, and city dwellers use discarded objects from a throw-away society. Cowboys, called vaqueros or gauchos in Latin America, have a long history of carving and weaving the by-products of their trade into interesting and useful folk art. Horsehair lariats, bridles and reins, hand-carved cooking utensils of bone and wood, and whistles and drinking vessels fashioned from cow horn are typical cowboy folk forms. The horn cup shown here is typical of the fine work still done by people whose roots are steeped in gaucho culture. Although clearly a utilitarian object, this cup was probably made for purely decorative reasons.

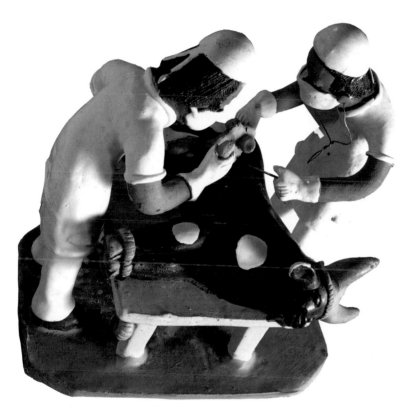

Plate 101. **Veterinary Scene,** Luis Antonio da Silva; Caruaru, Pernambuco, Brazil, c. 1987, Painted earthenware; 8" x 7" 4³/₄". (Collection of the Museum of American Folk Art)

Ceramic genre figures showing typical dress, occupations, and physical types are made in Tlaquepaque (Mexico), Mérida (Venezuela), Huancayo (Peru), Caruaru (Brazil), and dozens of other communities in Latin America. Genre figures became very popular during the early part of the nineteenth century when they were taken back to Europe and shown to a public eager to learn about newly independent Latin America. The wax figures of that time were strikingly lifelike, and served as models for later ceramic pieces. Today, many of these figures are used in the construction of nativity scenes at Christmas, a tradition that dates back to the earliest part of the colonial era. Others are sold to tourists who take them back home as cherished mementos of a place or event.

Ceramic genre figures are very popular in northeast Brazil today, and an entire section of the city of Caruaru is dedicated to their production. Hundreds of people are involved, many who are direct descendants of Mestre Vitalino, this century's most important figural ceramist. The calf delivery scene shown here was probably modeled after an early piece by Vitalino and is a popular decorative item in northeast Brazil where many of the families are involved in cattle ranching.

Plate 102. **Ark,** CANDELARIO MEDRANO; Santa Cruz de las Huertas, Jalisco, Mexico, c. 1975, Painted earthenware; 27½" x 18". (Collection of the San Antonio Museum Association)

Candelario Medrano, who died in 1988, was one of Mexico's most creative figural ceramists. A protégé of the late Julio Acero, Jalisco's leading ceramic toy artist, Medrano began by producing toy whistles, mermaids, roosters, and other animals. Later, he placed them on airplanes, boats, towers, merry-go-rounds, and trucks, thereby creating delightful and colorful scenes of fantasy. Pieces such as this were made for sale outside of Medrano's community, most likely to foreign collectors or museums. Although recreational in appearance, Medrano's objects are too fragile for play and were probably used more as decorative pieces.

Plate 103. **Woman in Yellow Dress with Boy,** José Belandria; Mérida, Venezuela, c. 1989, Crayon and ink on wood; 12³/₄" x 3³/₄" x 2¹/₂" (Woman). (Collection of the Museum of American Folk Art)

The elegant and charming wood carvings by José Belandria have become popular for collectors and museums alike in Venezuela. Working in a tiny shed connected to his house in a suburb of Mérida, every day Belandria brings to life a small group of historical and religious characters for which he is famous. Santa Teresa de Avila, Simón Bolívar, San Antonio de Padua, and a host of other figures popular in Venezuelan folk culture are carved and decorated by Belandria in a manner unlike that of any of his colleagues in Mérida. Belandria's trademarks are elegance of form, articulating arms and legs, greatly oversized hands, and finely rendered facial features. Also setting him apart from other folk carvers in the area is his use of crayon, which he manages very effectively. Lucky for all who appreciate excellent and culturally significant folk art, Belandria's son, Roberto, is following in his father's footsteps.

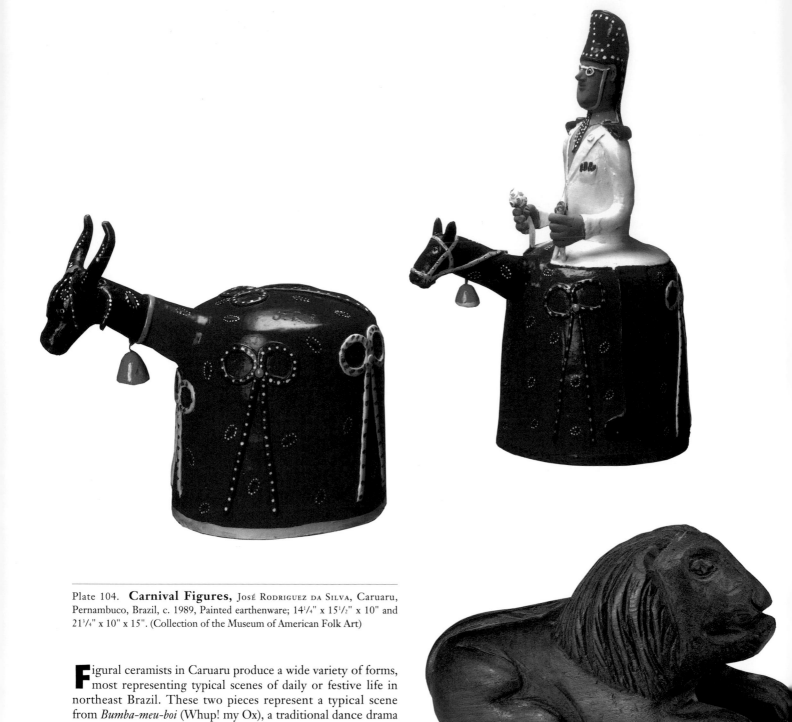

Plate 104. **Carnival Figures,** José Rodriguez da Silva, Caruaru, Pernambuco, Brazil, c. 1989, Painted earthenware; 14¼" x 15½" x 10" and 21¾" x 10" x 15". (Collection of the Museum of American Folk Art)

Plate 105. **Lion,** Artist unknown; Uruguay, c. 1960, Wood; 4¼" x 7½" x 2½". (Collection of Peter P. Cecere, Reston, Virginia)

Figural ceramists in Caruaru produce a wide variety of forms, most representing typical scenes of daily or festive life in northeast Brazil. These two pieces represent a typical scene from *Bumba-meu-boi* (Whup! my Ox), a traditional dance drama performed during the pre-Lenten celebrations in northeast Brazil. The drama itself is very complex and may involve as many as sixty characters, but usually only five or six. The scene represented here is that of the *capitâo*, or ranch owner, his horse, *cavalo-marinho*, and the boi, or bull. Basically, the plot revolves around the misfortunes of a bull, greatly prized by a rancher, who is stolen and eventually killed after a long series of comic episodes.[18]

Painted clay figures such as these are made in all sizes, from a few inches in height to near life-size. Da Silva's pair is especially well-made. Note the special attention he has given to the captain's elegant uniform.

Plate 106. **Genre Figures,** EULOGIO ALONSO; Puebla, Mexico, c. 1938, Painted earthenware; approx. 50 inches tall. (Collection of Jim Caswell, Santa Monica, California)

Eulogio Alonso was born around the turn of the century in the craft-oriented town of Amozoc, Puebla, of Indian parents. Around the age of seventeen, he moved to Barrio de la Luz, Puebla, and began working for the *alfarería* (pottery workshop) of Manuel Martínez. There he made typical Poblano pieces—pozole bowls, pulque pitchers, and cooking pots. In 1922, he opened his own pottery where he continued to produce typical items as well as an occasional figural object such as the two shown here. Eulogio Alonso died in 1969, and his pottery was taken over by his son, Gerónimo Alonso.[19]

These unusually large portraits of heroes of the Mexican Revolution of 1910–1919 (Emiliano Zapata and Venustiano Carranza) are typical of a type of nationalistic figural ceramics found throughout Latin America. Heroes of independence wars with Spain, favorite presidents and dictators, folk heroes, and prominent figures of popular culture are frequently made and sold to local citizens who place them in their homes as decorative items.

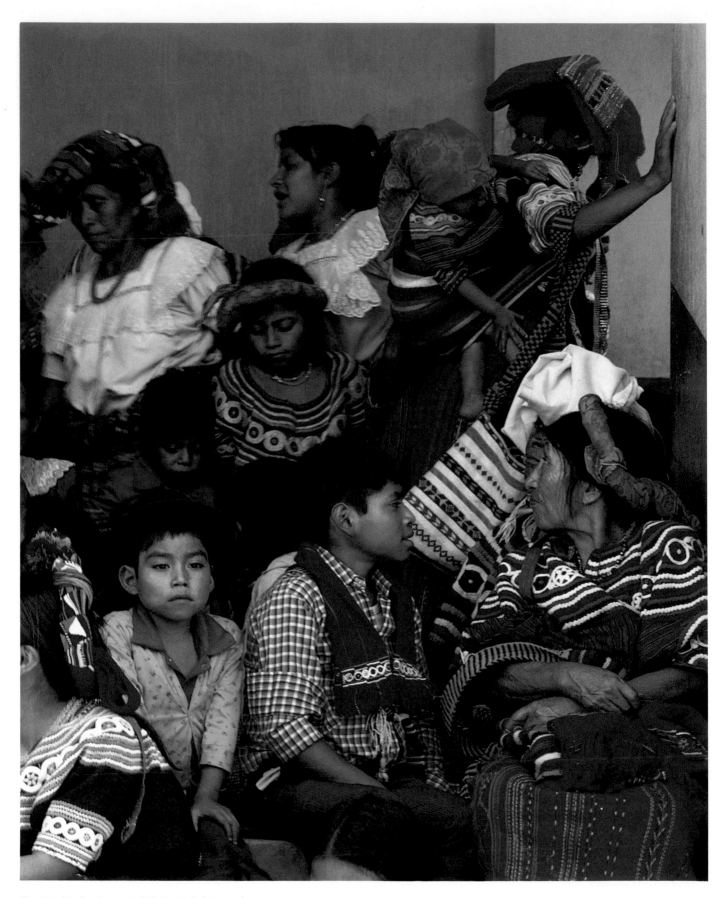

Fig. 33. *Market Scene*, c. 1988, Joyabaj, Guatemala.

CHANGE AND CONTINUITY

*"Folk art dies and
is born every day."*[1]

In this century, all over Latin America, virtually every aspect of society has undergone major change, and in recent decades, change has accelerated tremendously. Failure to meet the needs of rural societies in favor of large industrialized urban areas has taken its toll, resulting in a dramatic flight from countryside to city at alarming and catastrophic rates. Mexico City, for example, has grown from a manageable population of just under one-half million inhabitants in 1910 to over fifteen million at present! While some of this increase is due to natural growth, the great majority is the result of immigration by peasants seeking cash-paying jobs and the possibility of a better life for themselves and their families. Similar rural-urban scenarios can be found in Peru, Bolivia, Brazil, and most other countries in Latin America. This phenomenon, of course, has dramatically depleted villages of many of their bright and talented young people who would have become folk artists in earlier generations. This is not intended to imply that folk artists live only in rural areas —they do not. But, many of the traditions that give rise to rural folkways are destroyed when practitioners move to the city with its overwhelming appetite for mass-produced products.

Going in the other direction, the ever-widening network of roads and telecommunications and increasingly aggressive national education systems have brought previously isolated communities and their unique folk arts into national "folds." Religious icons, once made locally with strong regional accents, are now mass-produced and trucked into rural areas from Mexico City, Lima, Rio de Janeiro, and other large cities. Regional markets, which in the past displayed dozens of types of locally hand-crafted

pottery, perfected over hundreds of years, now offer garish standardized machine-made bowls and pots.[2]

In spite of the constant assault on traditional folkways by forces favoring their incorporation into standardized national forms not in tune with the needs of the community itself, traditional folk expression continues, changes, and becomes relevant again *(Plates 107–110)*. The aggressive presence of Latin American television evangelists, for example, has not stopped people from visiting important, time-tested pilgrimage centers, often taking traditional offerings with them as they go. Home altars, once constructed entirely of handmade objects from materials found in nature, now proudly display mass-produced plaster saints framed by plastic flowers. But materials do not a bona fide folk object make—traditional motivations do.

As we mentioned earlier, folk art is a cultural response to demands made in the social, spiritual, or physical environments. It is a way of coping with and adapting to situations at hand. Once Oaxacan wood-carvers made images to appease saints and thereby cope with the spiritual environment. Now, members of those same families are more likely to make them for export so they can cope with runaway inflation and a weakened national economy. And so, new folk art and new uses of folk art appear each day, meeting the changing demands of changing societies. Traditional folk painters in Haiti once painted delightfully telling pictures of their daily and ritual lives for themselves, but began exporting them when healthy markets appeared in Paris, New York, and elsewhere. Today, they are being called on to paint Haitian public health posters and billboards warning of the dangers of AIDS and other threats *(Fig. 34)*.

Unfortunately, there seems to be a correlation between underdevelopment and the persistence of traditional folk art. Most countries of Latin America, despite impressive recent strides in improved standards of living, still have many communities that are preindustrial and underdeveloped by modern standards, not only ours but theirs as well. Shortage of rural electrification in many parts of Brazil, Ecuador, Peru, Guatemala, and elsewhere has kept alive the need for the ingenious kerosene lamps we have seen earlier. The absence of portable water in many parts of Latin America makes it necessary to preserve traditional well-made and time-tested pottery for carrying and storing liquids.

Furthermore, throughout Latin America, there is often a disparity between people's knowledge of the existence of commercial products and their opportunities to purchase them, and this, too, keeps folk art alive. Children, unable to obtain manufactured toys they read about or see on television, make their own through recycling discarded materials to make cars, buses, and other recreational items.

And so, societies continue to create and adapt to the problems at hand. Throughout Latin America, folk art will die, change, and reemerge anew, always responding to the needs of a rapidly changing and increasingly complex environment. For those with the curiosity, patience, and energy required to seek it out, wherever it might be, the discovery of Latin American folk art will not only provide pleasure but also insight into the lives of those who make and use it.

Fig. 34. *Public Health Billboard*, c. 1989, Haiti.

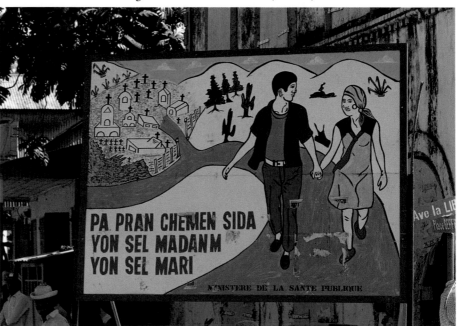

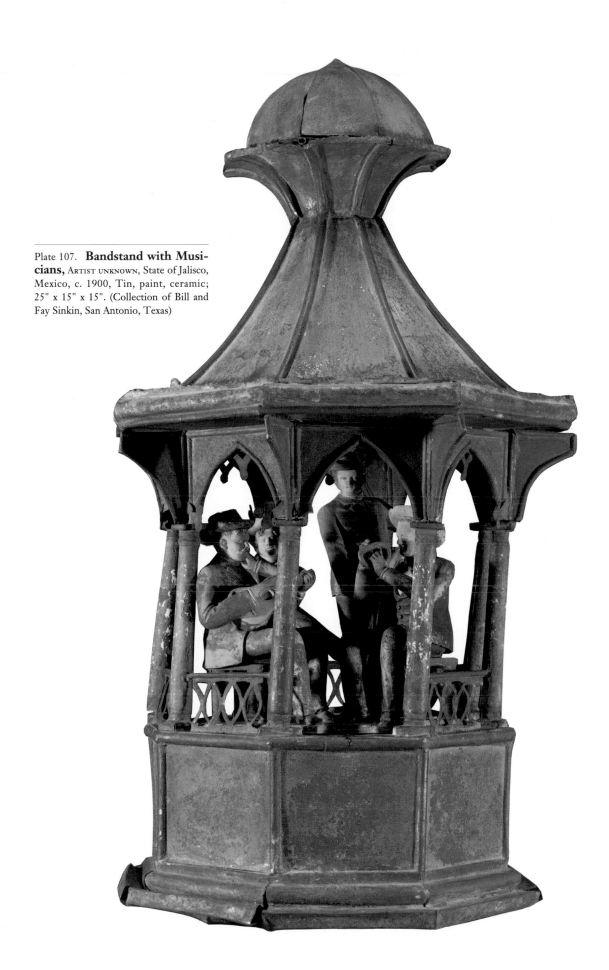

Plate 107. **Bandstand with Musicians,** ARTIST UNKNOWN, State of Jalisco, Mexico, c. 1900, Tin, paint, ceramic; 25" x 15" x 15". (Collection of Bill and Fay Sinkin, San Antonio, Texas)

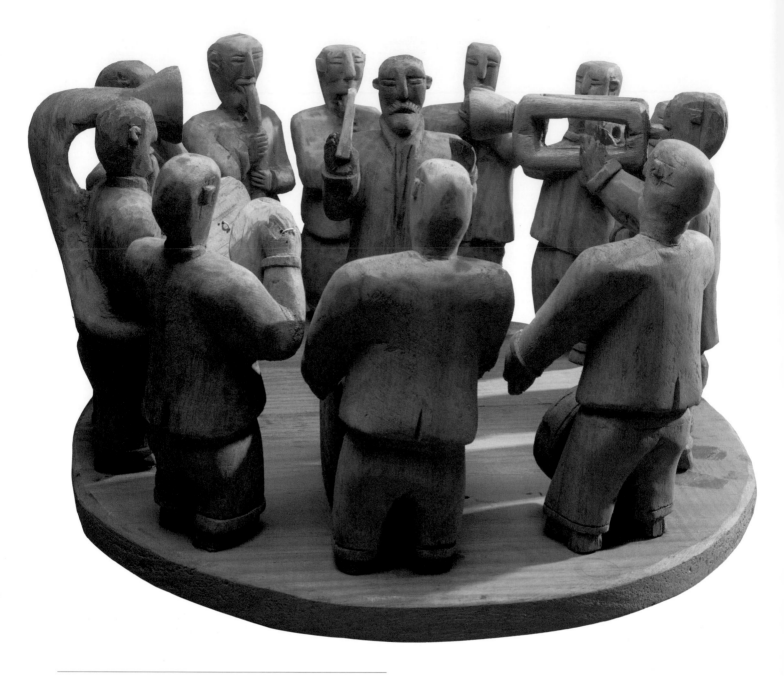

Plate 108. **Village Band,** Concepción Ocampo, Tocuaro, Michoacan, Mexico, c. 1988, Wood, cotton string; 10" x 16 ½" x 16 ½". (Collection of the Museum of American Folk Art)

Music is an integral part of community life in Latin America. It is used to entertain, to honor local, regional, and national leaders, and as an audible expression of devotion to saints and other religious figures. Many small towns in Latin America still have a central plaza where important secular and religious buildings are located. Some still have elaborate *kioskos* (gazebos) that are used for political gatherings, but mainly for weekend band concerts. The extraordinary *Bandstand with Musicians* from Jalisco is a splendid reminder of public architecture from the Porifiriato period in Mexico, a time when that country looked to Europe for aesthetic guidance. The lifelike clay genre figures inside reflect the dress of the same period in strikingly accurate detail. One can almost hear bars of "Sobre Las Olas," a popular waltz of the period, drifting romantically from this rare bandstand.

Present-day Michoacan's Concepción Ocampo has also chosen to recall the importance of village music in his *Village Band,* but has chosen to do so in a much simpler fashion. His unpainted eleven-piece band, however, has a similar power to call up strains of rustic music still typical of peasant Mexico.

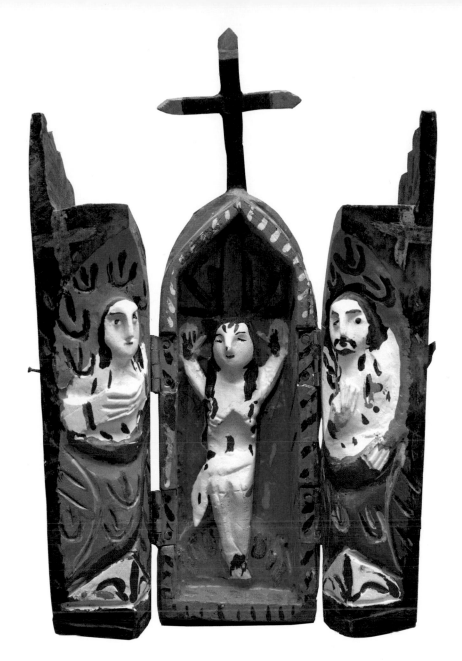

Plate 109. **Triptych,** Ana Pamplona, Antenor Navarro, Paraíba, Brazil, c. 1985, Polychromed wood, metal; 11" x 7¹/₂" x 3¹/₄". (Collection of the Museum of American Folk Art; gift of Roberto Emerson Câmera Benjamin)

These ingenious portable religious triptychs are called *oratorios de garrafa* (bottle oratories) because of their cylindrical shape when closed. They are also referred to as "saddlebag" oratories since they are portable, and, in past times, were transported from town to town on horseback. These triptychs were among a small number of essential possessions belonging to families who regularly moved about northeast Brazil to escape drought or to look for new employment. Typically, they depict Christ crucified in the center section, flanked by the Virgin María and San José. Portable triptychs were very popular during the nineteenth century, especially in Juaziero and other parts of the northeast. Portable altars from that period are still proudly owned and used by families today who pass them down from generation to generation. Ana Pamplona, a ninety-year-old *santera* from the state of Paraíba, has carved wood for much of her long life, and she continues to make portable altars and other traditional images. As one can see, her colors are bolder and her images a bit less realistic than earlier pieces from the same general area, but the basic features are the same. Iconographically, she has continued to include the traditional attributes associated with each image—José with his flowering staff, and María with her blue veil, for example.

"Friend, when I am dead, make a
cup of the clay I become. And,
if you remember me, drink from
it. Should your lips cling to
the cup, it will be but my earthy
kiss."

LATIN AMERICAN FOLK SONG[3]

Plate 110. **Triptych,** ARTIST UNKNOWN, Northeast Brazil, c. 1920, Polychromed wood, metal; 7¹/₂" x 5¹/₂" x 2". (Collection of the Museum of American Folk Art)

NOTES

Epigraph
1. Frances Toor, *A Treasury of Mexican Folkways* (New York: Crown, 1947), p. 541.

CHAPTER 1

1. Adolfo Best-Maugard, *Tradición, resurgimiento, y evolución del arte mexicano* (Mexico: Editorial de la Secretaría de Educación Pública, 1923).

2. Paul Richard, "Gentle Strokes from Gentle Folks," *The Washington Post*, November 19, 1981.

3. Charlene Cerny, "Everyday Masterpieces" (Review of *Young America* by Lipman, Warren, Bishop), *The New York Times*, p. 15. Feb. 22, 1987.

4. Robert T. Teske, "What is Folk Art?", *El Palacio*, Vol. 88, 1982 83, pp. 34 38.

5. Robert Redfield, *Peasant Society and Culture* (Chicago: The University of Chicago Press, 1956).

6. Fr. Bernardino de Sahagún, *General History of the Things of New Spain*, Book 10 (Santa Fe: The School of American Research, 1961), p. 25.

7. Ibid., p. 42.

8. Leopoldo Mendez et al., *The Ephemeral and the Eternal of Mexican Folk Art*, Vol. 1 (Mexico City: Fondo Editorial de la Plástica Mexicana, 1971), p. 59.

9. Elizabeth Wilder Wisemann, *Art and Time in Mexico: From the Conquest to the Revolution* (New York: Harper and Row, 1985), p. 198.

10. Karen Spalding, *Huarochri: An Andean Society under Inca and Spanish Rule* (Stanford: Stanford University Press, 1984), p. 280.

11. Janet Brody Esser, "The Persistent Memory: New Directions in Folk Art Studies," *Arte Vivo: Living Traditions in Mexican Folk Art*, edited by James Ramsey (Memphis: Memphis State University Gallery, 1984), p. 96.

12. Ibid.

13. Fatima Bercht, *House of Miracles: Votive Sculpture from Northeastern Brazil* (New York: Americas Society, 1989).

14. Robert Torrez, "Santiago: Observations of an Ancient Tradition in a Northern New Mexican Village," *El Palacio*, Vol. 95, No. 2, 1990.

15. Gloria Kay Giffords, *Mexican Folk Retablos: Masterpieces on Tin* (Tucson: University of Arizona Press, 1974), p. 113.

16. Tony Pasinski, *The Santos of Guatemala* (Guatemala City: Centro Científico, n.d.).

17. Patricia Altman, *Santos: Folk Sculpture from Guatemala* (Los Angeles: UCLA Museum of Cultural History, 1980), p.13.

18. Charles Hillinger, "Traditions behind the Fiesta Unmasked," *The Los Angeles Times*, May 6, 1990.

19. Toor, *A Treasury of Mexican Folkways*, p. 350.

20. Jeanette Peterson, *Precolumbian Flora and Fauna: Continuity of Plant and Animal Themes in Mesoamerican Art* (La Jolla, California: Mingei International Museum of World Folk Art, 1990), p. 90.

21. Ibid.

22. Nicolas J. Saunders, *People of the Jaguar: The Living Spirit of Ancient America* (London: Souvenir Press 1989), p. 150.

23. Ibid., p. 151.

24. Carlos Navarrete, "Prohibición de la danza del tigre," *Tlalocan*, Vol. 6, No. 4, pp. 374–76, 1971.

CHAPTER 2

1. Christine Mather, *Baroque to Folk* (Santa Fe: Museum of New Mexico Press, 1980), p. 38.

2. Marion Oettinger, Jr., *Dancing Faces: Mexican Masks in a Cultural Context* (Washington D.C.: Meridian House International, 1985).

3. Jim and Jeanne Pieper, *Guatemalan Masks: The Pieper Collection* (Los Angeles: The Craft and Folk Art Museum, 1988), p. 16.

4. Fernando Horcasitas, "Mexican Folk Art," *National Geographic*, 1978, Vol. 153, No. 5.

5. Marion Oettinger, Jr. and Ted Warmbold, *Zacualpa Ceramics: Traditional Pottery from Southern Mexico* (San Antonio: San Antonio Museum Association, 1986).

6. Ann Parker and Avon Neal, *Molas: Folk Art of the Cuna Indians* (Barre, Massachusetts: Barre Publishing, 1977).

7. Nancy Modiano, *Indian Education in the Chiapas Highlands* (New York: Holt, Rinehart and Winston, 1973).

8. Mariano Díaz, *El alma entre los dedos* (Caracas: Refolit, n.d.), p. 139.

9. Horcasitas, "Mexican Folk Art," p. 654.

10. Bercht, *House of Miracles*, p. 20.

11. Suzanne Seriff, *Mexican Folk Toys from the State of Guanajuato* (Research proposal, University of Texas at Austin, memo form), 1989, p. 9.

12. Pat Jasper and Kay Turner, *Art Among Us: Mexican American Folk Art of San Antonio* (San Antonio: San Antonio Museum Association, 1986), p. 66.

CHAPTER 3

1. Jean Charlot, *The Mexican Mural Renaissance, 1920–1921)* (New Haven: Yale University Press, 1963), p. 29.

2. Ibid.

3. John W. Nunley and Judith Bettelheim, *Caribbean Festival Arts: Each and Every Bit of Difference* (Seattle: University of Washington Press, 1988).

4. Giffords, *Mexican Folk Retablos*, p. 116.

5. Marilyn G. Karmason, "Shimmering and Brilliant: American Victorian Tinsel Paintings," *The Clarion*, Vol. 16, No. 4, 1991–92, pp. 73–79.

6. Giffords, *Mexican Folk Retablos*, pp. 102–103.

7. Gloria Kay Giffords, *The Art of Private Devotion: Retablo Painting of Mexico* (Dallas: The Meadows Museum, Southern Methodist University, 1991), p. 33.

8. Cecilia Steinfeldt, *Texas Folk Art: One Hundred Fifty Years of the Southwestern Tradition* (Austin: Texas Monthly Press, 1981), pp. 80–81.

9. Francisco Stastny, *Las Artes Populares del Peru* (Lima: Ediciones EDUBANCO, 1981), pp. 191–193.

10. Peter McFarren, *Plumas de los dioses* (Santiago: Museo Chileno de Arte Precolombino, 1989).

11. Paul van de Velde and Henriette van de Velde, *The Black Pottery of Coyotepec, Oaxaca, Mexico* (Los Angeles: The Southwest Museum, 1939)

12. Louana M. Lackey, *The Pottery of Acatlán: A Changing Mexican Tradition* (Norman: University of Oklahoma Press, 1982)

13. Joseph W. Bastien, *Mountain of the Condor: Metaphor and Ritual in an Andean Ayllu* (St. Paul., Minnesota: West Publishing Co., 1978).

14. Telephone interview with Ann Parker, 1991.

15. Annie O'Neill and Charlene Cerny, *Mexican Folk Art from the Collection of Nelson A. Rockefeller* (New York: Center for Inter-American Relations, 1984), p. 161.

16. George M. Foster, "Peasant Society and the Image of Limited Good," *American Anthropologist*, Vol. 67, No. 2, 1965.

17. José de J. Núñez y Domínguez, "Las loterías de figuras en Mexico", *Mexican Folkways*, 1932, Vol. 7, p. 99.

18. Katarina Real, *O folclore no carnaval do Recife* (Recife: Fundacâo Joaquin Nabuco, 1990), pp. 239–244.

19. Personal communication with Jim Caswell, November 19, 1991.

CHAPTER 4

1. Mendez, et al., *The Ephemeral and the Eternal in Mexican Folk Art*.

2. Oettinger, *Dancing Faces*.

3. Mendez, et al., *The Ephemeral and the Eternal in Mexican Folk Art*.

LIST OF WORKS CITED

Altman, Patricia. *Santos: Folk Sculpture from Guatemala*, Los Angeles: UCLA Museum of Cultural History. 1980.

Bastien, Joseph W. *Mountain of the Condor: Metaphor and Ritual in an Andean Ayllu*, St. Paul, Minnesota: West Publishng Co. 1978.

Bercht, Fatima. *House of Miracles: Votive Sculpture from Northeastern Brazil*, New York: The Americas Society. 1989.

Best-Maugard, Adolfo. *Tradición, resurgimiento y evolución del arte mexicano*, Mexico City: Editorial de la Secretaria de Educación Publica. 1923.

Cerny, Charlene. "Everyday Masterpieces," review of *Young America* by Lipman, Warren, Bishop, *The New York Times*, p. 15. Feb. 22. 1987.

Charlot, Jean. *The Mexican Mural Renaissance, 1920–1921*, New Haven: Yale University Press. 1963.

de Sahagún, Fr. Bernardino. *General History of the Things of New Spain*, Book 10, Santa Fe: The School of American Research. 1961.

Díaz, Mariano. *El alma entre los dedos*, Caracas: Refolit. n.d.

Esser, Janet Brody. "The Persistent Memory: New Directions in Folk Art Studies," In *Arte Vivo: Living Traditions in Mexican Folk Art*, edited by James Ramsey, Memphis: Memphis State University Gallery. 1984.

Foster, George M. "Peasant Society and the Image of Limited Good," *American Anthropologist*, Vol. 67, No. 2. 1965.

Giffords, Gloria Kay. *Mexican Folk Retablos: Masterpieces on Tin*, Tucson: University of Arizona Press. 1974.

The Art of Private Devotion: Retablo Painting of Mexico, Dallas: The Meadows Museum. 1991.

Hillinger, Charles. "Traditions behind the Fiesta Unmasked," *The Los Angeles Times*, May 6. 1990.

Horcasitas, Fernando. "Mexican Folk Art" in *National Geographic*, Vol. 153, No. 5. 1978.

Jasper, Pat and Kay Turner. *Art Among Us: Mexican American Folk Art of San Antonio*, San Antonio: San Antonio Museum Association. 1986.

Karmason, Marilyn G. "Shimmering and Brilliant: American Victorian Tinsel Paintings," in *The Clarion*, Vol. 16, No. 4. 1991.

Lackey, Louana M. *The Pottery of Acatlán: A Changing Mexican Tradition*, Norman: University of Oklahoma Press. 1982

Mather, Christine. *Baroque to Folk*, Santa Fe: Museum of New Mexico Press. 1980.

Mendez, Leopoldo, et al. *The Ephemeral and the Eternal of Mexican Folk Art*, Vol. 1, Mexico: Fondo Editorial de la Plástica Mexicana. 1971.

Modiano, Nancy. *Indian Education in the Chiapas Highlands*, New York: Holt, Rinehart and Winston. 1973.

McFarren, Peter. *Plumas de los dioses*, Santiago: Museo Chileno de Arte Precolombino. 1989.

Navarrete, Carlos. "Prohibición de la danza del tigre," in *Tlalocan*, Vol. 6, No. 4. 1971.

Nunley, John W. and Judith Bettelheim. *Caribbean Festival Arts: Each and Every Bit of Difference*, Seattle: University of Washington Press. 1988.

Nuñcz y Dominguez, José de J. "Las loterias de figuras en Mexico," in *Mexican Folkways*, Vol. 7. 1932.

Oettinger, Marion, Jr. *Dancing Faces: Mexican Masks in a Cultural Context*, Washington, D.C.: Meridian House International. 1985.

_____ and Ted Warmbold. *Zacualpa Ceramics: Traditional Pottery from Southern Mexico*, San Antonio: San Antonio Museum Association. 1986.

O'Neill, Annie and Charlene Cerny. *Mexican Folk Art from the Collection of Nelson A. Rockefeller*, New York: Center for Inter-American Relations. 1984.

Parker, Ann and Avon Neal. *Molas: Folk Art of the Cuna Indians*, Barre, Massachusetts: Barre Publishing. 1977.

Pasinski, Tony. *The Santos of Guatemala*, Guatemala: Centro Científico. n.d.

Peterson, Jeanette. *Precolumbian Flora and Fauna: Continuity of Plant and Animal Themes in Mesoamerican Art*, La Jolla: Mingei International Museum of World Folk Art. 1990.

Pieper, Jim and Jeanne. *Guatemalan Masks: The Pieper Collection*, Los Angeles: The Craft and Folk Art Museum. 1988.

Real, Katarina. *O folclore no carnaval do Recife*, Recife: Fundacâo Joaquim Nabuco. 1990.

Redfield, Robert. *Peasant Society and Culture*, Chicago: The University of Chicago Press. 1956.

Richard, Paul. "Gentle Strokes from Gentle Folks," *The Washington Post*, November 19, 1981.

Saunders, Nicolas J. *People of the Jaguar: The Living Spirit of Ancient America*, London: Souvenir Press. 1989.

Seriff, Suzanne. *Mexican Folk Toys from the State of Guanajuato*, Research proposal (memo form). 1989.

Spalding, Karen. *Huarochri: An Andean Society Under Inca and Spanish Rule*, Stanford: Stanford University Press. 1984.

Stastny, Francisco. *Las Artes Populares del Peru*, Lima: Ediciones EDUBANCO. 1981.

Steinfeldt, Cecilia. *Texas Folk Art: One Hundred Fifty Years of the Southwestern Tradition*, Austin: Texas Monthly Press. 1981.

Teske, Robert T. "What is Folk Art?", in *El Palacio*, Vol. 88. 1982.

Toor, Frances. *A Treasury of Mexican Folkways*, New York: Crown. 1947.

Torrez, Robert. "Santiago: Observations of an Ancient Tradition in a Northern New Mexican Village," in *El Palacio*, Vol. 95, No. 2. 1990.

van de Velde, Paul and Henriette. *The Black Pottery of Coyotepec, Oaxaca, Mexico*, Los Angeles: The Southwest Museum. 1939.

Wisemann, Elizabeth Wilder. *Art and Time in Mexico: From the Conquest to the Revolution*, New York: Harper and Row. 1985.

ANNOTATED BIBLIOGRAPHY

GENERAL WORKS ON LATIN AMERICAN FOLK ART

Andes, Dawn. *Art in Latin America: The Modern Era, 1820–1980*. Yale University Press: New Haven and London. 1989.

An excellent overview of Latin American art covering the past 175 years. Provides a good historical backdrop against which to understand folk art. Particularly interesting are discussions on the popular graphic tradition and *costumbrista* painting, a major source of information on folk art from the nineteenth century.

Castedo, Leopoldo. *A History of Latin American Art and Architecture: From Pre-Columbian Times to the Present*. Frederick A. Praeger: New York. 1969.

A good introductory overview of art in Latin America. Contains short discussion on popular painting.

de la Orden, José Tudela. *Arte Popular de América y Filipinas*. Instituto de Cultura Hispanica: Madrid. 1968.

An amazing collection of photographs of thousands of folk objects from all over Latin America. Very little discussion.

Egan, Martha. *Milagros: Votive Offerings from the Americas*. Foreword by Marion Oettinger, Jr. Museum of New Mexico Press: Santa Fe. 1991.

An excellent bilingual overview of votive objects in Latin America with a historical discussion on origins. Photographs, some contextual, are from various parts of Europe and Latin America.

Foster, George M. *Culture and Conquest: America's Spanish Heritage*. Viking Fund Publications in Anthropology 27. Chicago. 1960.

Essential reading for a good understanding of the interaction between European and New World cultural forms.

Glassie, Henry. *The Spirit of Folk Art: The Girard Collection at the Museum of International Folk Art*. Harry N. Abrams: New York. 1989.

An important publication on the Girard Collection, placed within a broader discussion on some of the main issues related to folk art.

Graburn, Nelson H.H. *Ethnic and Tourist Arts: Cultural Expressions from the Fourth World*. The University of California Press: Berkeley. 1976.

Contains six interesting chapters on specific forms of folk art from Latin America. Includes commentary on the relationship between traditional art production and that which is directed toward an outside market.

Mather, Christine. *Baroque to Folk*. Museum of International Folk Art: Santa Fe. 1980.

A modest but insightful bilingual publication on the fine arts of the baroque and the emerging folk arts of Spanish and Portuguese colonies.

Olien, Michael. *Latin Americans: Contemporary Peoples and their Cultural Traditions*. Holt, Rinehart and Winston: New York. 1973.

Although somewhat dated, this volume provides good geographical and cultural background with which to view Latin American folk art.

Panyella, August. *Folk Art of the Americas*. Harry N. Abrams: New York. 1981.

A major survey of folk art from Canada to Tierra del Fuego, accompanied by color photographs of objects and folk artists.

Pelauzy, M.A. *Spanish Folk Crafts*. Photographs by F. Catala Roca. Editorial Blume: Barcelona. 1978.

A good introduction to the folk art of Spain. Contains brief but interesting chapters on textiles, wood, toys, breads, nativity scenes, votive offerings, among others.

Schevill, Margot Blum. *Costume as Communication: Ethnographic Costumes and Textiles from Middle America and the Central Andes of South America.* University of Washington Press: Seattle. 1986.

An interesting study of an important collection of costumes from the Haffenreffer Museum at Brown University.

THE CARIBBEAN

Nunley, John W. and Judith Bettelheim. *Caribbean Festival Arts: Each and Every Bit of Difference.* The University of Washington Press: Seattle. 1988.

A pioneering exhibition catalogue related to the importance of festival arts in the Caribbean. Photographs and texts are well done and revealing.

Polanco Brito, Archbishop Hugo E. *Ex-votos y milagros del santuario de Higüey.* Ediciones Banco Central: Santo Domingo, Dominican Republic. 1984.

A very interesting "catalogue" on votive offerings and the votive art tradition of Higüey, Dominican Republic.

Rodman, Selden. *Where Art is Joy: Haitian Art, The First Forty Years.* Ruggles de Latour: New York. 1988.

One of the best publications yet on the history and evolution of Haitian art. The author has worked with Haitian art for over four decades.

Vidal, Teodoro. *Los milagros en metal y en cera de Puerto Rico.* Ediciones Alba: San Juan. 1974.

An important book on the history and meaning of Puerto Rican votive art.

Las Caretas de cartón del carnaval de Ponce. Ediciones Alba: San Juan. 1983.

An interesting glimpse into the ongoing masking tradition in Puerto Rico.

MEXICO AND CENTRAL AMERICA

El que se Mueve, no sale! Fotógrafos ambulantes. Dirección General de Culturas Populares: Mexico City. 1989.

An interesting exhibition catalogue related to itinerant photographers of Mexico and the hand-painted backdrops they use.

El arte popular de Mexico. Edición Extraordinario. Artes de Mexico: Mexico City. 1970.

Atl, Dr. (Gerardo Murillo). *Las artes populares en Mexico.* 2 vols. Editorial Cultura: Mexico City. 1921.

A classic publication on the folk arts of Mexico by one of her most illustrious painters and students of folk culture.

Castegnaro de Foletti, Alessandra. *Alfarería lenca contemporanea de Honduras.* Editorial Guaymuras, S.A. Tegunsigalpan. 1989.

An important and rare glimpse of a traditional type of pottery from Honduras.

Coulter, Lane and Maurice Dixon. *New Mexican Tinwork, 1840–1940.* University of New Mexico Press: Santa Fe. 1990.

A valuable publication on an important, albeit obscure, subject. Contains valuable data on Mexican and New Mexican tinwork through time. Coulter, himself a tinsmith, adds valuable insight to the publication.

Cordry, Donald B. and Dorothy M. *Mexican Indian Costumes.* University of Texas Press: Austin. 1968.

The best publication to date on Mexican costumes. Contains many important photographs by the Cordrys taken during thirty years of fieldwork.

Edwards, Emily. *Painted Walls of Mexico: From Prehistoric Times until Today.* Photographs by Manuel Alvarez Bravo. Foreword by Jean Charlot. University of Texas Press: Austin. 1966.

An excellent overview of wall painting in Mexico from pre-Columbian times to present. Inclusion of photographs and data on nineteenth-century hacienda paintings and twentieth-century *pulquería* decorations are unique and add valuable knowledge to the subject.

Espejel, Carlos. *Mexican Folk Crafts.* Editorial Blum: Barcelona. 1978.

A good introduction by the late Carlos Espejel, who was one of Mexico's leading champions of folk art and folk art preservation.

Esser, Janet Brody (editor). *Behind the Mask in Mexico.* Museum of International Folk Art. Museum of New Mexico Press: Santa Fe. 1988.

Best publication to date on the use and meaning of Mexican masks.

Giffords, Gloria Kay. *Mexican Folk Retablos: Masterpieces on Tin.* University of Arizona Press: Tucson. 1974.

A valuable and important publication on Mexican tin paintings with a useful discussion on iconography.

Hancock de Sandoval, Judith and Pal Kelemen. *Folk Baroque in Mexico: Mestizo Architecture through the Centuries.* The Smithsonian Institution: Washington, D.C. 1974.

A rare, albeit brief, look at folk architecture in Mexico by a leading Latin American art historian and photographer.

Harvey, Marian. *Mexican Crafts and Craftspeople.* The Art Alliance Press: Philadelphia. 1987.

Provides valuable insight into the production of a dozen or so different forms of folk art, with specific emphasis on process.

Lackey, Louana M. *The Pottery of Acatlan: A Changing Mexican Tradition.* The University of Oklahoma Press: Norman. 1982.

One of the most in-depth analyses yet offered of the folk art production of a single village.

Martínez Penaloza, Porfirio. *Arte popular Mexicano.* Editorial Herrero, S.A.: Mexico City. 1975.

A very good introduction to Mexican folk art with interesting essays by that country's leading investigators on the subject.

Mendez, Leopoldo, et al. *The Ephemeral and the Eternal of Mexican Folk Art.* 2 Vols. Fondo Editorial de la Plástica Mexicana: Mexico City. 1971.

Very possibly the best publication to date on Mexican folk art because of the quality of photographs and textual material.

Montenegro, Roberto. *Museo de Artes Populares.* Ediciones de Arte: Mexico City. 1948.

An interesting, but brief, examination of one of the earliest folk art collections in Latin America by one of Mexico's leading collectors and founder of the national folk art program just following the Mexican Revolution.

Morris, Walter F., Jr. *Living Maya.* Photographs by Jeffrey J. Foxx. Harry N. Abrams: New York. 1987.

A beautiful publication on traditional Maya culture with strong emphasis on textiles.

Mulryan, Lenore Hoag. *Mexican Figural Ceramics and their Works 1950–1981.* Museum of Cultural History. University of California at Los Angeles. 1982.

A short and insightful publication on five of Mexico's leading ceramists with very valuable observations gleaned from life histories.

Oettinger, Marion, Jr. *Dancing Faces: Mexican Masks in a Cultural Context.* Meridian House International: Washington, D.C. 1985.

Folk Treasures of Mexico: The Nelson A. Rockefeller Collection. Foreword by Nelson A. Rockefeller. Preface by Ann Rockefeller Roberts. Harry N. Abrams: New York. 1990.

A description and analysis of the Mexican folk art collection assembled by the late Gov. Nelson Rockefeller over a period of fifty years. Most color photographs by Lee Boltin.

Osborne, Lilly de Jongh. *Indian Crafts of Guatemala and El Salvador.* University of Oklahoma Press: Norman. 1965.

A good, encyclopedic treatment of the folk arts of Guatemala and El Salvador. An essential starting point for those interested in folk art research in that part of Latin America.

Parker, Ann and Avon Neal. *Molas: Folk Art of the Cuna Indians.* Barre Publishing: Barre, Massachusetts. 1977.

An attractive, well-written book on mola art of the San Blas Islands in Panama. Contains many excellent color photographs of molas.

Los Ambulantes: The Itinerant Photographers of Guatemala. The MIT Press: Cambridge, Massachusetts. 1982.

An interesting and valuable study of itinerant photographers in Guatemala with excellent photographs of these artists and their subjects.

Pasinski, Tony. *The Santos of Guatemala.* 2 Vols. Centro Científico Cultural: Guatemala City.

An encyclopedic treatment of Guatemalan *santos* dealing with history, legend, and iconography.

Reina, Ruben E. and Robert M. Hill. *Traditional Pottery of Guatemala.* University of Texas: Austin. 1978.

An important study of traditional pottery from all over Guatemala. Both authors are anthropologists and use good, solid ethnographic methodology to explore this rich form of folk expression. Loaded with excellent photographs and drawings.

Rubin de la Borbolla, Daniel F. *Arte popular Mexicano.* Fondo de Cultura Económica: Mexico City. 1974.

A valuable essay on Mexican folk art from pre-Columbian times to the present.

Salvador, Mary Lynn. *Yer Dailege! Kuna Women's Art.* University of New Mexico Press: Albuquerque. 1978.

An important anthropological study of the Kuna of the San Blas Islands in Panama with special attention given to mola art and other forms of folk expression.

Sayer, Chloe. *Costumes of Mexico.* The University of Texas Press: Austin. 1985.

An excellent introductory volume on Mexican dress. Sayer's historical essay is very good and provides an important context for dealing with costume.

Arts and Crafts of Mexico. Chronicle Books: San Francisco. 1990.

Starr, Frederick. *Catalogue of a Collection of Objects Illustrating the Folklore of Mexico*. the Folk-lore Society: London. 1898.

The first publication in English on Mexican folk art. Related to a collection now in storage at Cambridge University, England. One of the first publications to describe folk art as that produced by peasant society. This is a study to which all subsequent publications on Mexican folk art must relate.

Taylor, Barbara Howland. *Mexico: Her Daily and Festive Breads*. Photographs by Merle G. Wachter. The Creative Press: Claremont, California.

This unusual volume devotes itself to one of the most ephemeral forms of folk expression in Mexico and provides a very good overview of the important role played by bread in the daily and ritual lives of Mexicans, past and present.

Toor, Frances. *A Treasury of Mexican Folkways*. Crown: New York. 1947.

A valuable composite of short folk studies conducted by Toor over many years. An encyclopedia of Mexican folk culture.

Turok, Marta. *Como acercarse a la artesania*. Editorial Plaza y Valdez: Mexico City. 1988.

Weismann, Elizabeth Wilder. *Art and Time in Mexico: From the Conquest to the Revolution*. Photographs by Judith Hancock Sandoval. Harper and Row: New York. 1985.

A good overview with a separate chapter on folk art.

SOUTH AMERICA

Colecâo culto Afro-Brasileiro: Um testemunho do xango pernambuco. Museu do Estado de Pernambuco: Recife, Brazil. 1983.

An examination of ceremonial folk art associated with Afro-Brazilian cults in northeast Brazil.

Brazil: Arte do Noreste/ Art of the Northeast. Banco do Brazil, SPALA Editora: Rio de Janeiro. 1985.

An opulent publication, in Portuguese and English, full of color photographs, outlining the art of northeast Brazil. Much attention paid to folk art from colonial times to the present. A good overview for beginners.

Andrade, Jaime, et al. *Arte popular del Ecuador: areas norte, sur, y centro*. 2a Edición. Ediciones ABYA-YALA: Ouito. 1989.

A useful guide to contemporary folk art of Ecuador.

Aretz, Isabel. *La artesania folklórica de Venezuela*. Monte Avila Editores, C.A.: Caracas. 1979.

A good overview.

Barrionuevo, Alfonsina. *Artistas populares del Peru*. SAGSA: Lima. n.d.

An interesting glimpse at some of Peru's leading folk artists.

Bercht, Fatima. *House of Miracles: Votive Sculptures of Northeastern Brazil*. The Americas Society: New York. 1989.

An important catalogue of an exhibit on Brazilian votive art.

CIDAP. *Creación: El arte popular en el Museo Comunidad de Chordeleg*. Centro Interamericano de Artesanias y Artes Populares: Cuenca. 1988.

Coelho Frota, Lelia. *Brazil: Arte popular hoje*. Editoracâo Publicacoes Ltda.: Sâo Paulo. 1987.

An exhibition catalogue that can serve as a valuable guide to the folk art of Brazil.

Díaz, Mariano. *Milagreros del camino*. Fundación Bigott. Refolit: Caracas. 1989.

A fascinating book on roadside shrines and other pilgrimage spots in Venezuela with excellent photographs of people and places.

María Lionza: Religiosidad mágica de Venezuela. Refolit: Caracas.

An extroardinary photo-study of the cult of María Lionza in Venezuela with commentary on the phenomenon by practitioners, anthropologists, psychiatrists, theologians, and others.

El alma entre los dedos. Refolit: Caracas.

A sensitive look at traditional folk sculptors in Venezuela.

Friedemann, Nina S. de. *Carnaval en Barranquilla*. Editorial La Rosa: Bogotá. 1985.

A superb study of carnival in Barranquilla by one of Colombia's leading anthropologists/photographers.

Gisbert, Teresa, et al. *Arte textil y mundo Andino*. Gisbert y Cia.: La Paz. 1987.

Contains important comments on the meaning of traditional design motifs in contemporary Andean textiles.

Gonzales, Susana M. *El pase del niño*. Centro Interamericano de Artesanias y Artes Populares: Cuenca. 1981.

A good description and analysis of one of Ecuador's most colorful traditions.

Martínez Borrero, Juan. *La pintura popular del Carmen: Identidad y cultura en el siglo XVIII*. Centro Interamericano de Artesanias y Artes Populares: Cuenca.

A rare glimpse at the folk murals in the Convent of Carmen in Cuenca, Ecuador.

Penley, Dennis. *Panos de Gualaceo*. Centro Interamericano de Artesanias y Artes Populares: Cuenca. 1988.

An analysis of ikat-dyed shawls from southern Ecuador.

Pollak-Eltz, Angelina. *Las animas milagrosas en Venezuela*. Fundación Bigott. Refolit: Caracas. 1989.

A valuable examination of miracles and miracle makers in Venezuela by one of that nation's leading anthropologists.

Price, Sally and Richard. *Afro-American Arts of the Suriname Rain Forest*. University of California Press: Berkeley. 1980.

A very well done publication on African-American arts by leading scholars on the region. Excellent photographs.

Slater, Candace. *Stories on a String: The Brazilian "Literature de Cordel."* University of California Press: Berkeley. 1982.

An in-depth study of the Brazilian chap book and its meaning. A valuable source for information on Brazilian folk poetry, legend, and popular literature.

Stastny, Francisco. *Las artes populares del Peru*. Ediciones Educanco: Madrid. 1979.

An important book on Peruvian folk art, concentrating on material made by Peruvians for Peruvians. First part is background and deals with such issues as "What is folk art?" "Historical dimensions of folk art," etc. Second part deals with author's categories, i.e., ceramics, *retablos* and statuary, masks, textiles, popular painting. Contains many good and interesting photographs, most in color.

A NOTE ABOUT THE AUTHOR

Marion Oettinger, Jr., is a cultural anthropologist who specializes in Latin American ethnology, Spanish colonial art, and folk art. He has lived and worked in Mexico, Guatemala, Bolivia, and other parts of Latin America for over twenty years. Dr. Oettinger has lectured widely in the United States, Latin America, and Europe on folk-art topics and related subjects. He has taught at Cornell University, Occidental College, and the University of North Carolina at Chapel Hill, and has been a research associate at the Instituto de Investigaciones Antropológicas at Mexico's National Autonomous University. He is the author of numerous articles and books on Latin American anthropology and folkways, the most recent of which is *Folk Treasures of Mexico: The Nelson A. Rockefeller Collection* (Harry N. Abrams, N.Y., 1990). He has been the recipient of research grants from the National Geographic Society, the American Philosophical Society, and the National Science Foundation, and a senior research fellowship from the Fulbright program. Dr. Oettinger and his family live in San Antonio, Texas, where he is Curator of Folk Art and Latin American Art at the San Antonio Museum of Art.

FIGURE AND PLATE CREDITS

Figures
Roger Fry: 9, 10, 11
Marion Oettinger, Jr.: 1–8, 13–24, 26–34
Donna Pierce: 10

Plates

Gavin Ashworth: 6, 8, 11–17, 19, 20, 22–30, 33, 36–57, 60–71, 76–78, 80–82, 86, 87, 91–96, 98, 99, 101, 103–105, 109, 110
Roger Fry: 1, 2, 7, 9, 10, 21, 31, 32, 34, 35, 58, 72, 74, 79, 83–85, 90, 102, 107, 108
Jeff Oshiro: 106
Anthony Richardson: 3–5, 59, 73, 75, 88, 89, 97, 100
Steve Tucker: 18